MODERN VINTAGE ILLUSTRATION

MARTIN DAWBER

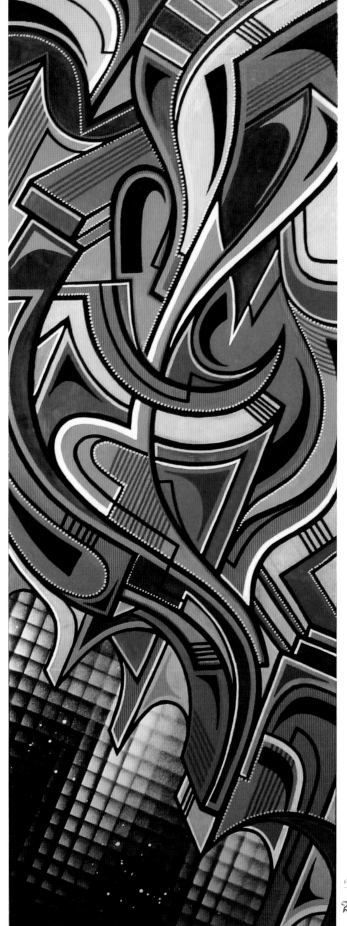

'And yet, unless my senses deceive me, the old centuries had, and have, powers of their own which mere 'modernity' cannot kill.'
Bram Stoker (*Dracula*)

DEDICATION
For my mother – she made all this possible.

First published in the United Kingdom in 2012 by
Batsford
10 Southcombe Street
London
W14 0RA

An imprint of Anova Books Company Ltd

ISBN: 9781849940320

A CIP catalogue record for this book is available from the British Library.

20 19 18 17 16 15 14 13 12
10 9 8 7 6 5 4 3 2 1

Reproduction by Mission Productions Ltd, Hong Kong
Printed and bound by 1010 Printing International Ltd, China

This book can be ordered direct from the publisher at the website:
www.anovabooks.com

5405000385898
23nd AUGUST 2012

MODERN VINTAGE ILLUSTRATION

MARTIN DAWBER

BATSFORD

CONT

E N T S

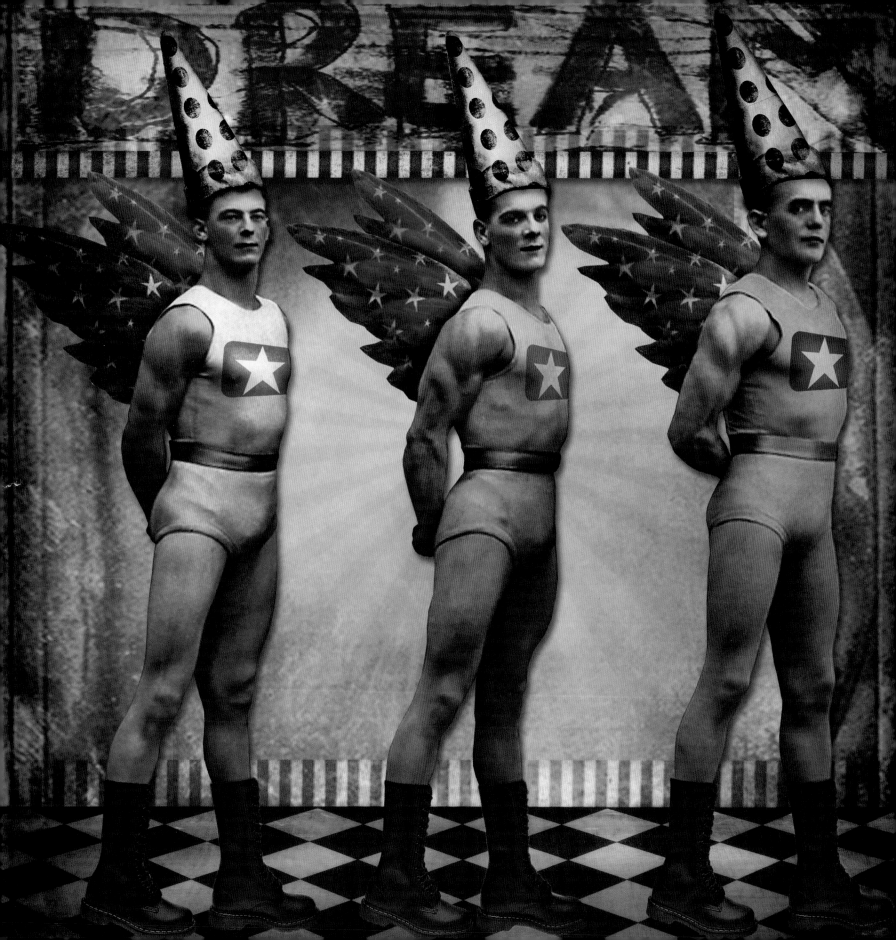

F O R E W O R D

John Updike once contemptuously said of Tom Wolfe 'it's not literature, it's entertainment'. That says a lot about Updike's expectations of literature: it must not be accessible, amusing, enjoyable, desirable, popular. Never mind that Wolfe was much the better wordsmith: more inventive than Updike, but also more readable and funny. These things did not matter because Updike had promoted himself above the marketplace to the highground of 'literature', a microcosm with rules of its own....none of which required it to be enjoyed. Indeed, difficulty was an actual test of quality. And this microcosm was policed by pitiless self-elected forces whose sole idea of entertainment was professional incest and career petting in a private orgy of self-regard. No wonder they called it 'The New York Review of Eachother's Books'.

And it was the same with art. I was always dismayed when I heard people say of a picture 'that's not art, it's illustration'. As if art had no duty to elucidate its subject. In this interpretation, art must be incomprehensible. If it could be read and enjoyed, it was evidently lacking seriousness, so it was illustration: facile, inferior, junior, middlebrow. No matter the technical achievement, no matter how validated by popularity, illustration was held in lofty disdain by a fatigued elite who mistook being baffling for being profound. Strange to have art defined by what it is not: it must not delight, not represent, not communicate. Instead, it must represent a concept. Well that's alright, except all the concepts were so feeble.

You can make your own mind up about when this ridiculous schism between art and illustration occurred, but by about 1960 the vanguard of art had more-or-less abandoned any obligation to prioritise the visual. In fact, industrial designers had long since usurped the artist's role in the manufacture of beauty. Thus, by about 1960 you find a vanguard artist putting excrement into a tin and at about the same time you find an engineer in Coventry drawing the Jaguar E-Type, the car usually cited as the most beautiful machine ever made.

This, at least to me, is the context of 'commercial art', the patronising term once used to suggest that true success was authentically vulgar. When I look at the contents of *Modern Vintage Illustration* I see, with mingled delight and dismay, what may be, perhaps, the last great pictorial episode in Western art. With the joyless, arid, nugatory futility of conceptualism on one historic side and the era of digital art next-up with its yet-to-be-written rules, here is a body of work whose essential, defining quality is visual.

I love the disciplines of illustration: the brief, the technical and budget constraints, the requirement to communicate with wit and ingenuity, the need to be original, but not abstruse, the acceptance of a market, the risk of failure. Rules like these are inspirations to creativity, not impediments to it. And what's 'creativity'? One answer is, a genius for synopsis. That's illustration. And if it's entertaining too, who cares if it's art?

Stephen Bayley

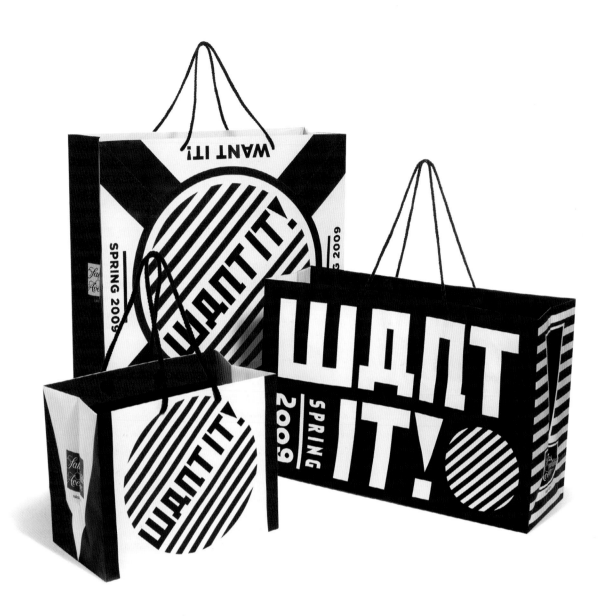

INTRODUCTION

In the spring of 2009, shoppers in midtown Manhattan were checking out the annual 'Want it!' ad campaign by New York's luxury fashion retailers, Saks Fifth Avenue.

To the casual observer these dynamic black and white images, accompanied with dramatic diagonal red slashes, appeared as just another gimmick for marketing the latest trends. Few recognised that this fist raising campaign had its roots in the propaganda artwork created almost a hundred years earlier by the Russian constructivist artist, Alexander Rodchenko.

Those original compositions had been skillfully modified by guerilla street artist and Studio Number One founder, Shepard Fairey, whose own controversial 'Hope' poster of Barack Obama had been used as a rallying image during the presidential election a year earlier, to now proclaim in distinctive angular type, 'Reform the Polo', 'Deconstruct the Sport Coat' and 'Electrify your Colors'.

This transition of art styles from the past appearing in contemporary guise was nothing new. Art and design seem to persist in self-referencing and the appropriation of artistic mannerisms from the recent past to fuel the future is ever more commonplace today.

Rodchenko's influence in the world of illustration and design remains unquestionable. His legendary 1924 photomontage of Lilya Brik graphically shouting out the word 'Books', similarly materialised on the music albums of the Dutch punk band, The Ex, when incorporated onto various 7" vinyls, and more famously onto the cover of Franz Ferdinand's *You Could Have It So Much Better* as recreated by Matthew Cooper.

These inspired examples easily show how valued art movements from the 20th century continue to impact in the work of today's artists and illustrators.

Turning the pages of *Modern Vintage Illustration* will arouse in its readers a feeling of déjà-vu as each chapter presents evermore personal and individual reactions to these past styles and techniques. Each page seems to prompt, "where have I seen that before?" as the characteristic handwriting of earlier exponents is reinvented for contemporary eyes.

At times these reworkings can become a labour of love as another artist meticulously pays homage to their source. Elsewhere the designer lets the style traverse his subconscious to provide a conduit for his own artistic expression to evolve on the page (or screen). They are able to create visual spoonerisms as recognisable gestures from the past are skillfully intermingled.

Although the range of contemporary illustration styles has never been broader and more varied, given today's unprecedented means of expression, artists seem to be keeping an ever-watchful eye over their shoulder.

Modern Vintage Illustration represents contemporary illustration from a different perspective as these earlier modes and manners are jumbled up to fashion new and exciting visuals. What Dalí did in oils, today's creatives are able to do with pixels. These re-inventions not only inform the initiated but impact on a wider audience by pointing a new generation of creatives to seek out and admire the key movers and shakers from the past century.

Nowhere is this more obvious than in the countless advertising campaigns that have learned to attach style to their products by raiding the past in order to offer an experience distinct from just an ordinary purchase.

Biba did it in the late 60s and early 70s by launching itself via the heady mix of Anthony Little's Art Nouveau squiggles and the faded glory of London's landmark Art Deco department store, Derry and Tom's. Levi's evokes its make-believe heritage by always verifying their cowboy and lumberjack tradition through its cunning labeling and signage. The once derided vernacular of Pop Art is so fashionable today that it fearlessly appears on everything from birthday cards to T-shirts and it will come as no surprise, that in this cutting edge digital age, a hand-rendered Victorian look is more valued than ever in contemporary typefaces.

Surveying the current scene on show in *Modern Vintage Illustration*, it doesn't look as if there is going to be any immediate let-up by present-day illustrators who are still profiting from the currency and characteristic features of the past.

*I want to lead the Victorian life,
surrounded by exquisite clutter.*

Freddie Mercury

VICTORIANA

The sixty-three year reign of Queen Victoria was an era of unprecedented scientific invention and pioneering exploration in Britain. It was a period of strong moral and religious beliefs marked by social extremes with prosperous and gracious living in direct contrast to slum dwelling and abject poverty.

The Victorians had a high regard for hand-craftsmanship. It was the era of the individual artist/designer/craftsman. The earlier revivals of medieval and gothic design were replaced by the High Victorian style with its overbearing and cluttered decoration passionately aligned to nostalgia and sentimentality.

Although conscious of the improvements that the British industrial revolution had brought into daily existence, Victorian designers went to great lengths to disguise and hide anything considered technical or mechanical under layers of exaggerated and complex ornamentation.

Architectural framing and symmetry prevailed throughout all aspects of design ranging from the latest transportation vehicles to 'simple' graphic packaging. Ornate curvilinear hand-drawn lettering became commonplace on advertisements and posters.

Pastimes and home leisure pursuits were more popular than ever. Collecting and cataloging flora and fauna became all the rage. Scrapbooks developed into extremely popular keepsakes to be passed from generation to generation. Enormous care was taken to imaginatively arrange the contents that included all manner of contemporaneous memorabilia. Intricate needlework and embroidery was a major indoor occupation for girls starting with simple samplers and increasing in skill to all manner of decorative output.

(1837–1901)

1851 CRYSTAL PALACE EXHIBITION • AUGUSTUS PUGIN • GUSTAVE DORÉ • HENRY NOEL HUMPHREYS • ISAMBARD KINGDOM BRUNEL • JOHANN HEINRICH FÜSSLI JOHN TENNIEL • PHINEAS T. BARNUM • PHIZ • POLLOCK'S TOY THEATRES • VICTORIA AND ALBERT MUSEUM

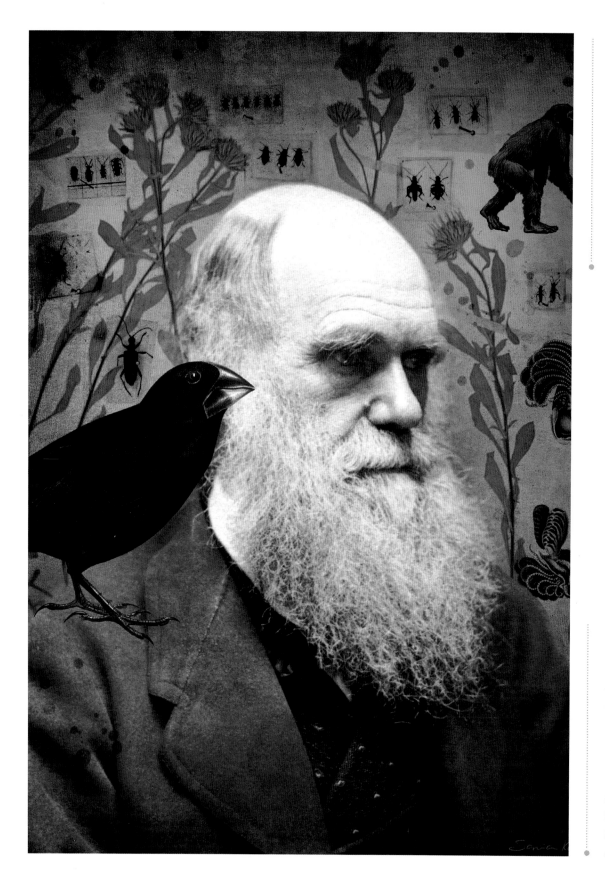

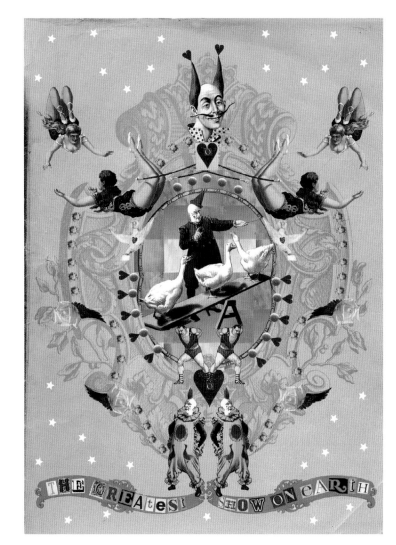

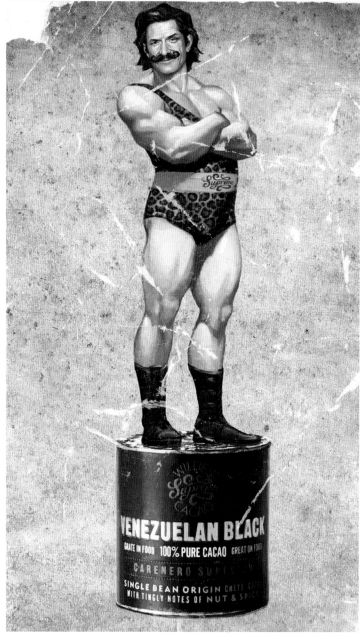

ABOVE: **NICKY ACKLAND-SNOW**

CIRCUS (2010)

Adobe Photoshop

This illustration was completed as part of the *Lions of Bath 2010* sculpture event, and incorporates vintage Victorian circus imagery in a pastiche of a typical showground poster. American showman Phineas T. Barnum (1810–1891) distinctively advertised his Barnum & Bailey travelling circus as *The Greatest Show on Earth*.

ABOVE: **SAM HADLEY**

WILLIE'S CACAO (2008)

Adobe Photoshop

This point of sale commission for Taxi Studio in Bristol owes much to the celebrated image of the Victorian bodybuilder and weightlifter Eugen Sandow (1867–1925) who became the epitome of the circus strongman. His celebration of male physical fitness paved the way for the iconic Charles Atlas physical exercise regime during the 1940s and today's mainstream interest in bodybuilding as a sport.

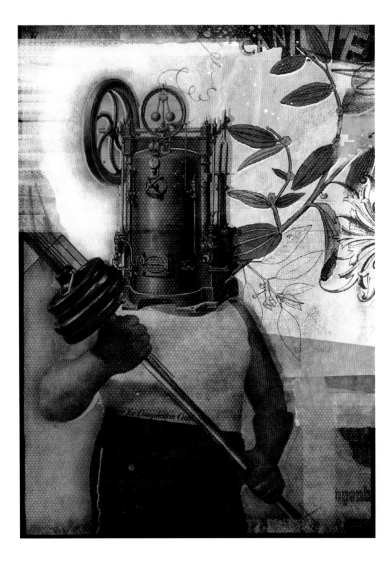

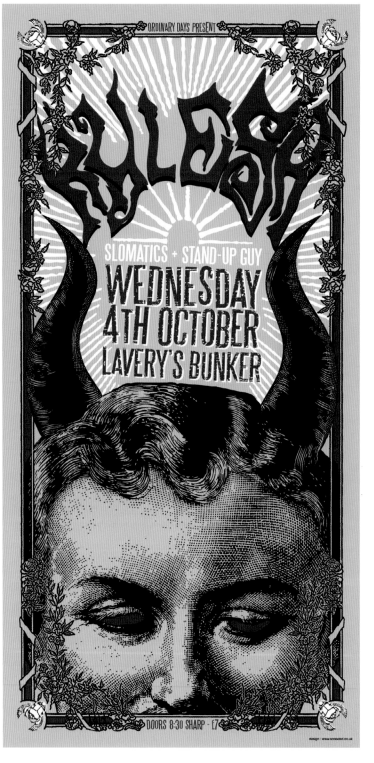

ABOVE: EZEQUIEL EDUARDO RUIZ

MACHINE (2008)

Pen & ink/Adobe Photoshop

The Victorian's engineering prowess with locomotives and ships makes the prospect of a mechanical man none too implausible. This digital collage strengthens that impression by restructuring Victorian engravings to suggest a suitable opponent for Paul Guinan's hoax tin robot, *Boilerman*.

RIGHT: GLYN SMYTH

KYLESA – GIG POSTER (2006)

Adobe Photoshop/Screenprint

Eye masks were an essential accessory at a Victorian fancy dress party. In this screen printed poster for the metal band, *Kylesa*, the artist has incorporated a classic Lucifer mask within a symmetrical layout bordered with Victorian ornamentation embellished with characteristic curvilinear hard-drawn lettering.

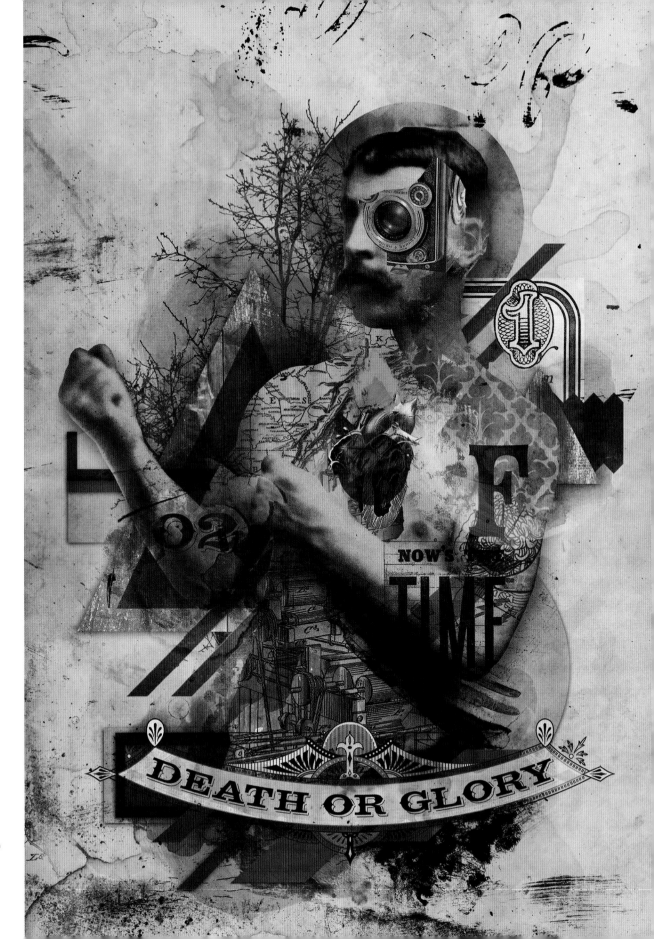

RIGHT: JOSÉ IGNACIO FERNÁNDEZ
DEATH OR GLORY (2010)
Adobe Photoshop

This digital montage was created as a concept for a fanzine. Pugilistic sports were a common pastimes at Victorian showgrounds. By the late nineteenth century, watching bare knuckle fighting had become akin to the current passion for football.

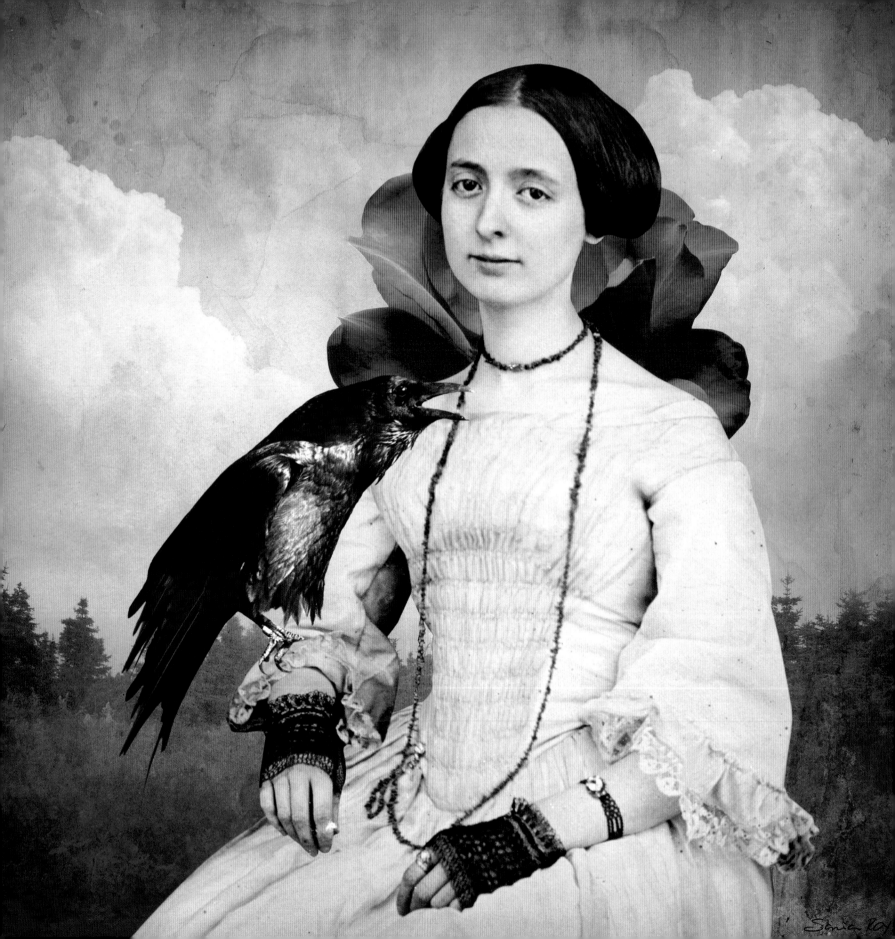

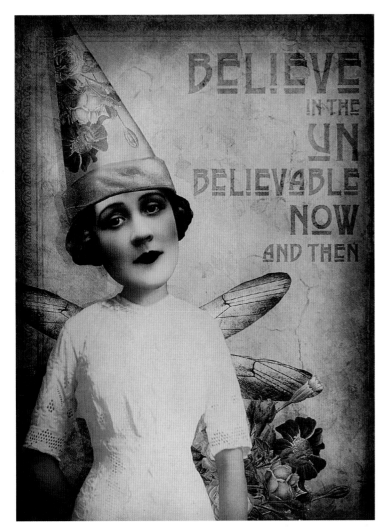

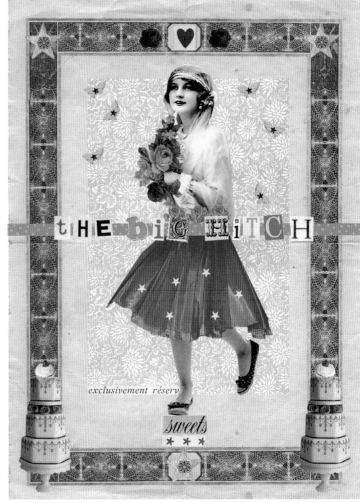

ABOVE: MARSHA JORGENSEN

UNBELIEVABLE (2011)

Adobe Photoshop

A whimsical collage that takes advantage of the sentimentality of the Victorian style. The artist's use of wings in her work reinforces the fact that she does not concern herself with reality in her digital illustrations.

OPPOSITE PAGE: SONIA ROY

ELISE AND THE CROW (2009)

Adobe Photoshop

This digital collage transports a typical monochrome Victorian vintage photograph into a contemporary coloured landscape. The unnatural posture of most Victorian sitters was a result of the primitive photographic techniques that required a long exposure to achieve acceptable results.

ABOVE: NICKY ACKLAND-SNOW

THE BIG HITCH (2004)

Adobe Photoshop

Here, the artist has exploited the over-romanticising in Victorian art for this nostalgic wedding invite. The symmetry of the layout and complex border detail are typical of the Victorian approach.

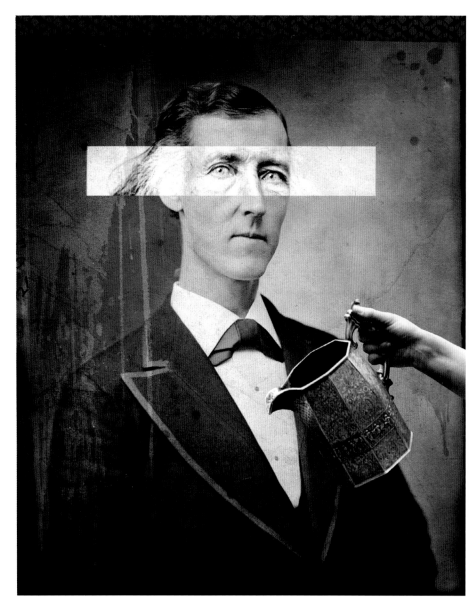

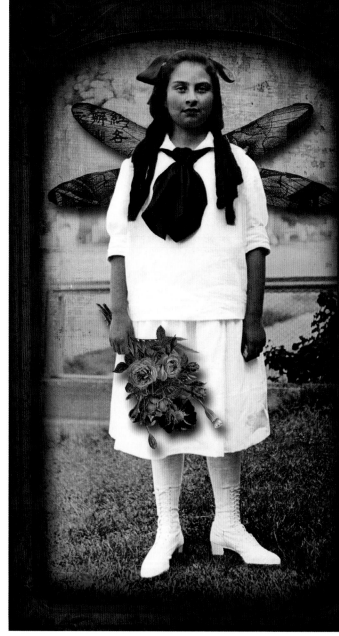

ABOVE: **SONIA ROY**

FENTRE DE LUCIDITE PERSO (2010)

Adobe Photoshop

The artist was compelled to use this Victorian photograph by the hypnotic gaze of the original sitter. She has drawn even more attention to the eyes by highlighting them with a contrasting white rectangle that reinforces the ancient proverb that 'the eyes are the window of the soul'.

ABOVE: **MARSHA JORGENSEN**

INDIFFERENT (2010)

Adobe Photoshop

This digitally imported figure is taken from a Victorian photographic album and is typical of the unenthusiastic posture and expression of these early sitters. Pioneering Victorian photography called for long exposures requiring the subjects to sustain their pose for several minutes.

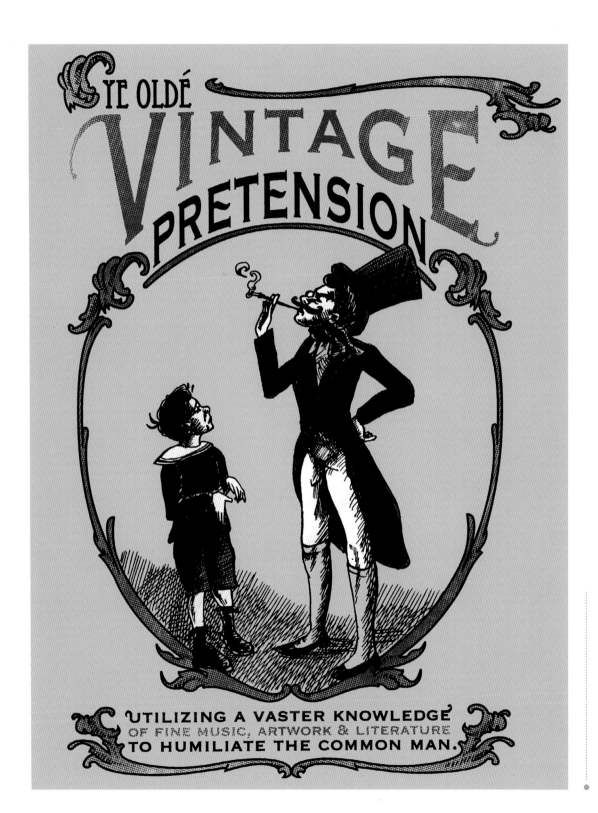

LEFT: **JOSHUA KEMBLE**
VINTAGE PRETENSION (2010)
Pen & ink/Adobe Illustrator/
Adobe Photoshop
A T-shirt design for 'Go Ape Shirts'
that takes it inspiration from vintage
Spanish matchbook advertising. The
humour of the concept is dressed up
in ornate Victorian finery that makes
full use of characteristically elegant
hand-drawn lettering.

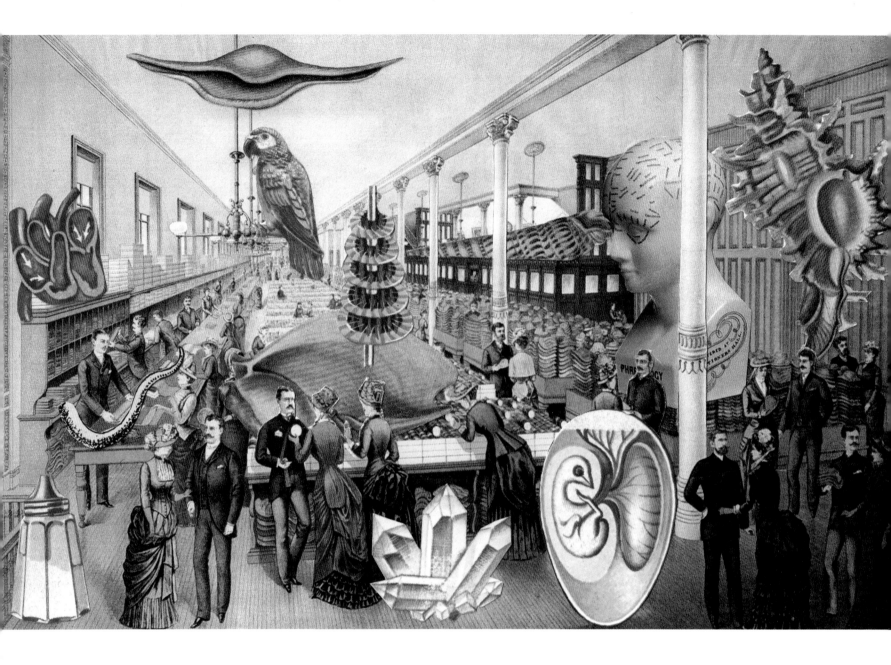

ABOVE: **MICHAEL LEIGH**

MUSEUM SHOP (2008)

Collage

The Victorians were passionate collectors and loved to repackage their finds in ever more impressive ways. The ultimate Victorian 'store' house is The Victorian and Albert Museum in Kensington, London. This collage was created for the traditional cut and paste collage blog, *Scrapiteria*.

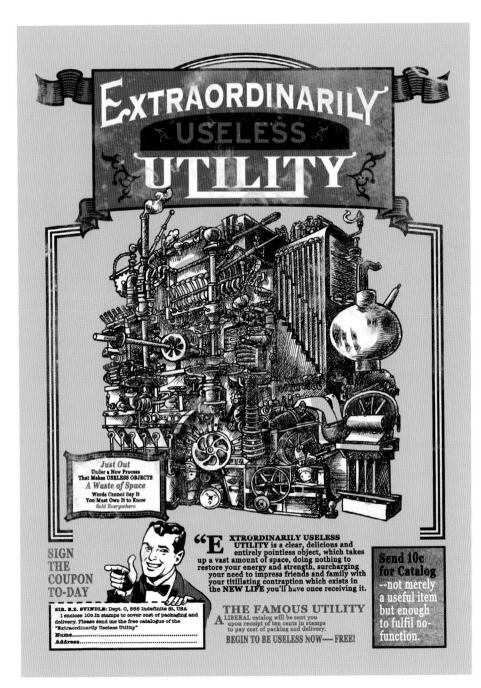

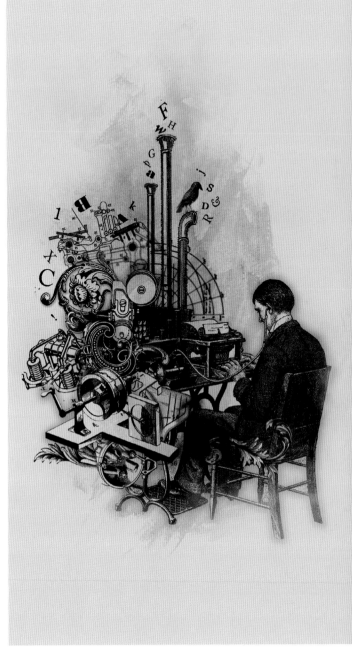

RIGHT: CHRISTIAN NORTHEAST

TONY'S (2008)

Ink/Adobe Photoshop

For a *New York Times* editorial concerning the Tony awards, the artist exploited traditional Victorian styled packaging for a quack medicine that mimicked the shortlisted plays' inclination to play it safe during that season. The overcrowded layout and multifarious styles of typography are representative of the period.

BELOW: TONWEN JONES

HOLD YOUR APPLAUSE (2010)

Collage with hand-drawn elements/Adobe Photoshop

This illustration was a commission by *The Guardian* newspaper to accompany an article about the amount of accepted applause at concerts. The fussy attention to detailing in the assembled images is typical of the Victorian period and the symmetry of the chairs and columns evokes the style of a Pollock's Toy Theatre proscenium.

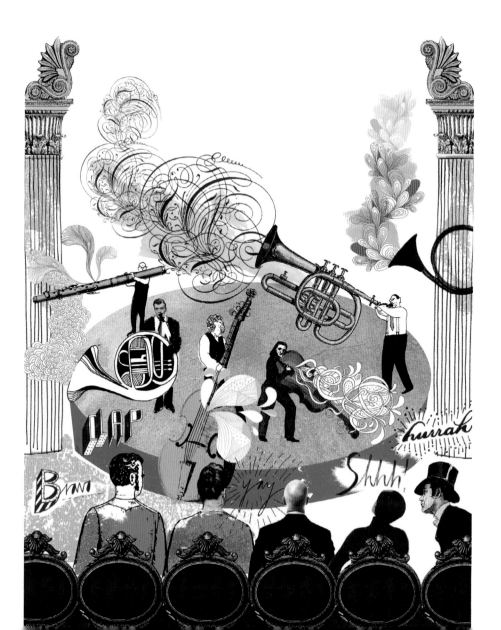

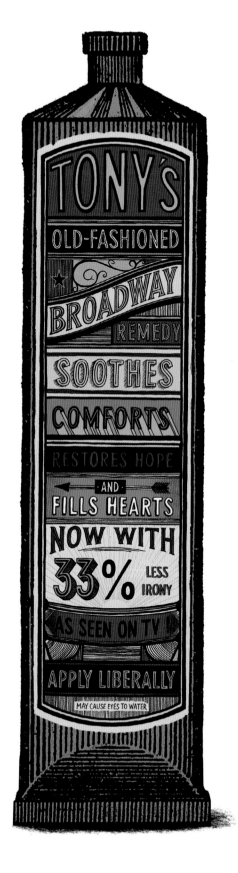

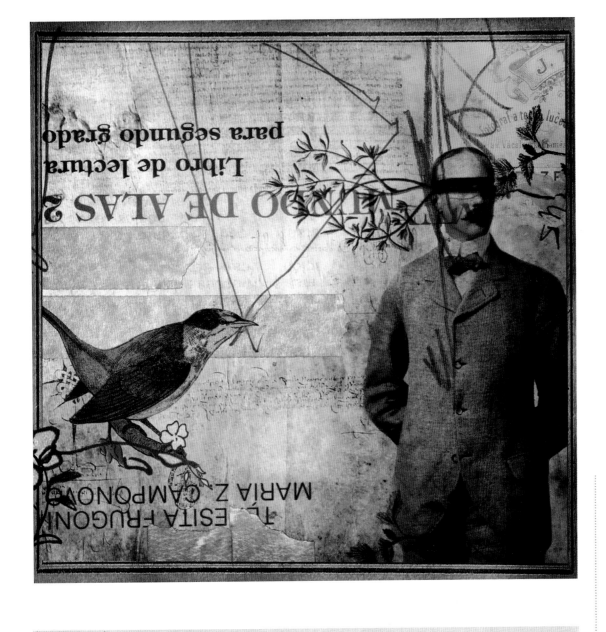

**ABOVE LEFT: EZEQUIEL
EDUARDO RUIZ
THE BOYFRIEND OF LUISITA
(2008)**
Pen & ink/Adobe Photoshop
A contemporary example of assembling
die cut scraps in imitation of Victorian
correspondence that makes use of a
purposely-positioned tableau of images
and text to suggest more than it shows.

**LEFT: MICHAEL LEIGH
A1 SCRAPMETAL (2006)**
Adobe Photoshop
This collage was assembled for the artist
and inventor Hazel Jones as the banner
for her collecting blog. The framing of
the small metal objects evokes the
archetypal overloading typical of
Victorian trade catalogues.

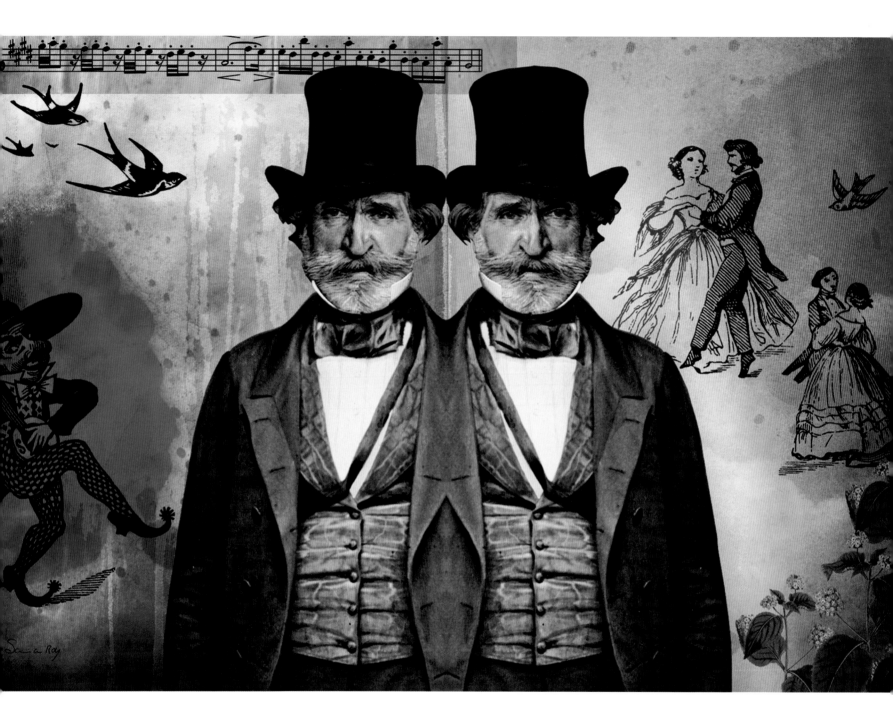

ABOVE: **SONIA ROY**

VERDI OPERAS (2009)

Adobe Photoshop

Giuseppe Verdi (1813–1901) was one of the most prolific operatic composers
of the Victorian era. This illustration resulted from a commission for *Vancouver Magazine*
contrasting two Verdi operas, *Falstaff* and *Rigoletto*. The mirroring of the composer allowed
the artist to express both sides of the composer's output, comedy and tragedy.

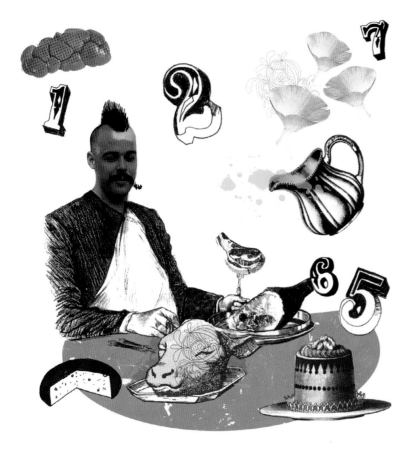

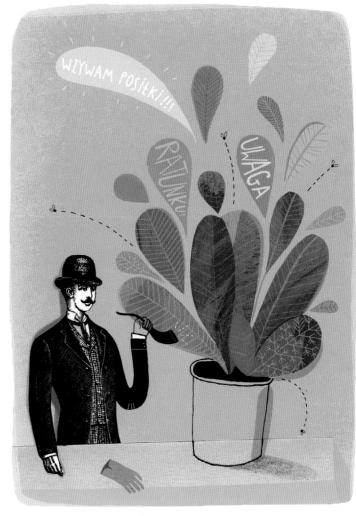

TONWEN JONES

FOODEATER (2010)

Collage/Adobe Photoshop

The Victorians certainly lived by the motto 'eat, drink and be merry'. Their love of food was evident in the lavish rituals of serving food in increasingly ornate ways. The ritual of afternoon tea was a staple of Victorian respectability and it was essential to be properly dressed for each separate meal serving.

AGATA DUDEK

PLANT (2009)

Mixed media/Lithography

A collaged pastiche for the Polish newsmagazine *Przekrój* that pokes fun at the fascination of nineteenth century scientists with all things horticultural by appropriating Victorian engravings with a Pythonesque wit to imply that plants may talk.

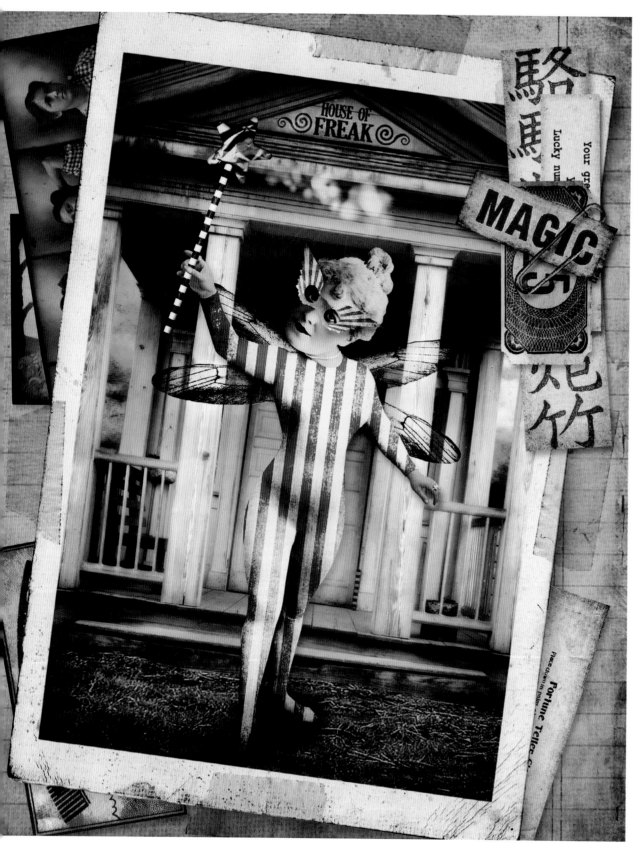

LEFT: MARSHA JORGENSEN
FREAKY FAIRY JOURNAL (2011)
Adobe Photoshop

The Victorians had a morbid fascination with physical curiosities to the extent that unlike earlier travelling shows, permanent venues were established including the Egyptian Hall in London's Piccadilly and in lower Broadway, New York for P. T. Barnum's American Museum.

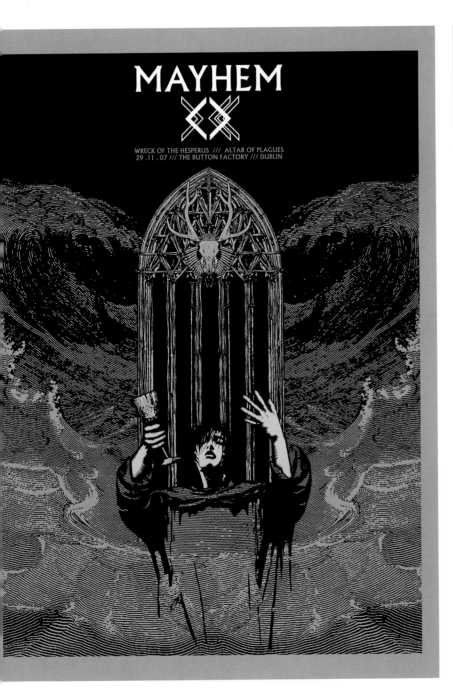

ABOVE: GLYN SMITH

MAYHEM – GIG POSTER (2007)

Pen/Adobe Photoshop/Screenprint

This illustration pays homage to the prolific Victorian illustrator and engraver Gustave Doré (1832–1883). His distinct style epitomised the Victorian's romanticised view of the fantastic and bizarre with stark and apocalyptic images. His 1865 *English Bible*, for which he produced 238 engravings, was a runaway success.

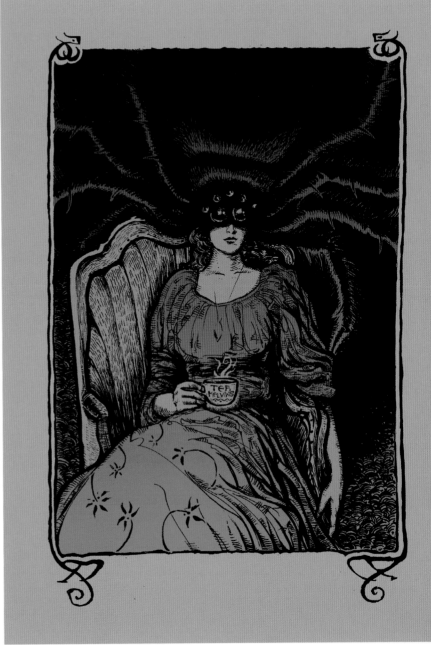

ABOVE: MALLEUS

SPIDER (2008)

Handmade silkscreen

Commissioned by the band The Melvins for a concert in Milan, the inspiration for this poster came from combining grotesque Victorian bookplates with the supernatural paintings of Johann Heinrich Füssli (1741–1825).

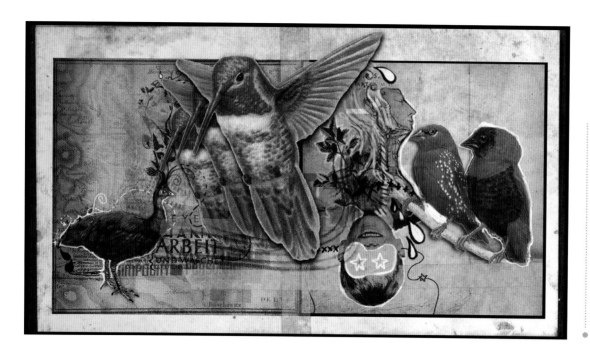

**AVES 8 & 9/COLLAGE OF BIRDS
(2008)**
Pen & ink/Adobe Photoshop

The Victorians were obsessed with collecting and cataloguing nature and natural history. Their interest lead to the formation of the British Ornithologists' Union in 1858 and its quarterly publication – *Ibis* – is still published today. Their fascination is well represented in this scrapbook display.

BELOW: **JAVIER EDUARDO PIRAGAUTA MORA**

LOVE GO!!! (2008)

Adobe Photoshop

The artist has taken his inspiration from the exceedingly sentimental representation of children by Victorian photographers. Childhood was considered a time of innocence to be protected and prolonged. Children often remained unsuitably garbed in incongruous juvenile garments until early teens.

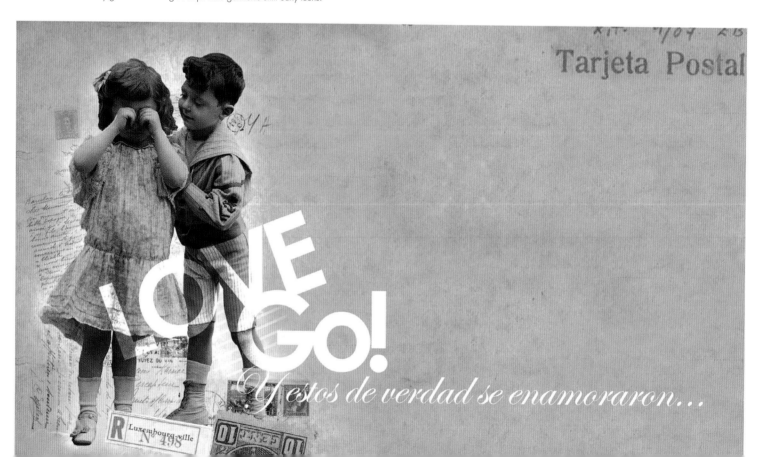

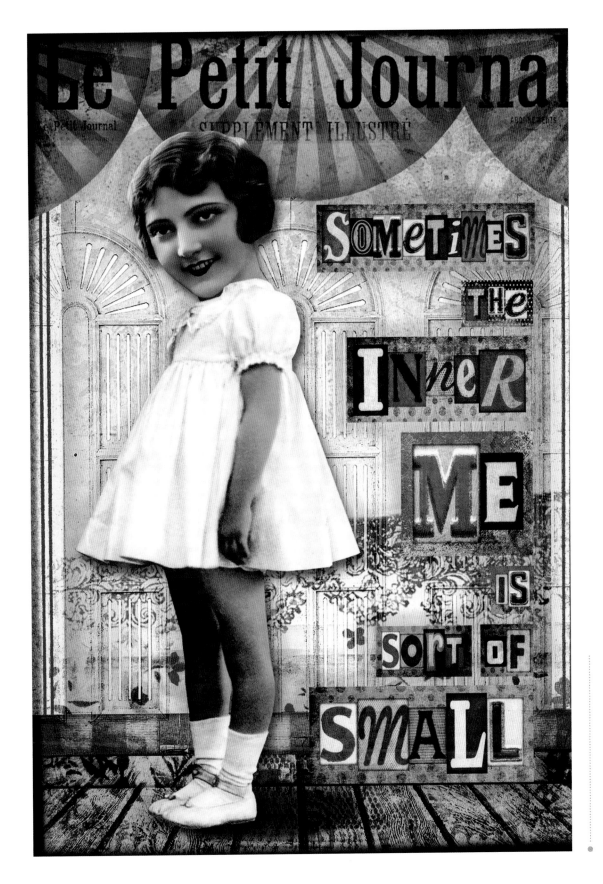

LEFT: MARSHA JORGENSEN

SMALL ME (2010)

Adobe Photoshop

This autobiographical digital collage, expressing the artist's self-doubts and lack of confidence, is laid out in imitation of the daily Parisian broadsheet *Le Petit Journal* (1863–1944). Children in the Victorian era were deemed symbolic of unsullied beauty and purity, emphasised in this cutting via the bleached clothing.

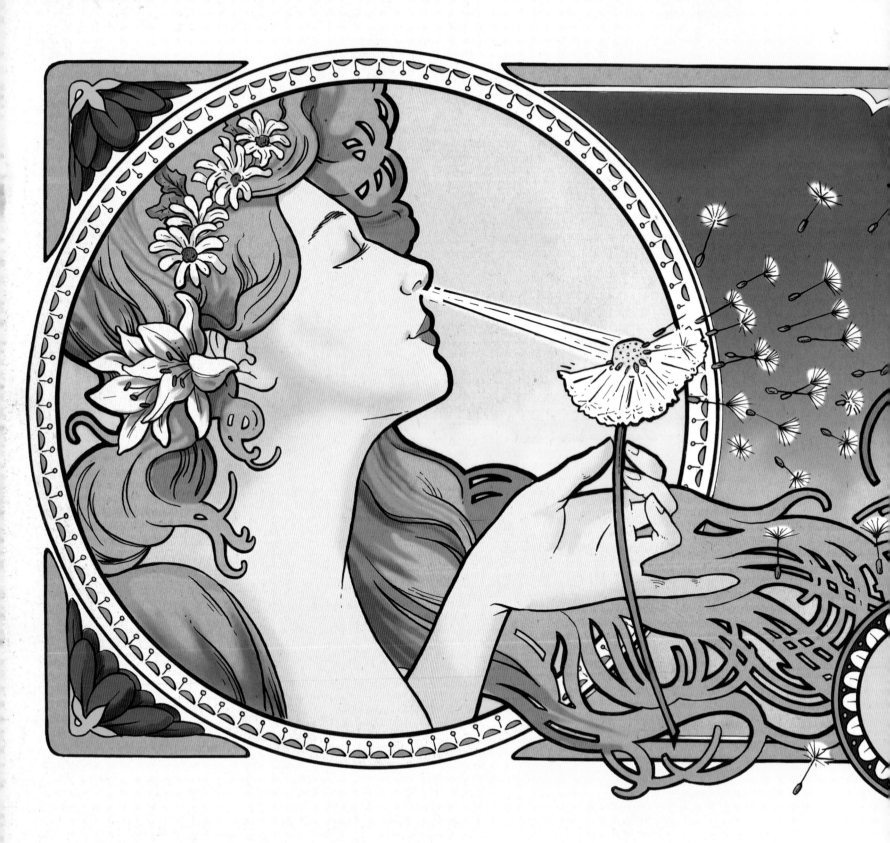

ART NOUVEAU

The term *Art Nouveau* (New Art) originated from the name of an interior design gallery in Paris owned by Siegfried 'Samuel' Bing, who in December 1895 renamed his shop, Maison de l'Art Nouveau. It was a catchall expression that took in both the fine arts of painting and drawing as well as the applied and decorative arts.

Its most famous exponent wasn't a Frenchman, however, but a Czech artist – Alphonse Maria Mucha (1860–1939) who is today recognized as the father of Art Nouveau. Mucha's flowing decorative style became the epitome of art nouveau to the extent that the original movement was often referred to as the ´Le style Mucha´.

The main characteristics of Art Nouveau are the absence of any straight lines and right angles. The distinctive curvilinear lines resulted in the nicknames of 'whiplash' and 'tapeworm' to express the decorative organic swirls. The sinuous patterns and motifs used in Art Nouveau were extracted from the flora and fauna of nature. This was viewed as an inexhaustible source of colour and shape and a rejection of the geometric and orderly values of Victorian design.

(1880s – THE FIRST WORLD WAR)
AUBREY BEARDSLEY • ÉMILE GALLÉ• ANTONIO GAUDÍ • EUGÈNE GRASSET • HECTOR GUIMARD • RENÉ JULES LALIQUE • HENRI DE TOULOUSE-LAUTREC • ALPHONSE MUCHA • THÉOPHILE STEINLEN • LOUIS COMFORT TIFFANY

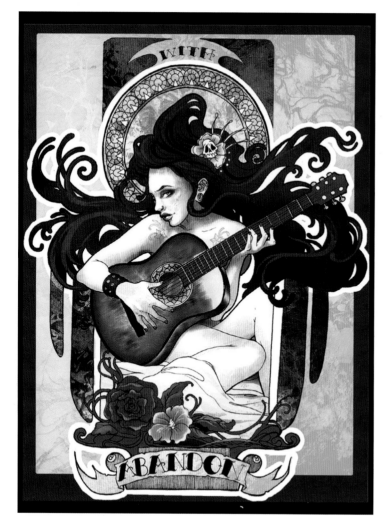

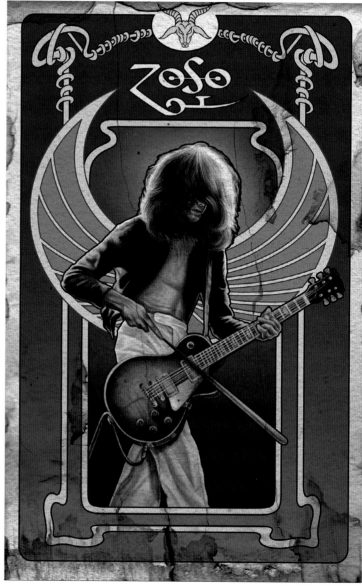

PREVIOUS PAGE:
FRED VAN DEELEN

OTRIVIN NOSE SPRAY (2007)

Pen & ink/Adobe Photoshop

Part of a commission by Saatchi & Saatchi Simko (Geneva) for an Ortrivin Nose Spray campaign. The idealisation of feminine beauty was a recurring aspect of Art Nouveau advertising. The head in profile (to emphasise her clear sinuses) is also typical of the style.

ABOVE: TARA PHILLIPS

WITH ABANDON (2008)

Pen/Adobe Photoshop

A modern twist on the formulaic exuberance of Alphonse Mucha's poster art underpinned by the sexuality of the coy naked female at the centre of the arrangement.

OPPOSITE PAGE: MALLEUS

ASYMMETRY (2010)

Handmade silkscreen

This gigposter for the Polish festival *Asymmetry* employs the distinctive motifs, decorative mannerisms and mirrored symmetry of Art Nouveau elegance.

ABOVE: JACK C GREGORY

THE HERMIT (2010)

Gouache/Adobe Illustrator/Adobe Photoshop

The artist was motivated to create this illustration following the reunion concert by Led Zeppelin at London's O2 Arena in 2007. Guitarist Jimmy Page's interest in the occult presented the opportunity for an Art Nouveau framed tarot card.

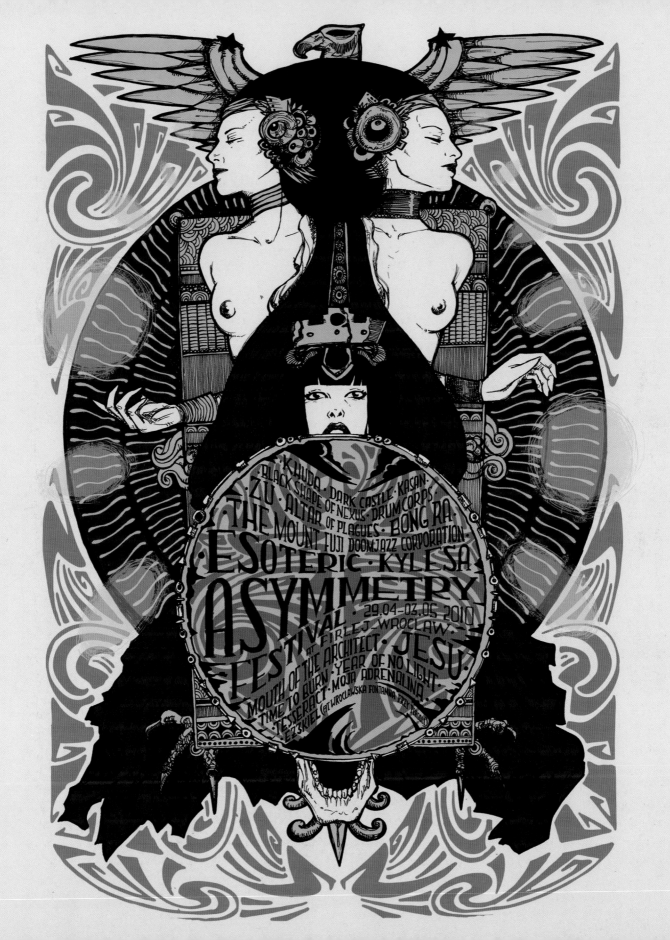

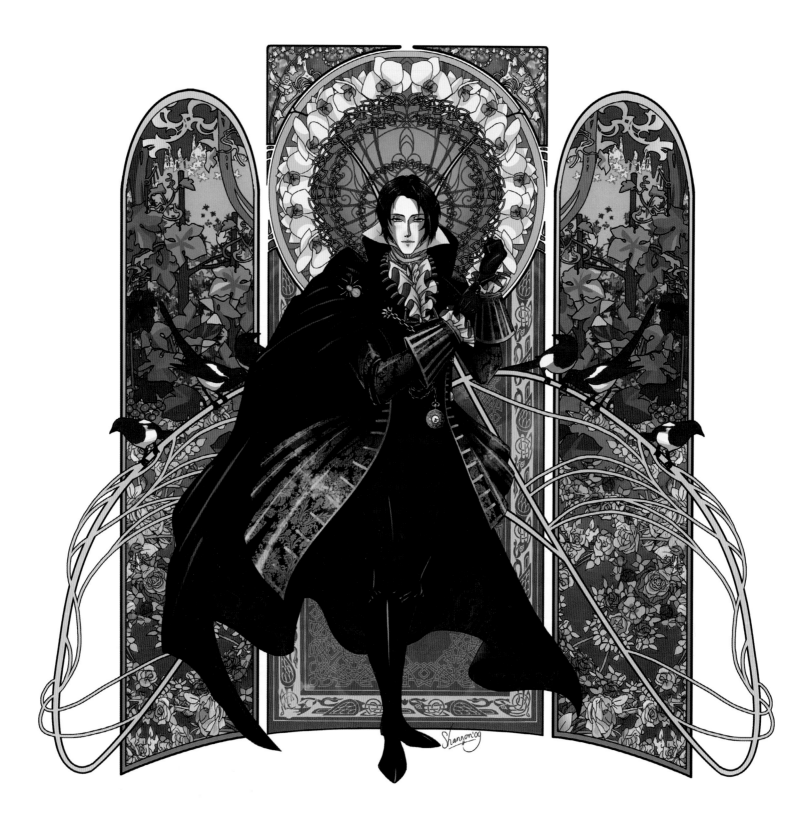

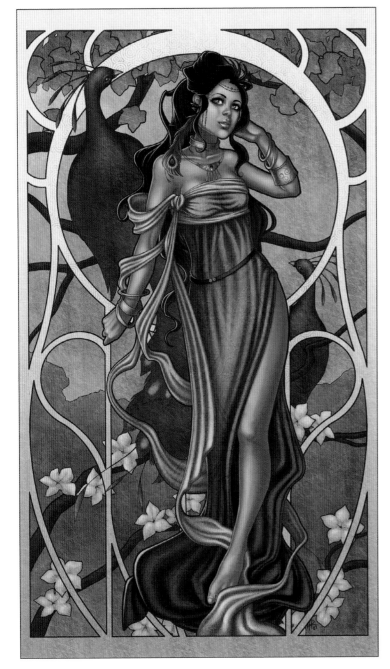

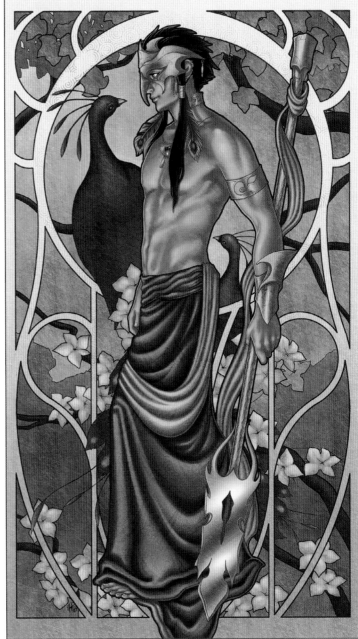

SHANNON VAN MUIJDEN

DECLAN O'DWYER (2009)

Adobe Photoshop

This elegant Art Nouveau treatment was the result of a commission that allowed the artist to test out some of her earlier experiments using the mannerisms of the period. The elaborate background patterning is in typical Mucha style with a deliberate placing of his habitual circular halo within the composition.

ANNA RIGBY

PEACOCK GARDEN (2008)

Adobe Photoshop

Birds and peacocks were favourite subjects of Art Nouveau artists, most famously in the glassware of Louis Comfort Tiffany (1848—933). Here the illustrator has allowed for a digital gradation of the bodyflesh and garment fabric to add a personal dimension to the typical flat and outlined colour that is a signature feature of Art Nouveau.

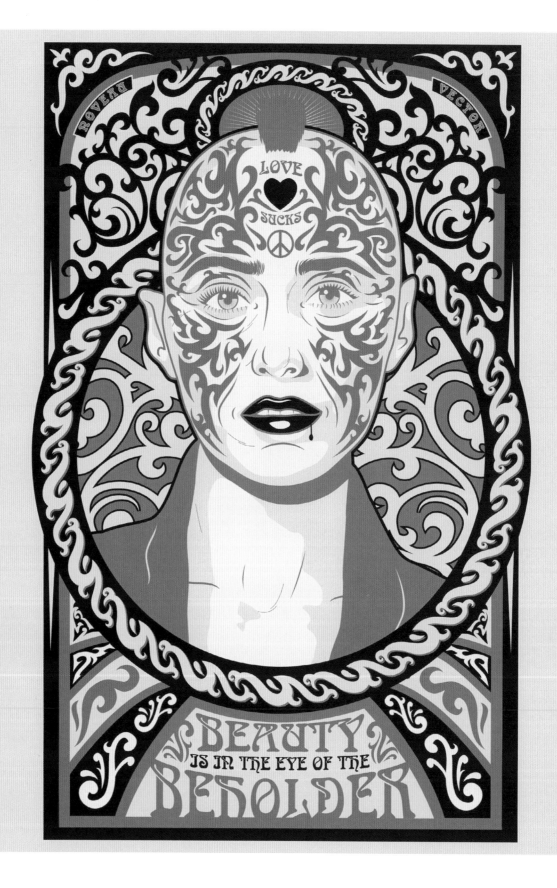

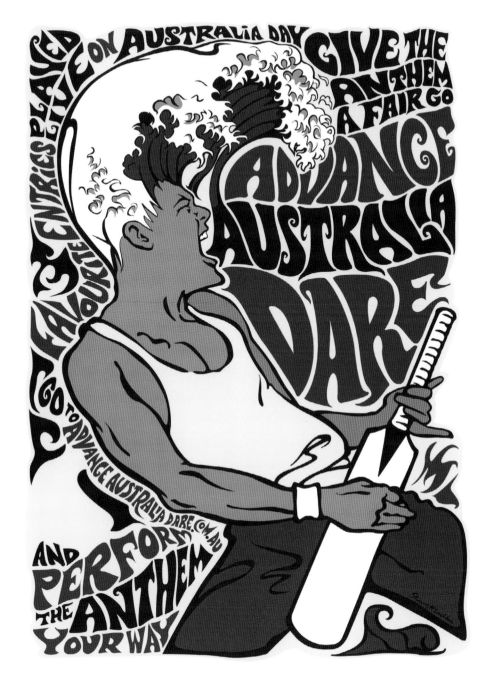

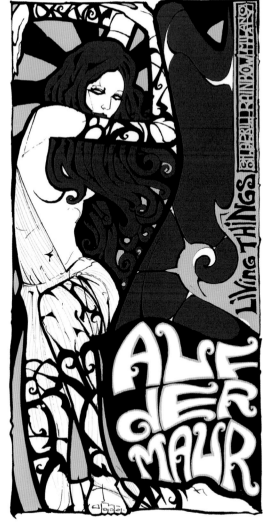

OPPOSITE PAGE: **ROBERLAN BORGES PARESQUI**

VECTOR ART NOUVEAU (2008)

Adobe Illustrator

This digital illustration uses the customary symmetry of Art Nouveau poster art and fuses it with Punk references to create a new variant on Mucha's idealisation of women.

ABOVE LEFT: STUART MCLACHLAN

ADVANCE AUSTRALIA DARE POSTER (2009)

Adobe Photoshop

An Australian poster that writhes in a decorative display of Art Nouveau fonts. The fluorescent colours are reminiscent of 60s and 70s rock posters The musician's tsunami hair pays homage to Katsushika Hokusai's woodblock print, *The Great Wave* (1890).

ABOVE RIGHT: MALLEUS

MELISSA AUF DER MAUR (2003)

Handmade silkscreen

The complexity of the image and its compression within the rectangular frame follow the style of Art Nouveau with its distinctive solid colouring outlined in heavy black line.

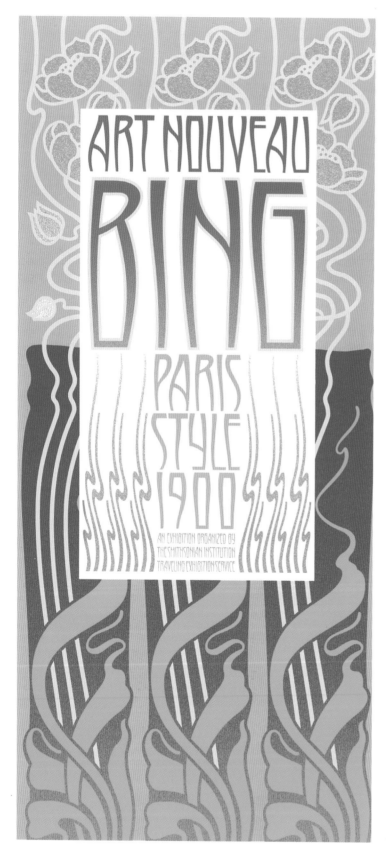

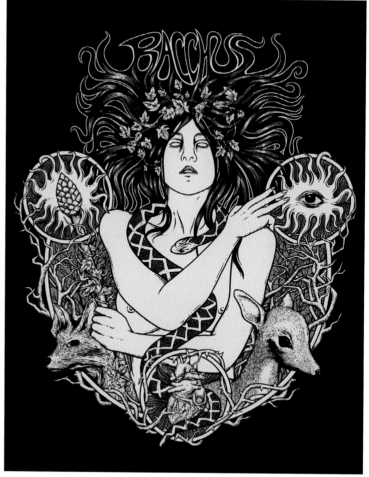

ABOVE: GLYN SMYTH

BACCHUS – T-SHIRT (2009)

Pen & ink/Adobe Photoshop

This T-shirt image is a personal representation of a Maenad – one of the fierce female followers of the Greek god, Bacchus. Although predominantly Art Nouveau in structure and rhythm, there are also hints of Ancient Greece and Pre-Raphaelite art.

LEFT: DANIEL PELAVIN

ART NOUVEAU BING (1986)

Pre-separated mechanical art

A commissioned poster for a retrospective exhibition held at the Smithsonian Institution in Washington D.C. on French art collector and dealer, Samuel Bing (1838–1905). Bing was a key player in the development of Art Nouveau by his acknowledgement and support for contemporary artists of the era.

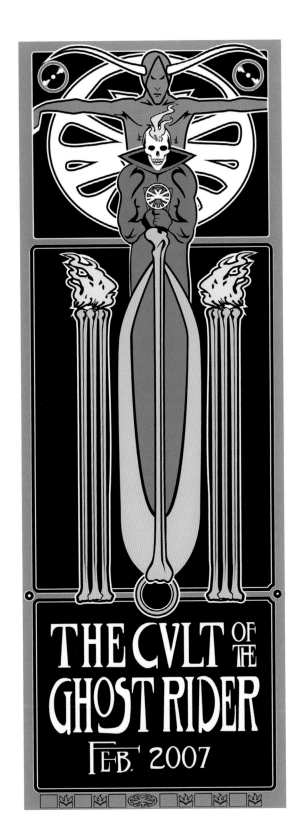

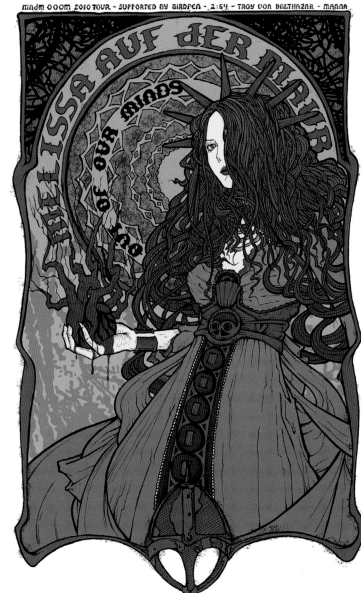

LEFT: **RUDY GARDEA**

THE CULT OF THE GHOST RIDER (2008)

Adobe Illustrator

The artist has personalised the famous poster designed by sisters, Frances and Margaret Macdonald working with James Herbert McNair for The Glasgow Institute of Fine Arts in 1896. Along with Charles Rennie Mackintosh, who became Margaret Macdonald's husband, they formed the 'Glasgow Four' and worked in a design style that directed the excesses of Art Nouveau towards Secessionism.

ABOVE RIGHT: **MALLEUS**

MADM – OUT OF OUR MINDS (2010)

Handmade silkscreen

This commissioned gigposter takes obvious inspiration from Mucha's 1898 lithograph, *Au Quartier Latin*. The characteristic Nouveau abstraction of the hair is echoed in the stylised tendrils that form the border.

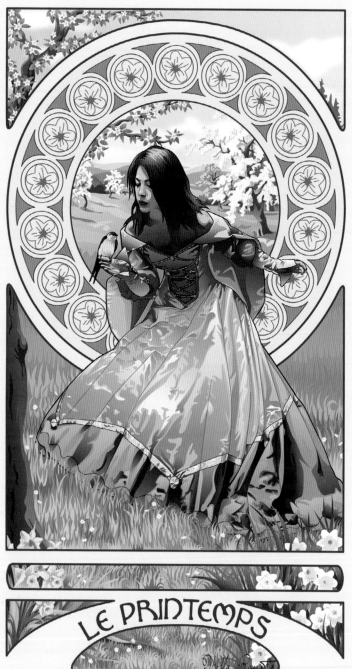

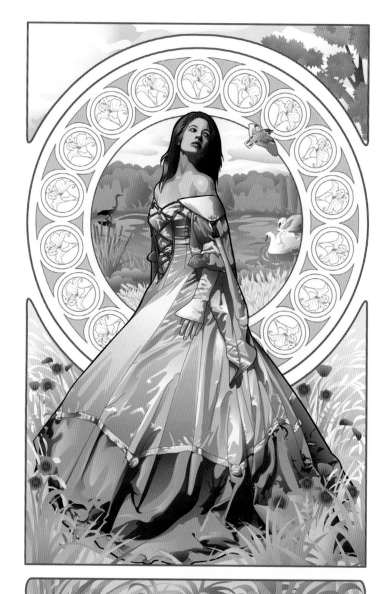

BOTH PAGES: DHELLA ROUAT

THE FOUR SEASONS (2005–2006)

Adobe Illustrator

The artist here is paying homage to the first set of decorative panneaux that Alphonse Mucha created in 1896 for the printer

F. Champenois depicting the changing seasons. As here, each season was represented by a different body position and framed in

subtly transforming borders to represent the four temperaments.

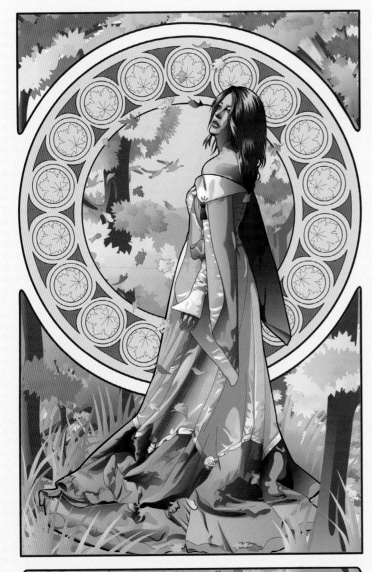

L'AUTOMNE

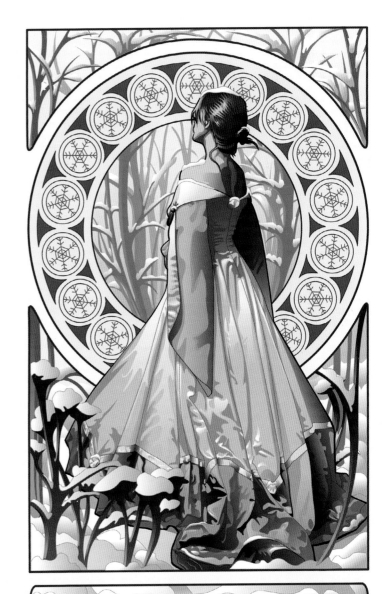

L'HIVER

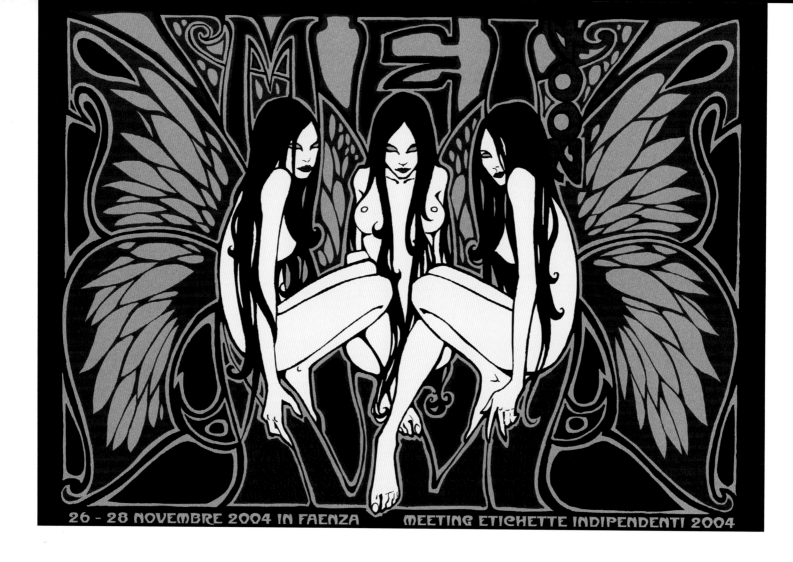

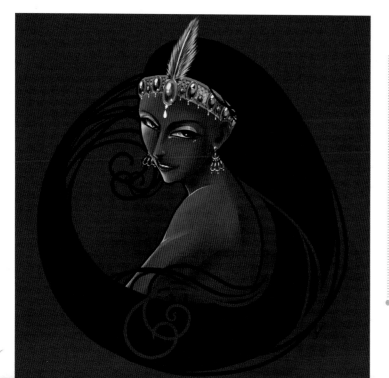

ABOVE: MALLEUS

MEI 2004 (2004)

Handmade silkscreen

For this commission for the Italian music event, MEI, there is an obvious Art Nouveau ambience within the illustration that exploits the classic unification of undulating text and image throughout the composition.

LEFT: SHANNON VAN MUIJDEN

CLEO (2010)

Systemax PaintTool SAI

Inspired by the dramatic shadowing effects caused its original setting, in this Art Nouveau reworking the illustrator uses the flowing lines of the period to evoke a seductive temptress from the 1920s. The jeweled headband is inspired by Mucha's 1896 lithograph, *Zodiac*.

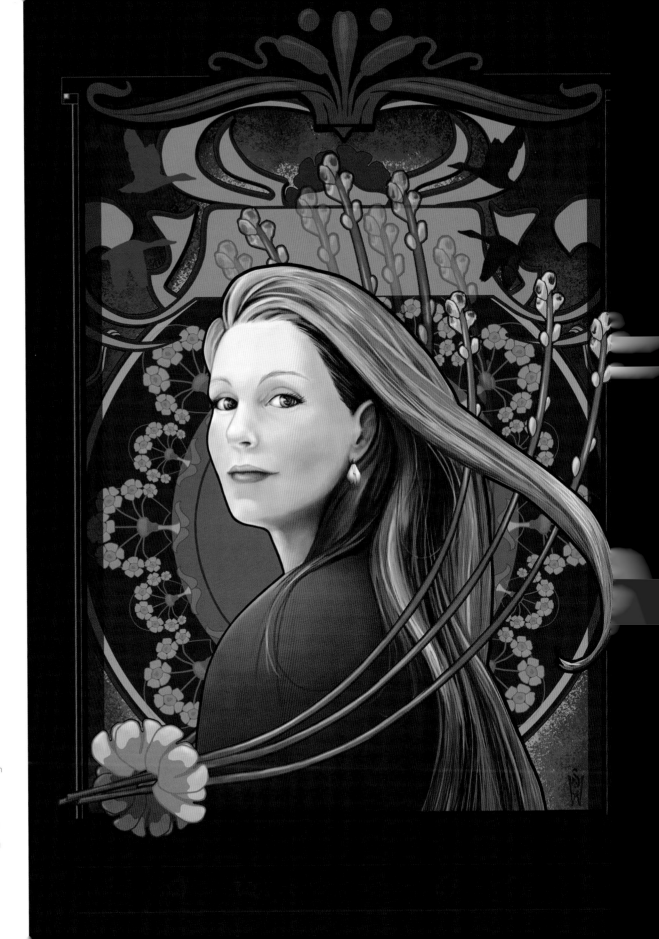

RIGHT: STINA WIIK

THE MAGICAL ESSENCE

OF SPRING (2006)

Corel Painter/Adobe
Photoshop/Adobe Illustrator

As well as the obvious Art Nouveau
expression in this digital portrait, the
illustrator has also taken her ideas from
the writings of the Swedish feminist
writer, Ellen Karolina Sofia Key
(1849–1926) 'The harmony between
usefulness and beauty is the only thing
worth striving for.'

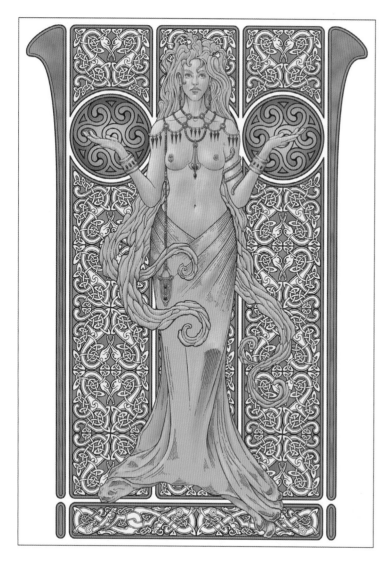

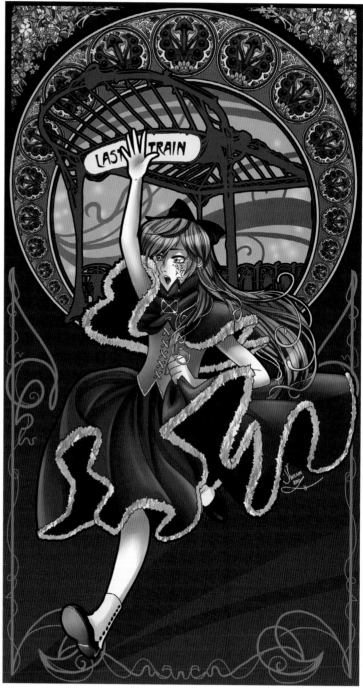

ABOVE: CHRIS DOWN

SERENITY (2009)

Pen & ink/Adobe Illustrator/Adobe Photoshop/Corel Painter

This illustration combines the characteristics of Art Nouveau with the ornate patterning of Celtic Art for an image inspired by both Alphonse Mucha and contemporary Irish artist Jim Fitzpatrick. The renewal of interest in Celtic Art, plus the growing passion for Japanese Art, were soon included in the Art Nouveau vernacular.

OPPOSITE PAGE: FELIX TJAHYADI

LEO (2008)

Graphite/Watercolour/Adobe Photoshop

The overall framing and patterned circular background are Art Nouveau characteristics that were executed on innumerable posters of the era. Here the distinctive mannerisms of Mucha interpret the essence of feminine beauty found in the South African Ndebele tribe. Her sphinx-like companion emphasises the qualities of the star sign Leo.

ABOVE: SHANNON VAN MUIJDEN

LAST TRAIN (2010)

Systemax PaintTool SAI and Adobe Photoshop

This Art Nouveau-Manga cocktail was the result of a contest organised by the Dutch d jinshi circle *Tea Tales* to reinterpret a character by Yeaka. One of Hector Guimard's (1867–1942) iconic Art Nouveau Paris Métro entrances provides both a narrative to the illustration and a fitting background to the Manga treatment of the running figure.

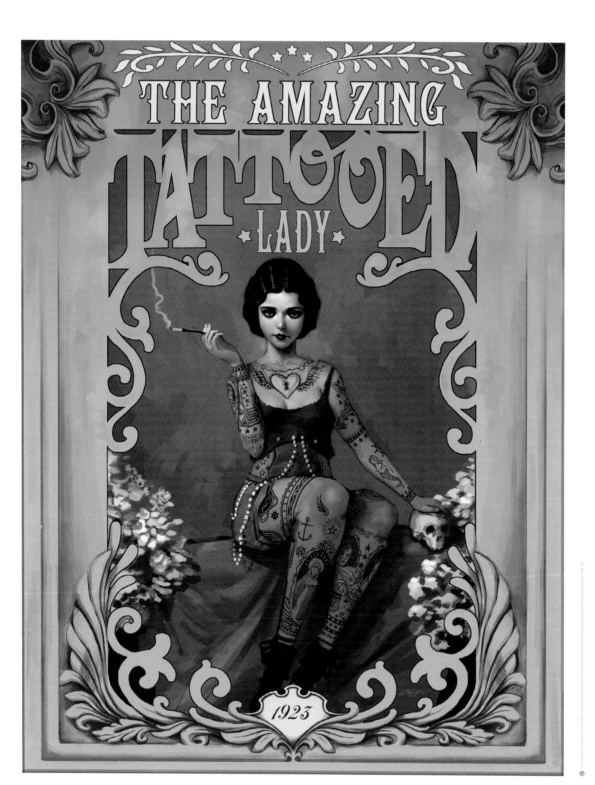

Taking his inspiration from vintage photographs of showgirls the artist has here conjured up a likely carnival character from a travelling freak show. The ornamentation framing the central figure is a reiteration of the outlined shaping found in Art Nouveau here combined with Victorian fretwork text.

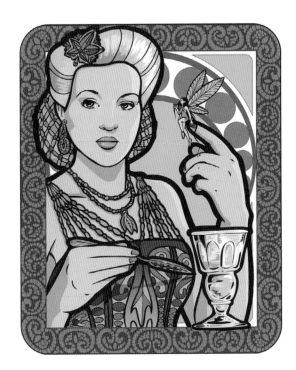
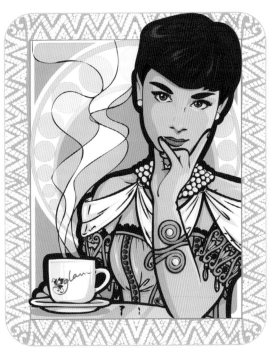
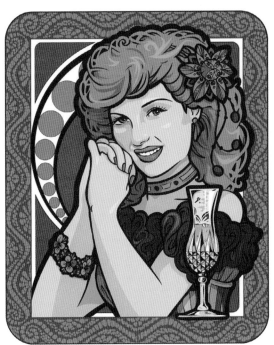
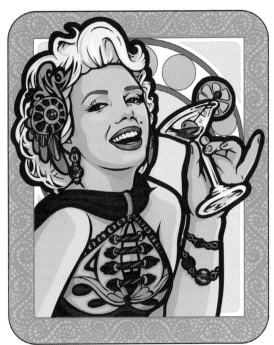

ABOVE: SARA KITAKUTIKULA

CLOCKWISE FROM BOTTOM LEFT: RITA'S SPRING, BETTY'S AUTUMN, AUDREY'S WINTER, MARILYN'S SUMMER (2008)

Freehand/Adobe Illustrator

French stage actress, Sara Bernhardt (1844–1923), was the most famous celebrity to appear on Alphonse Mucha posters. His long-term relationship with the actress also resulted in designing her costumes, jewellery and set designs. Here, four 20th century stars of Hollywood are awarded a similar ornamental treatment and stylisation.

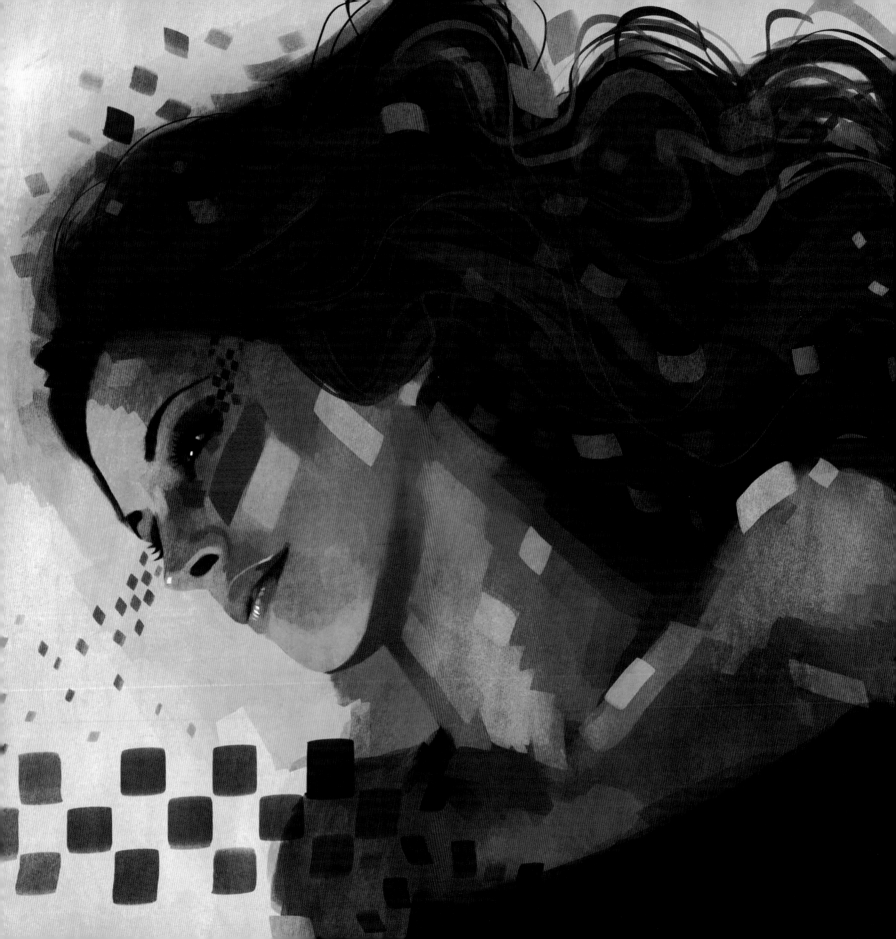

To restrict the artist is a crime. It is to murder germinating life.

Egon Schiele

Art is a line around your thoughts.

Gustav Klimt

VIENNA SECESSIONISM

Secessionism was an attempt by a group of progressive European artists to synthesise art and design into the ideal of a *Gesamtkunstwerk* (total work of art). Their philosophy was the challenge of bridging the gap between the applied and fine arts with the conviction that artists could also have an important influence on everyday and practical objects.

Gustav Klimt (1862–1918), who was one of the founders of The Vienna Secession (Association of Austrian Visual Artists) and the short-lived Egon Schiele (1890–1918) remain two of the most influential of the movement's artists.

The open eroticism in their work was considered both shocking and scandalous. Klimt was accused of 'excessive perversion' and Schiele was actually arrested and imprisoned in 1911 due to his 'salacious' drawings. Both artists continually clashed with the often repressive and hypocritical values of their contemporary society.

Klimt luxuriated in lavish Byzantine patterning that often camouflaged his figures. When painting his allegorical subjects he used a palette that was overtly ostentatious often preferring metallic gold to add further embellishment.

In contrast Schiele, for whom drawing was his chief medium, used a sparer and more intense outline. His unadulterated representation of the naked body had nothing to do with the accepted idealization of the classical nude. Nor were they disguised like Klimt's. Schiele's provocatively depicted bodies are more clinical and raw in their representation.

(1890–EARLY 1900S)
ARNOLD BÖCKLIN • JOSEF ENGELHART • JOSEF HOFFMANN • GUSTAV KLIMT • MAX KURZWEIL • CHARLES RENNIE MACKINTOSH • CARL MOLL •JOSEF MARIA OLBRICH • ALFRED ROLLER • EGON SCHIELE • OTTO WAGNER

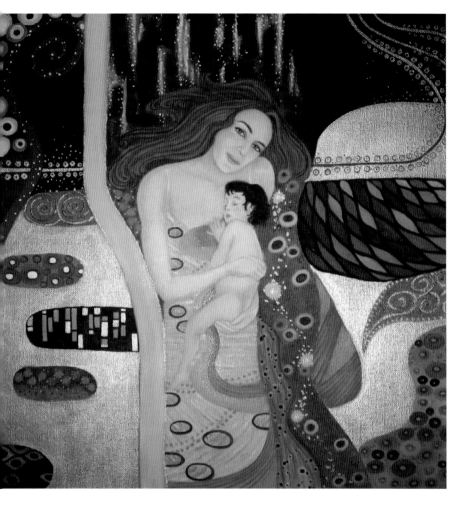

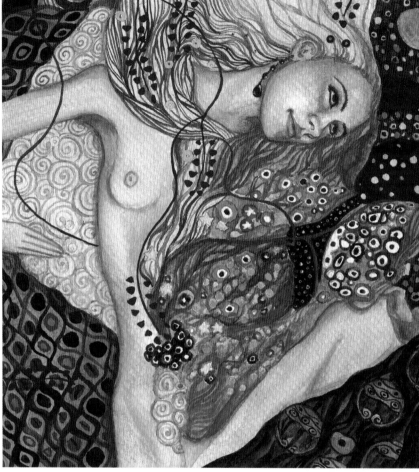

SENSATION (2008)

Adobe Photoshop

The golden patterning in this digital illustration is reminiscent of the burnished palette favoured by Gustav Klimt during his Golden Period. Klimt's first use of his trademark gold leaf was in his *Pallas Athene* (1898).

ABOVE: **ANNE BAIL-DECAEN**

MATERNITÉ II, LES DEUX ÂGES DE CAROLE (2008)

Oils

This image uses the allegorical language of Gustav Klimt to evoke the sitter's own blend of mystery, passion, fragility and force. The artist has employed an increasingly less naturalistic representation throughout the painting by the introduction of flat mosaics of Secessionist colour and patterning to shroud the mother and child.

ABOVE: **ALEKSANDRA SENDECKA**

IN THE WORLD OF GUSTAV (2009)

Watercolour

For this watercolour portrait of a friend, the artist has freely borrowed from the paintings of Gustav Klimt. The posture of the sitter is similar to that used in *Wasserschlangen I* (1904–07) and the predictably profuse patterning is similarly expressed to that in both *Danaë* (1907) and *The Three Ages of Woman* (1905).

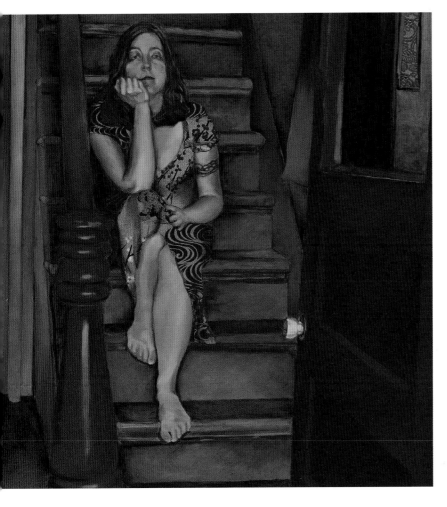

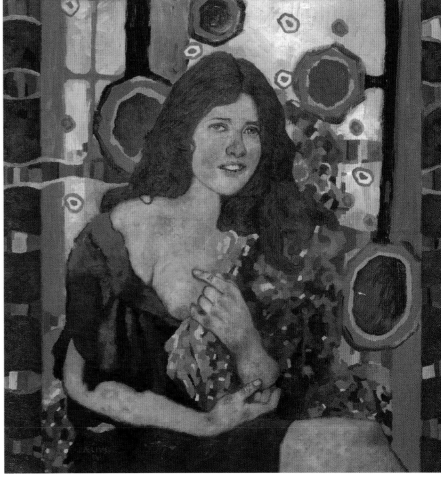

MARGO MCCAFFERTY-RUDD

URSULA IN CALUMET (2008)

Oils/Acrylic/Collaged chiyogami

This portrait of the artist's daughter, webcomic writer and illustrator Ursula Vernon, references the swirling gold patterns of Gustav Klimt to echo the sitter's own interests in the work of the Vienna Secessionists.

ELIO MARRUFFO PEREA

THE GIRL OF THE NEWSPAPER (2008)

Oils

Working from an old photograph, the artist has taken advantage of the Secessionist's characteristic balance between the purely figurative and abstract patterning to celebrate his own tribute to feminine beauty.

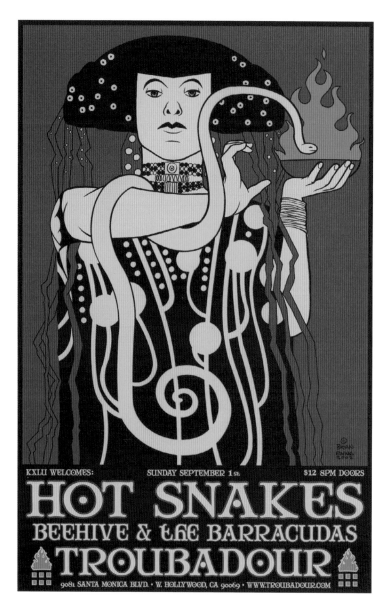

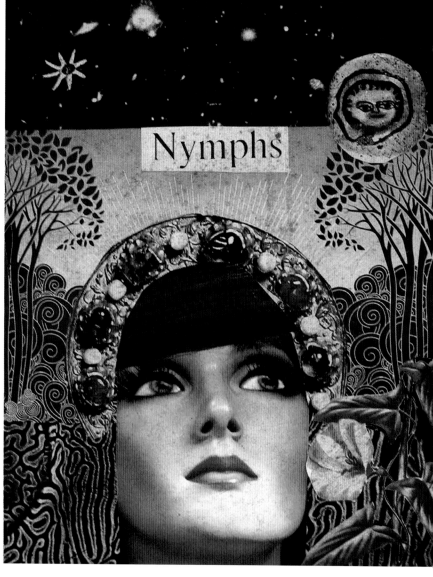

HOT SNAKES (2002)

Hand-drawn/Adobe Illustrator

This commission from American post-punk band Hot Snakes takes inspiration from the style of Klimt combined with comic book artist Jack Kirby (1917–1994). The female figure is a reinvention of the Greek Goddess Hygieia as depicted in the Klimt's mural *Medicine*, created for the Great Hall of Vienna University and subsequently destroyed during WWII.

NYMPHS (2008)

Collage

For this artist, the legend 'Nymphs' is suggestive of both female yearning and pond life. He contrasts the real and synthetic by a mixture of Secessionist and surreal imagery. The ornamentation of the female face is similar to the decoration afforded to the sitters in Klimt's portraits.

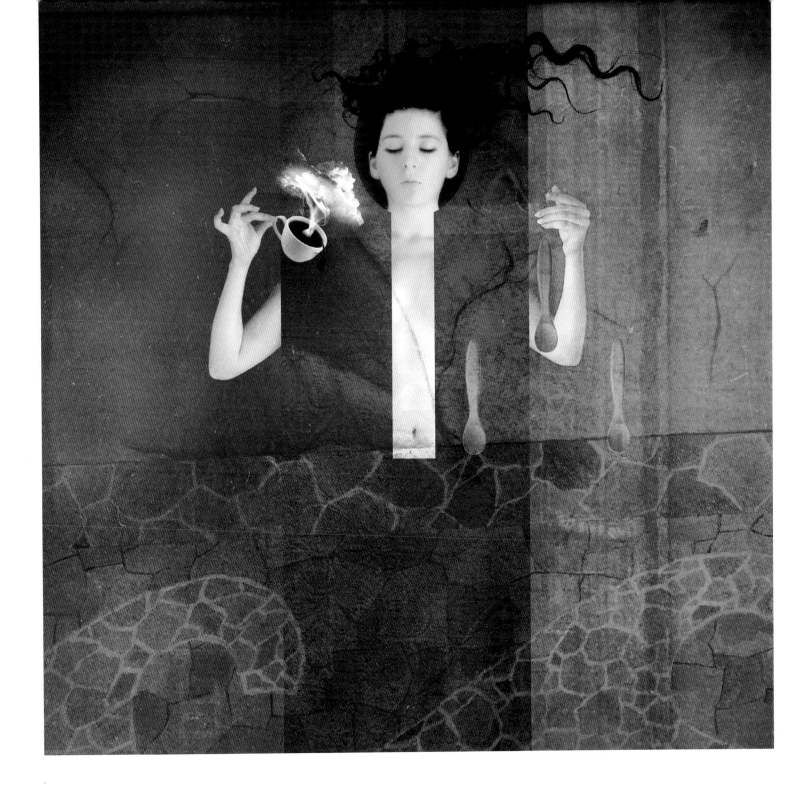

SOLACE (2009)

Adobe Photoshop

This digital photo-manipulation has all the hallmarks of a Secessionist painting with its burnished colour palette and female subject embedded

within the surface patterning. Gustav Klimt often featured figures emerging from the complex mosaic backgrounds within his paintings.

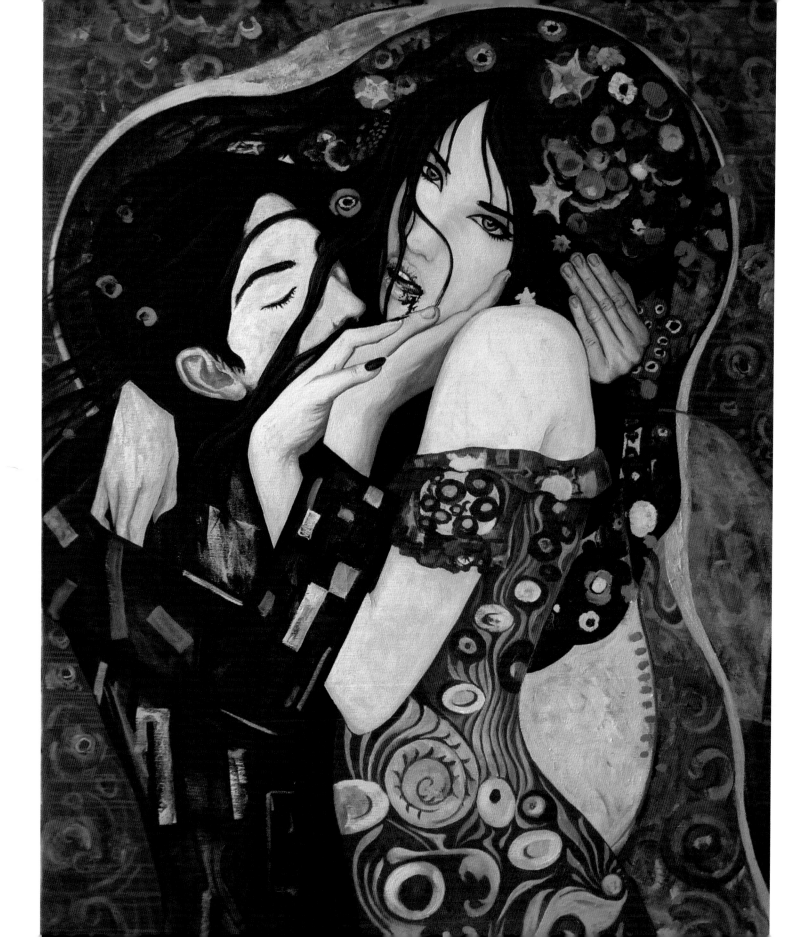

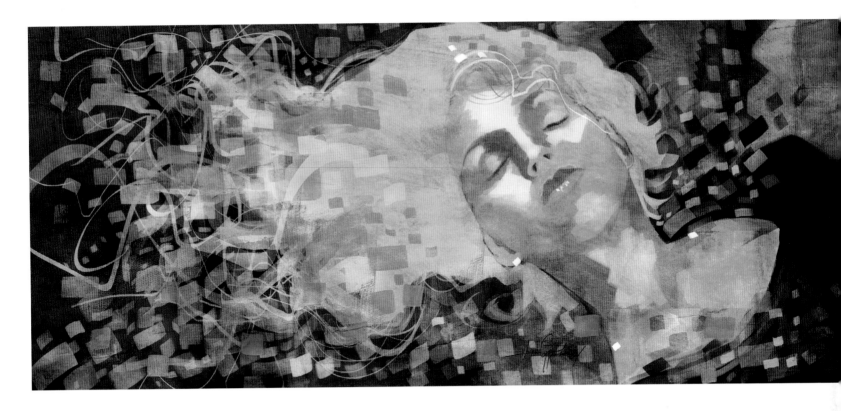

OPPOSITE PAGE: ADRIAN BORDA

SHE HAD FLOWERS IN HER HAIR (2009)

Oils

Embellished with Secessionist patterning this painting exploits
Gustav Klimt's personal viewpoint that his idealisation of the
Viennese woman of the 1900s was as a female vamp.

ABOVE: JAVIER GONZALEZ PACHECO

BURN HAIR (2008)

Adobe Photoshop

Gustav Klimt's most recognisable trademark after the eroticism of
his figures is the distinguishing golden decoration that saturates
paintings such as *The Kiss* (1907–08) and the *Portrait of Adele
Bloch-Bauer I* (1907).

RIGHT: ADAM KISSEL

NEROLI DREAMS (2010)

Adobe Photoshop

Again the artist's colour palette references the warmth of the
Golden Period of Gustav Klimt. The realism of the sleeping figure
is distressed by digital photomanipulation that allows the pixels to
fade and merge like dreams of the subconscious.

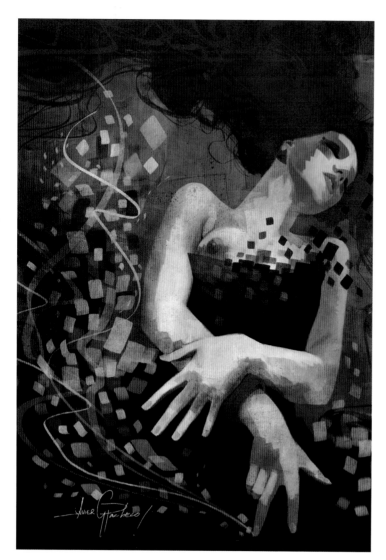

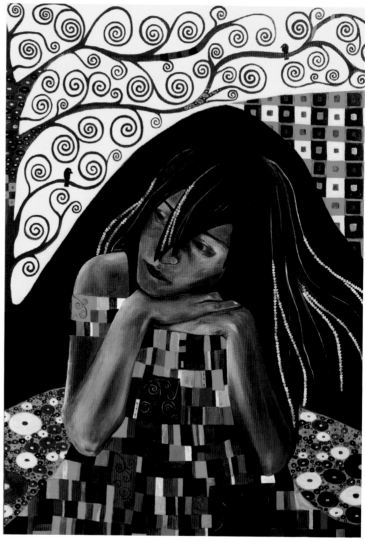

ABOVE: **GILLESSE UKARDI**

GAZE (2006)

Acrylic

This figure is framed by characteristic repeated rectangles and stacked Egyptian eye motifs of the Secessionist era. The ever-spiraling branches in the background offer a direct link to Gustav Klimt's symbolic mural, *The Tree of Life* painted for the Palais Stoclet in 1909.

OPPOSITE PAGE: **MALLEUS**

DELTAHEAD (2007)

Handmade silkscreen

This poster takes its inspiration from the Austrian Wiener Werkstätte style using minimal decoration and pattern throughout. The typeface is unified in the archetypal use of straight lines and decorative squares.

ABOVE: **JAVIER GONZALEZ PACHECO**

TRAVEL IN RED (2008)

Adobe Photoshop

The rapt posture and abstracted decorative treatment uses an updated Secessionist style for a digital illustration that owes a debt to both Klimt and Schiele. The hot colouring and expressive fingers hark back to the distinctive mannerisms of these early painters.

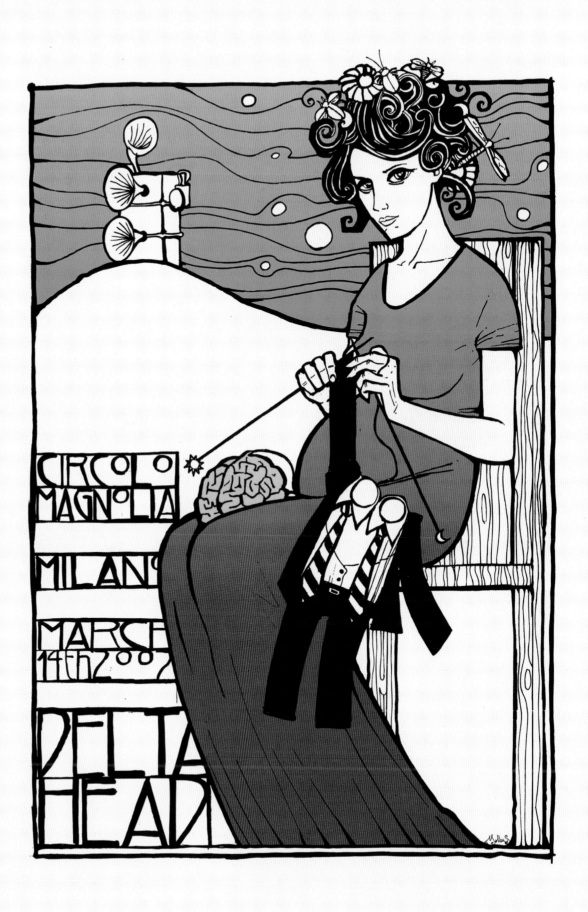

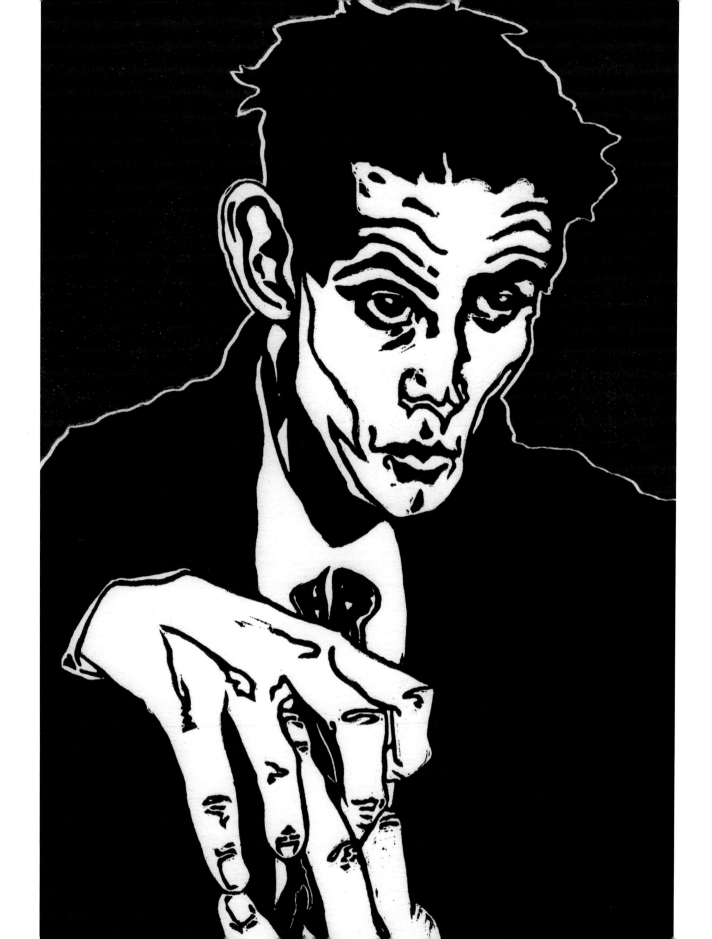

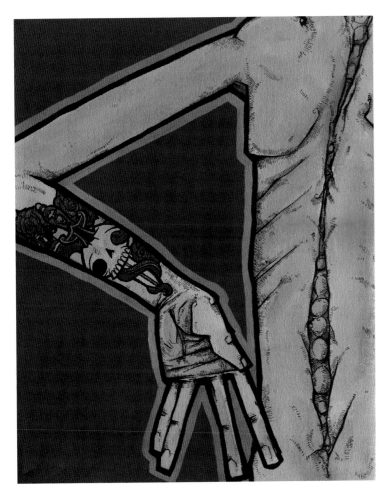

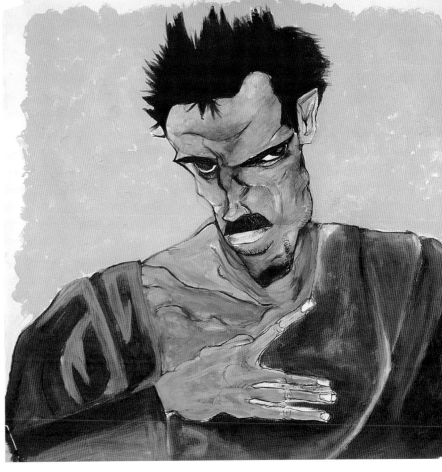

OPPOSITE PAGE: JOSH EMERY

HERR SCHIELE (2008)

Linocut

Egon Schiele's narcissism and obsession with his own image lead to large number of self-portraits. Here the artist has employed the unusual medium of linocut to reinforce Schiele's constant look of anguish and torment.

ABOVE: JOSH TAYLOR

MAN WITH BAD BACK AND TATTOO (2008)

Acrylic/Ink

Egon Schiele's own expressive hands are well documented in the numerous portraits taken of the artist by Anton Jôsef Trcka (1893–1940). Here, the artist perpetuates that mannered image on a contemporary tattooed arm.

ABOVE: ARNAUD DIMBERTON (A.K.A. NOXEA)

SCHIELE AS A B-BOY (OR B-BOY EGON) (2010)

Oils/Acrylic/Pastels

Taking the lead from the way that Egon Schiele conveyed hands this illustrator has updated those same expressive gestures to the B-boys of today who use their fingers and hands to communicate and identify themselves.

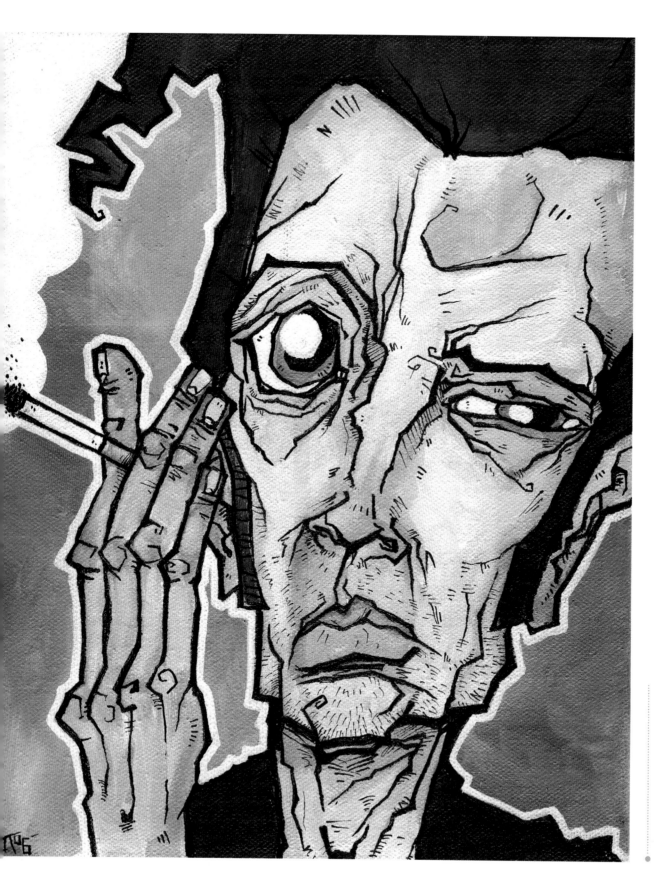

LEFT: JOSH TAYLOR
MAN OF ACTION #1 (2006)
Acrylic/Ink

Drawn originally for an animation pitch, the elongated fingers are typical of the boney and arthritic treatment that Egon Schiele executed in his drawings. The image also owes inspiration to the creator of Æon Flux, Korean animator, Peter Kunshik Chung.

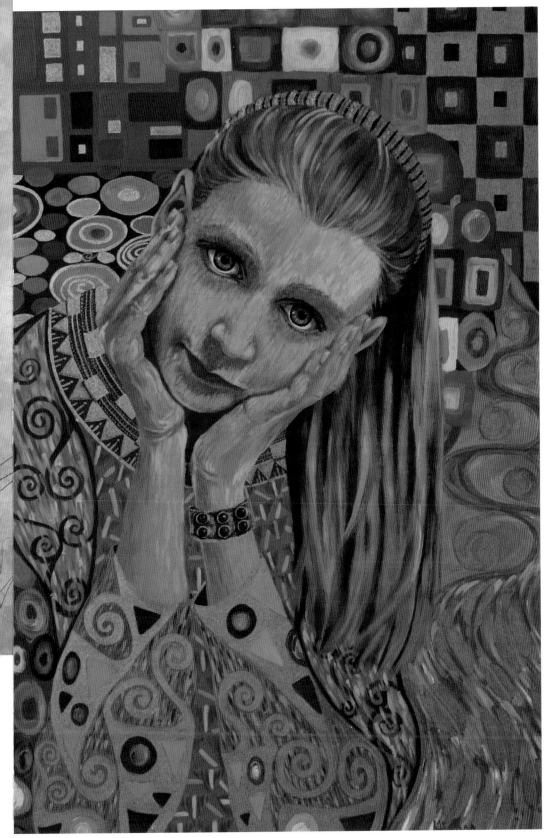

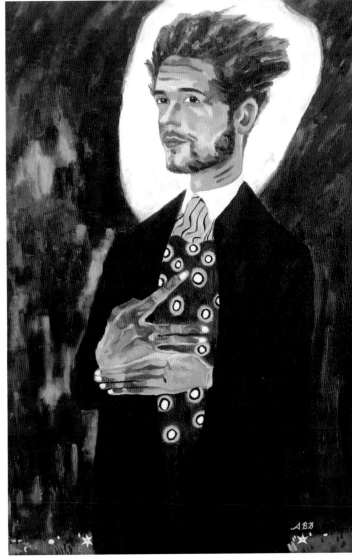

LEFT: KATRINA SHILLAKER

LYDIA (2008)

Acrylic/Gold paint

A portrait of the artist's daughter incorporating the mosaic patterning and Byzantine stylisation that Gustav Klimt featured so prominently in his paintings.

ABOVE: ANNE BAIL-DECAE

DANDY, PORTRAIT OF VINCENT (2008)

Oils

The artist has based this portrait on Schiele's *Self Portrait with Peacock Waistcoat* (1910). She considered the personality of her own sitter to be akin to the complex character of Schiele himself.

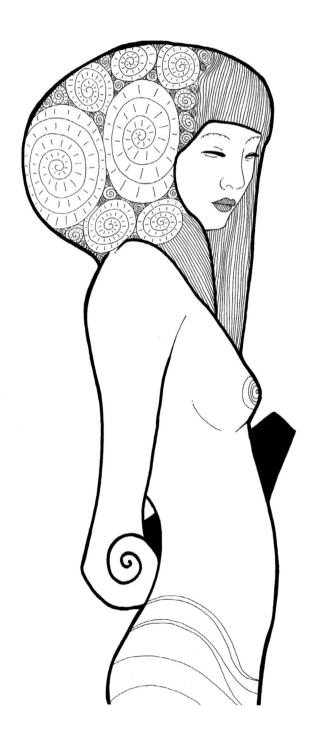

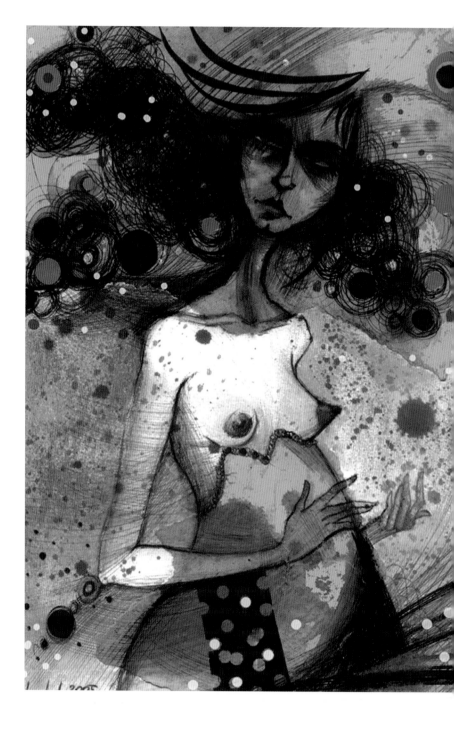

ABOVE: **FRANCESCO D'ISA**

KALLEIS (2008)

Ink

Part of a series of three ink illustrations for the Italian cosmetic company, Kalleis, this erotically charged female has her origin in Gustav Klimt's *Acqua Mossa* (1898). The elongated outlined body form and patterned hair are typical of his work during this period.

ABOVE: **AGATA DUDEK**

GOLDEN BONBONS (2006–2007)

Mixed media/Adobe Photoshop

Unlike elsewhere in the story of art, the pregnant female form was not an uncommon image in Secessionist art. It is usually portrayed, as here, shamelessly naked, which is also the case with Gustav Klimt's *Hope 1* (1903).

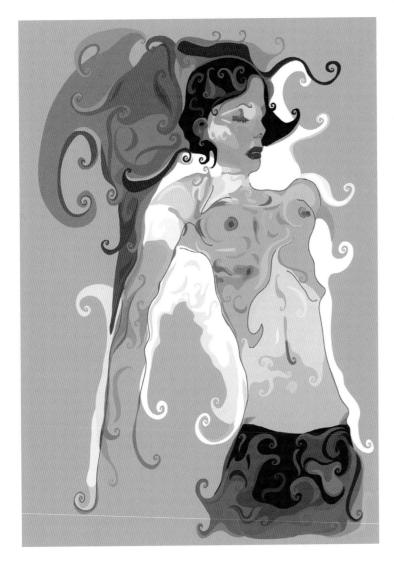

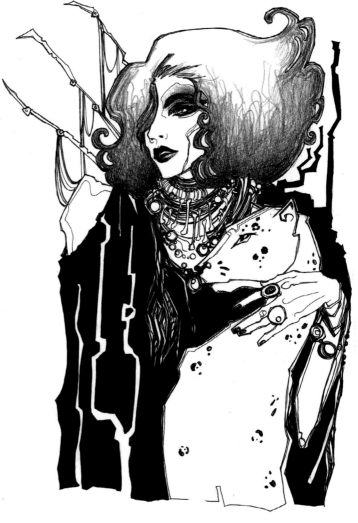

ABOVE: **ALESSANDRO PAUTASSO**

EGON SCHIELE REINTERPRETED (2004)

Adobe Illustrator

Egon Schiele enjoyed using eccentric poses in his figure drawings. The illustrator here has retained a similarly provocative stance for his own digital re-interpretation using the Secessionist style.

ABOVE: **ROSARIA BATTILORO**

LA CASATI (2009)

Marker/Coloured pencils

This is a dramatic portrait of The Marchesa Luisa Casati (1881–1957), an eccentric Italian celebrity who became the most significant muse of her era. She was painted, photographed and dressed by key artists and designers. Her elongated, Schiele-like fingers stroke one of her famous cheetahs.

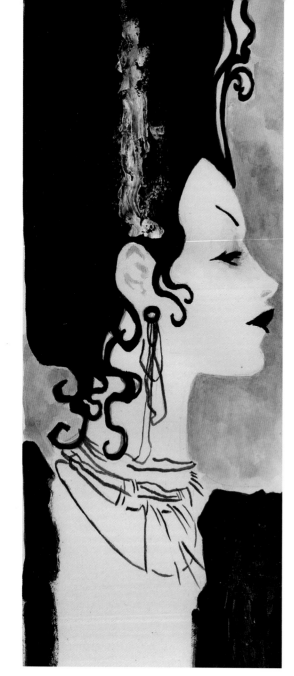

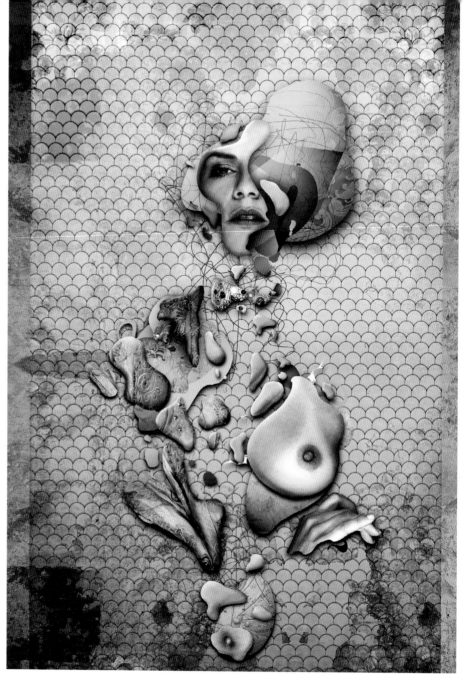

ABOVE: ROSARIA BATTILORO

L'HABIT DE LA MORT (2010)

Acrylic/Watercolour/Coloured paper

This regal profile takes equal inspiration from both Secessionist art and DC comic artist, Bill Sienkiewicz, to invent a character that could have stepped out of a classic Universal horror movie. The lightning flash in the hair suggests the iconic Nefertiti hairstyle of *The Bride of Frankenstein* (1935).

ABOVE: OLIVIER LUTAUD

FLOATING FLOATING JUDITH (2009)

Adobe Photoshop/Adobe Illustrator

This illustration was a commission for the opening of an online art gallery requiring a Secessionist theme. The fragmented female image floats upwards within a honeycomb of Gustav Klimt gold leaf like the wax bubbles in a 1960s lava lamp.

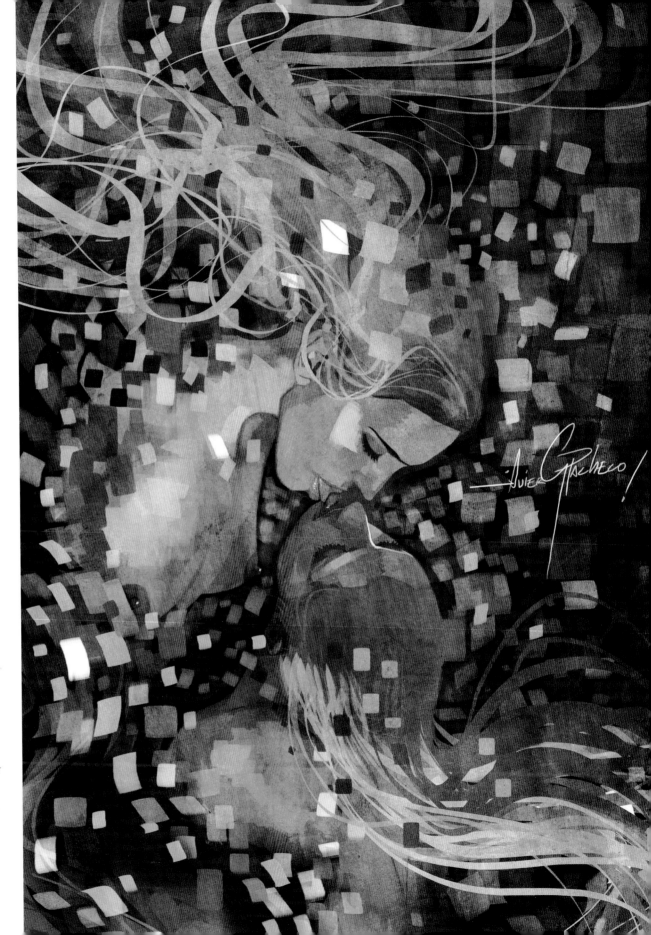

RIGHT: JAVIER GONZALEZ PACHECO
TRAVEL IN RED (2008)
Adobe Photoshop

This digital image pursues the same erotic language as Gustav Klimt's *Water Serpents 1* (1904–07). The passion between the two kissing females is here visualised by a shimmering sea of abstract pattern that also assumes the golden palette much favoured by Klimt.

> Art is called upon to accompany man everywhere where his tireless life takes place and acts: at the workbench, at the office, at work, at rest, and at leisure; work days and holidays, at home and on the road, so that the flame of life does not go out in man.
>
> **Naum Gabo and Antoine Pevsner (*Realistic Manifesto*)**

CONSTRUCTIVISM

Constructivism was an artistic and architectural movement that grew to prominence in Russia following the 1917 October Revolution. Its supporters set about questioning the future of art within their new Communist regime and agreed that it needed to be reinvented to add more value to everyday life.

The term 'Constructivism' first appeared in 1920 in Naum Gabo's (1890–1977) *Realistic Manifesto*.

The Constructivists discarded the abstract ideas of art and replaced composition with construction and design. New Media was often employed in their works and their admiration of machinery and technology gave rise to the members being nicknamed 'artist-engineers'. Unique within twentieth century art, equality of the sexes was a key factor. In keeping with the Principles of Communism, female artists were equally as respected as their male counterparts.

Typography was key in communicating their message as clearly as possible to the proletariat and gave rise to a distinctive use of lettering on posters and the printed page that left no room for any misunderstanding. Text was used in a very confident manner and usually appeared in bold primary colours. Letters were often set at right-angles to one another or arranged on a diagonal axis in striking asymmetrical compositions.

(1917–LATE 1930s)
ALEXANDRA EXTER • NAUM GABO • KASIMIR MALEVICH • LAZAR MARKOVICH LISSITSKY • ANTOINE PEVSNER • LYUBOV POPOVA • ALEKSANDER RODCHENKO • VARVARA STEPANOVA • VLADIMIR TATLIN

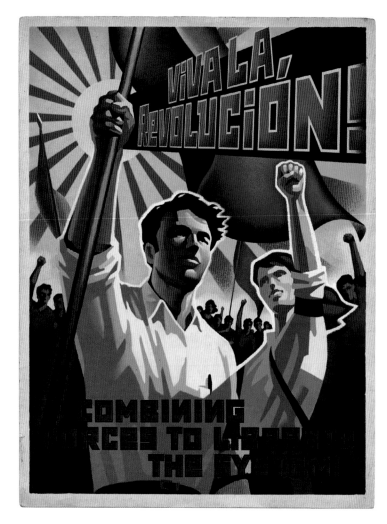

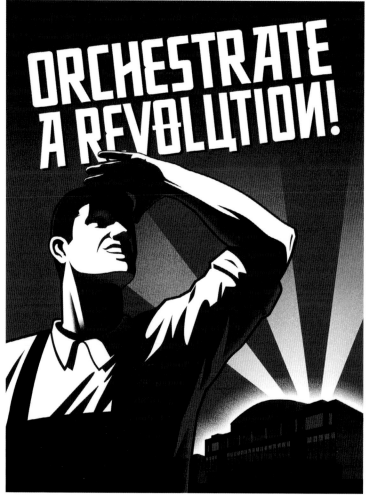

PREVIOUS PAGE: **LIAM BARDSLEY**

ONE BIG MESS (2010)

Collage/Adobe Photoshop/Adobe Illustrator

This image was produced for the Private View column in *Design Week* and takes its inspiration from the Constructivist artist, Gustav Klutsis (1895–1938). Although he worked in a variety of media, he is best remembered today for his photomontage propaganda posters of the period.

ABOVE: **JEFF FOSTER**

VIVA LA REVOLUTION (2008)

Adobe Photoshop

This was a commission for Staccato Design, Portland, Oregon to develop a propaganda style poster that illustrated the concept of change. The crescendo of text and the raised clenched fist are common motifs used in revolutionary poster art.

ABOVE: **LAURENCE WHITELEY**

ORCHESTRATE A REVOLUTION! (2006)

Adobe Photoshop

One of a series of four commissioned illustrations from The Royal Festival Hall on London's Southbank to advertise a concert season of Russian classical music. This image duplicates the typical dramatic flavour of Soviet propaganda poster art by its strong expressionistic treatment and minimal colour palette.

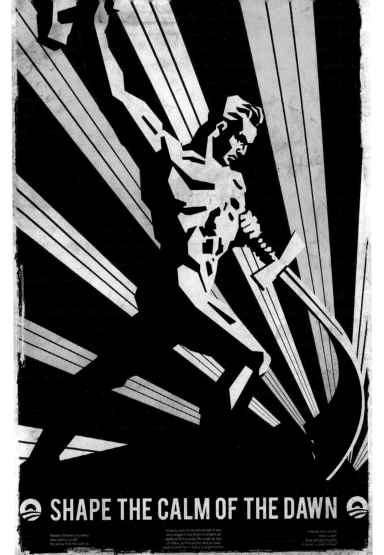

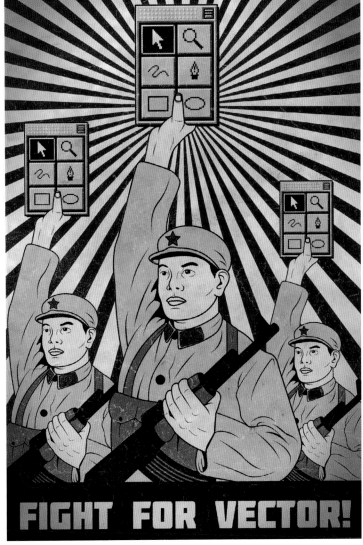

ABOVE: **JONATHAN HAGGARD**

CALM OF THE DAWN (2008)

Adobe Photoshop

The artist here has produced his own self-started advertisement for Barack Obama's 2008 presidential campaign. His poster takes advantage of the typical Constructivist values of art and politics in its own symbolic image of a hero forging a new future silhouetted against the dawning of a new era in American politics.

ABOVE: **ROBERLAN BORGES PARESQUI**

FIGHT FOR VECTOR! (2008)

Adobe Photoshop/Adobe Illustrator

This illustrator was inspired by old Chinese propaganda posters that visualised the same revolutionary zeal and optimism as those created after the Russian Revolution by using typically strong contrasting colours and radiating diagonal lines.

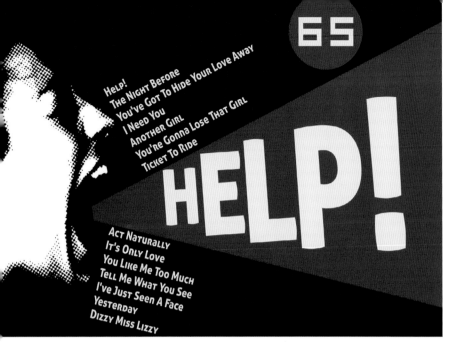

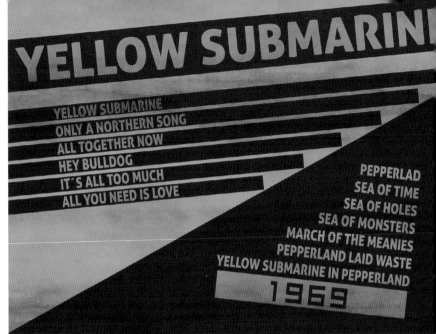

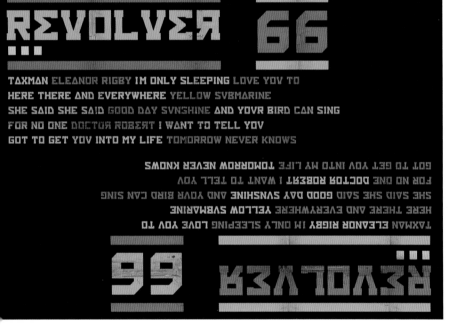

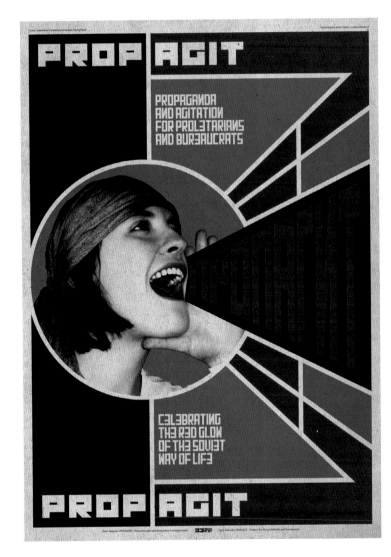

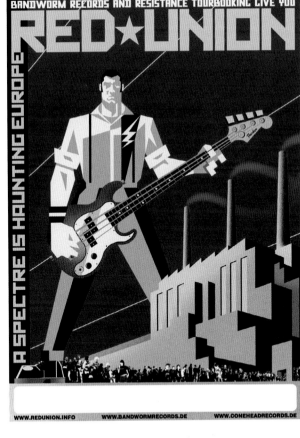

ABOVE RIGHT: DAVE WITTEKIND

HAYMARKET ANNIVERSARY GIG POSTER (2011)

Adobe Photoshop/Adobe Illustrator

A commission from The Illinois Labor History Society to promote the 125th anniversary

of the Haymarket Martyrs in 1886, this dramatic poster evokes the austere palette and

blunt typography of Russian constructivist style.

RIGHT: LJUBOMIR BABIC

A SPECTRE IS HAUNTING EUROPE – RED UNION TOUR (2007)

Adobe Photoshop

Taking his inspiration from the Stenberg Brothers' poster art for the 1928 movie

The Eleventh, the illustrator has produced a striking poster for his own band's 2008

European Tour.

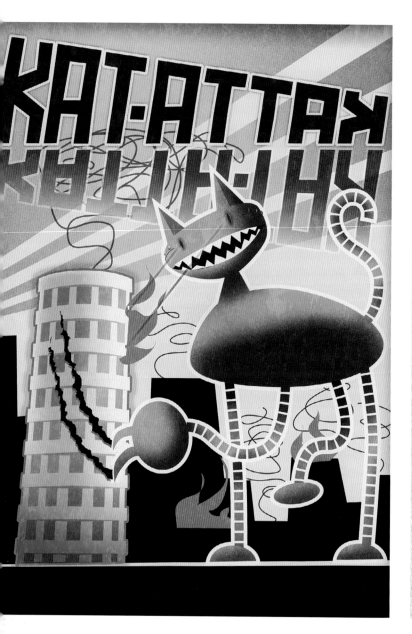

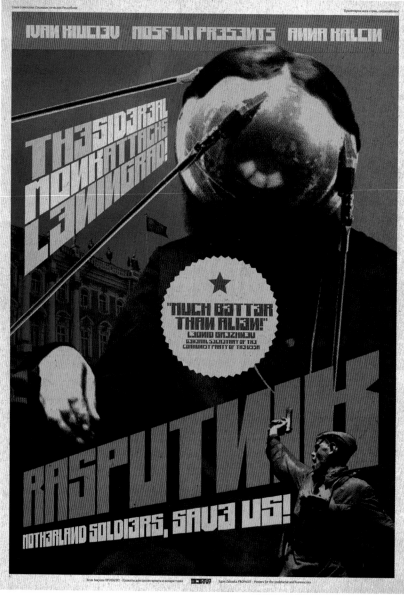

ABOVE: **DAVE WITTEKIND**

KATATTACK (2010)

Adobe Photoshop/Adobe Illustrator

A personal promotional illustration that humorously combines Russian Constructivist attributes with the sc-fi poster art of 1950s 'B' movies.

ABOVE: **EGON ZAKUSKA**

RASPUTNIK (2009)

Adobe Photoshop/CorelDraw

The artist here pokes fun at Constructivist art with this Soviet style movie poster for a fictional space-horror science fiction movie where a Rasputin/Sputnik creature terrorises Leningrad.

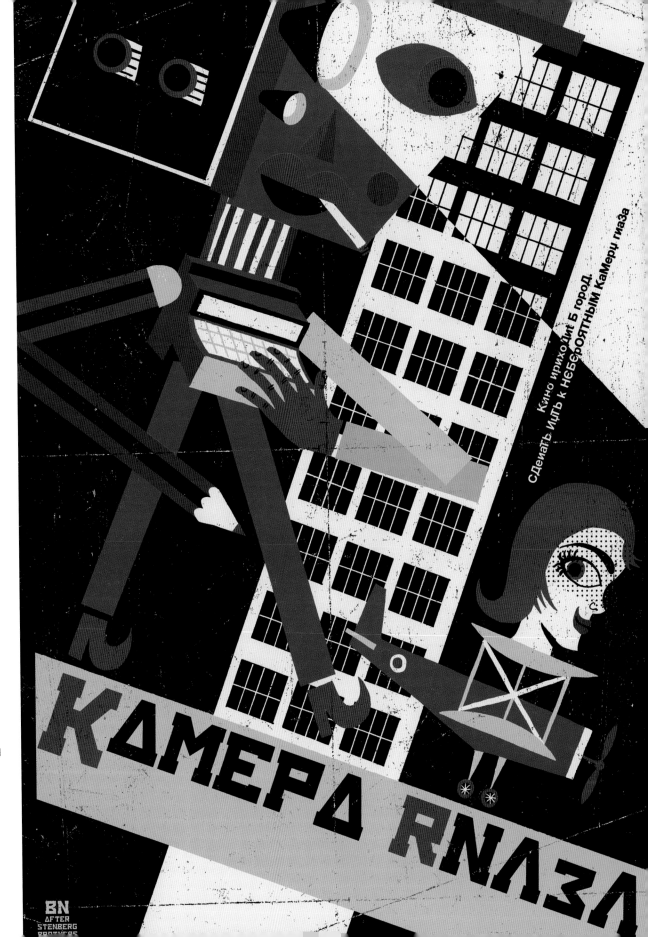

RIGHT: BEN NEWMAN

CAMERA HEAD (2008)

Pencil/Adobe Photoshop

This image was created for a Russian themed exhibition in Germany organised by Rotopol Press. It pays homage to the Constructivist film poster designed by The Stenberg Brothers Georgii (1900–1933) and Vladimir (1899–1982) for the film *The Symphony of a Big City* (1928).

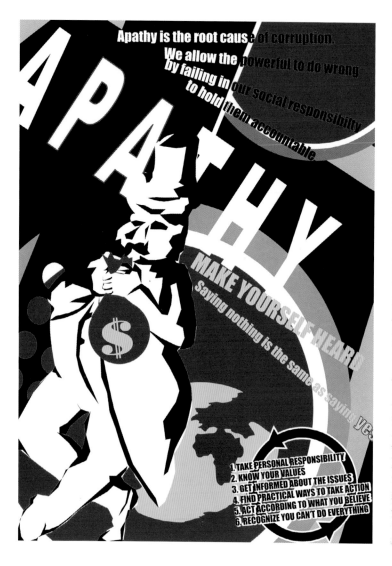

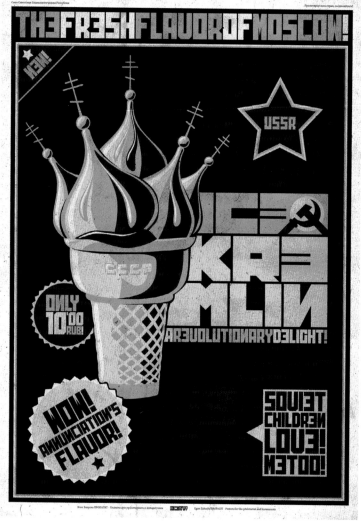

WHITTNEY A STREETER

UNTITLED: APATHY POSTER 2 (2007)

Adobe Illustrator

Here the artist has used the visual language of the Russian Constructivists to draw attention to what she views as the biggest problem in current American politics – apathy. The diagonal framing within the poster is typical of the style, as are the radiating lines of text.

EGON ZAKUSKA

ICE-KREMLIN (2009)

Adobe Photoshop/CorelDraw

This witty play on words exploits the five-domed Uspensky (Assumption) Cathedral (1474–1479), located inside the Kremlin in Moscow, with scoops of ice cream on sale as part of a fictional Soviet economic plan.

RIGHT: ROSE LLOYD

LONDON TRANSPORT (2009)

Mixed media/Adobe

Photoshop/Adobe Illustrator

This was an entry for the Association of

Illustrators/London Transport Museum

poster competition. The image was

inspired by Kazimir Malevich's

(1879–1935) geometric shapes that

became symbols of a new form of

abstract painting – *nonobjectivity* – later

referred to as Suprematism.

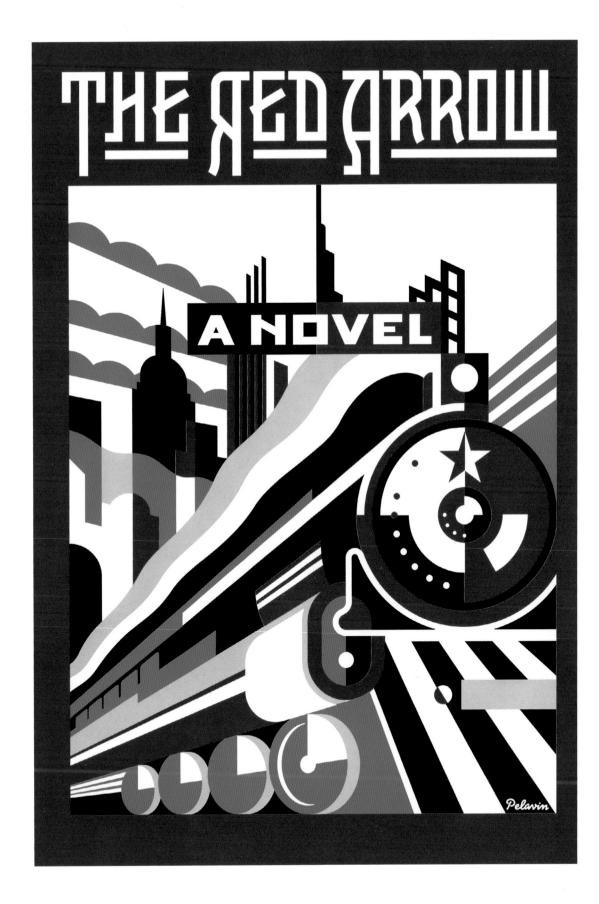

RIGHT: **DANIEL PELAVIN**
THE RED ARROW (2009)
Pre-separated mechanical art
This cover for an adventure novel
set in pre-Soviet Russia exploits
the spatial compositions and
bold colours characteristic of
Constructivism. The abstraction
of the train into dynamic geometric
shapes is typical of the style.

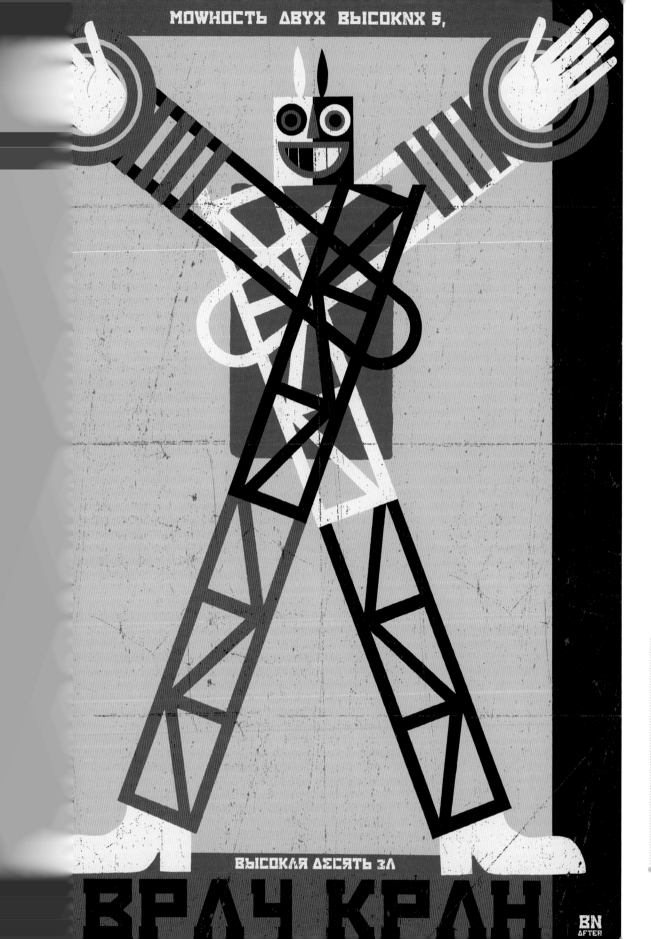

MOWHOCTЬ ДВYX BЫCOKNX 5,

BЫCOKЛЯ ДЕCЯTЬ 3Л

BPAY KPAH

BN
AFTER

LEFT: BEN NEWMAN

DOCTOR CRANE (2009)

Pencil/Adobe Photoshop

Another of the artist's reinvented
Constructivist posters (see p75) from the
Rotopol Press curated exhibition in
Germany. This time the illustrator
reworked the poster designed by
Semenov-Menes Semen Abramovich
(1895–1972) for the 1929 Russian
documentary film, *Turksib*, that celebrated
the construction of the first railroad from
Turkestan to Siberia.

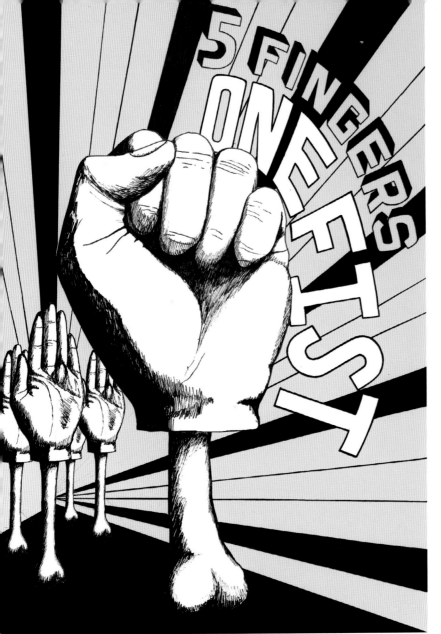

LEFT: OLI FRAPE

FIVE FINGERS, ONE FIST (2009)

Pencil/Pen/Adobe Photoshop

This illustrator takes a lot of his personal inspiration from Constructivist poster art and war propaganda imagery. The linear precision of the radial background and the integration of image with text are both traits of the Constructivist approach.

RIGHT: THOMAS BERGMANN

FINGER CHOCKING (2010)

Adobe Illustrator

The stark red and black colouring in this digital illustration instantly conjures up the Constructivist palette that combined art with politics to reinforce the revolutionary times at the beginning of the 20th century. There are also similarities with the composition of Roy Lichtenstein's 1973 screen-print, *Finger Pointing*.

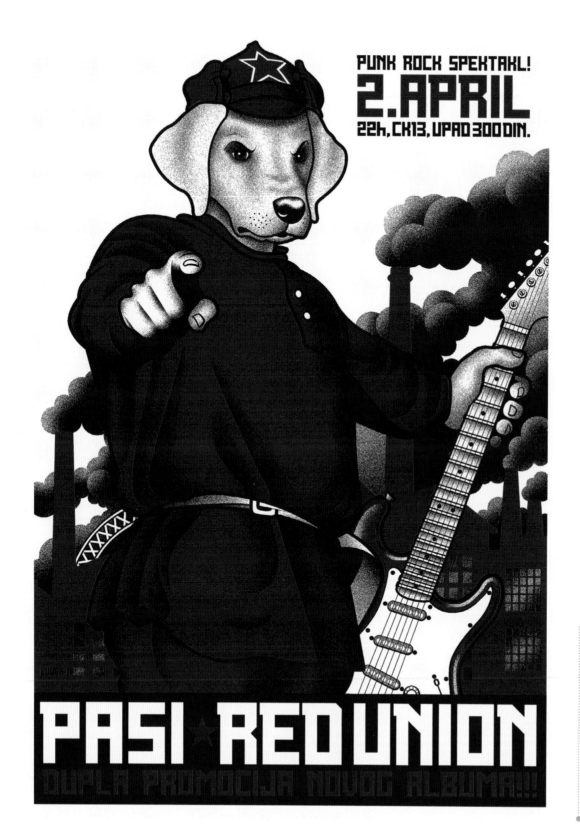

LEFT: **LJUBOMIR BABIĆ**
APRIL 2 (PASI & RED UNION)
Adobe Photoshop

This illustrator has taken his inspiration from the 1920 poster, *Have you Volunteered for the Red Army?* by Russian propaganda artist, Dmitry Moor (1883–1946), which in turn was modeled on the US Uncle Sam and British John Bull WWI recruitment posters.

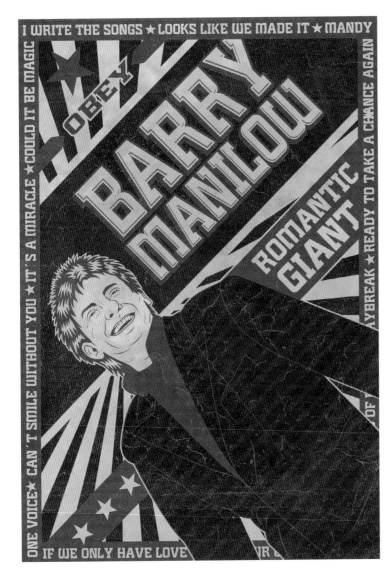

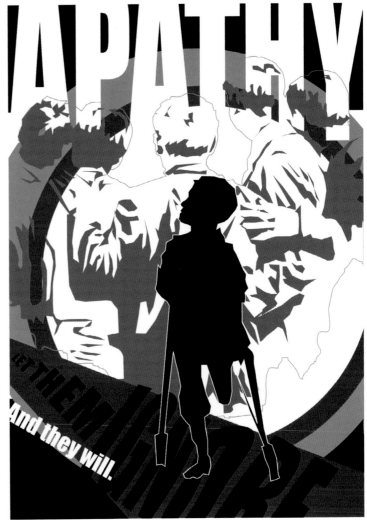

OBEY MANILOW (2007)

Adobe Illustrator/Adobe Photoshop

The artist uses a low angle image of American singer-songwriter, Barry Manilow (b.1943), in the same way that the likeness of Joseph Stalin (1878–1953) was elevated to larger than life status in Soviet propaganda posters

UNTITLED: APATHY POSTER 1 (2006–2007)

Adobe Illustrator

A further example from this series of non-partisan political posters where the artist uses the eye-catching and abrasive graphics of Constructivism to attempt to stir the viewer into physical action, rather than merely casting their vote. The use of a tilted axis and bold colour scheme are typical of the style.

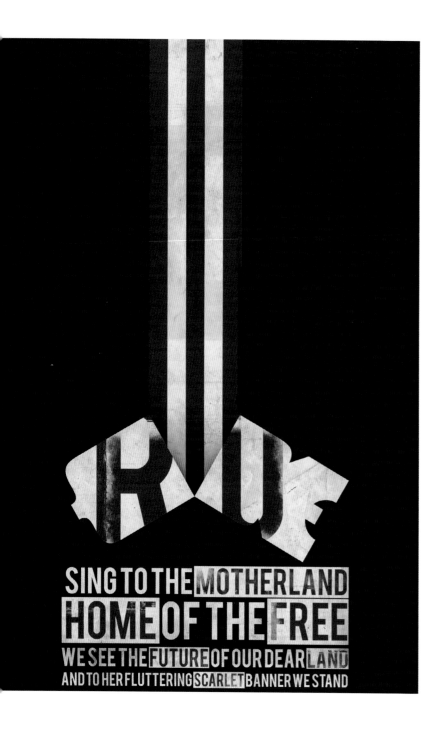

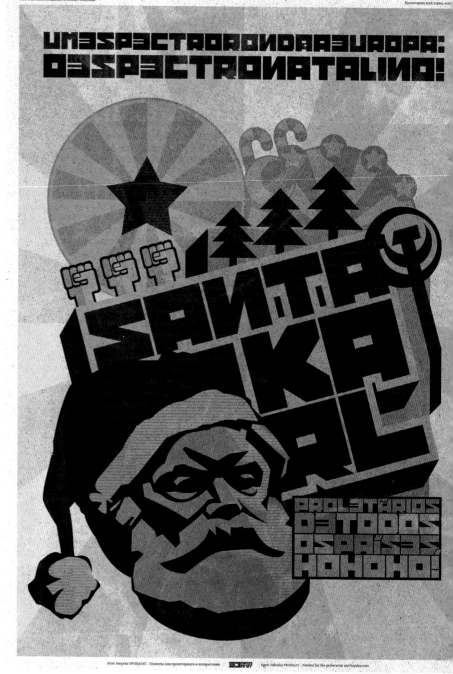

ABOVE: JONATHAN HAGGARD

RUSSIE (2008)

Adobe Photoshop

Here the artist has adapted the chorus refrain from the National Anthem of the Soviet Union for this propagandist treatment. The dominant Constructivist palette of red and black is put to good use in support of the symbolic metaphor in this powerful reinvention.

ABOVE: EGON ZAKUSKA

SANTA KARL (2009)

Adobe Photoshop/CorelDraw

A satirical poster that pits Karl Marx (1818–1883) against Santa Claus with suitably modified quotes from the 1848 *Communist Manifesto*: 'a specter is haunting Europe: the Christmas spectrum" and 'proletarians of all countries: hohohoho'.

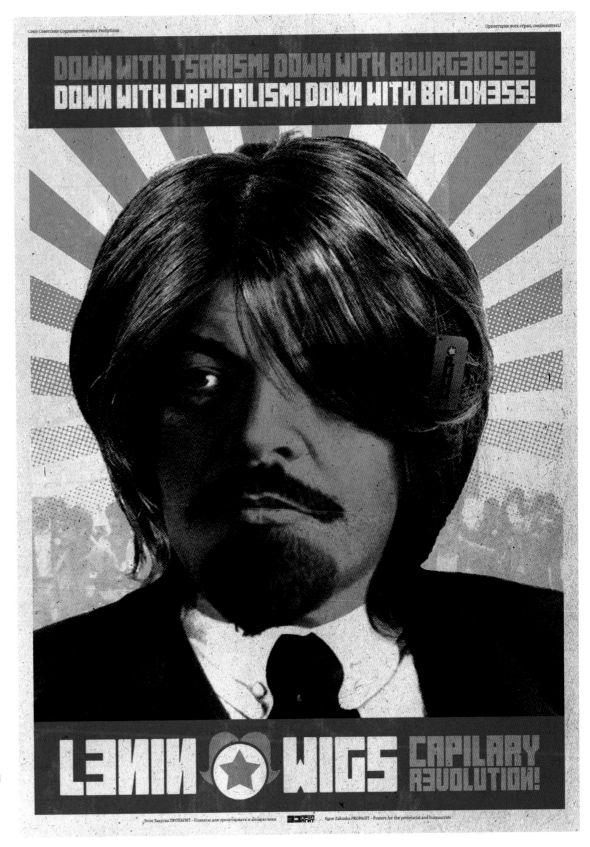

EGON ZAKUSKA

LENIN (2009)

Adobe Photoshop/CorelDraw

A tongue-in-cheek image that exploits Vladimir Lenin's (1870–1924) celebrated baldness with the idea that wigs might be equally revolutionary for those who do not have their own hair.

DADA

Unlike earlier art movements Dada is notorious for being 'anti-art'. The aim of the Dadaists was to upturn the artistic values of the past as a way of protesting against the horrors of the First World War. Conceived by a number of intellectuals, artists and writers based in Zürich (which was neutral territory at the time), the Dadaists vehemently protested against the political establishment for allowing war to break out.

Its distinctive name was a made up nonsense word that suggested baby talk. In their own inimitable way they began fighting art with art itself and protested their beliefs with a barrage of artistic weaponry. The most recognizable outputs of this creative anarchy are the grotesque and satirical collages created from torn newspaper, used tram tickets and broken pieces of driftwood that took eccentricity to the limit. The Dadaists use of scissors and glue instead of brushes and paint became a powerful tool in their armory of protest.

Raul Hausmann (1886–1971) who edited the movement's magazine, *Der Dada* between 1918–1920 was able to fill its pages with the then new medium of photomontage and pioneered using multiple and exploding typefaces to express the journal's text. Despite their anti-art philosophy it remains ironic that Dada became an influence on generations of successive artists. The movement is easily recognisable as the launching pad for Surrealism.

(1916–1924)
JEAN ARP • MARCEL DUCHAMP • GEORGE GROSZ • RAOUL HAUSMANN • JOHN HEARTFIELD • HANNAH HÖCH • RICHARD HUELSENBECK • FRANCIS PICABIA • KURT SCHWITTERS • TRISTAN TZARA

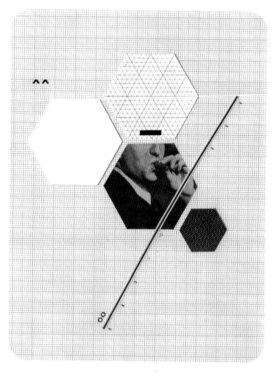

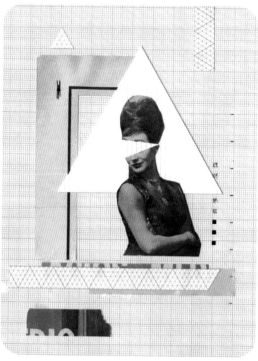

PREVIOUS PAGE:

MATHILDE AUBIER

TERRAECO HD (2010)

Adobe Photoshop

Photomontage became the language
that allowed the Dadaists to ridicule
conventional art. One of the earliest
exponents was German artist, John
Heartfield (1891–1968), who gained
the nickname of 'Monteur Heartfield'
because he came to work wearing his
overalls like a real mechanic ('monteur').

RIGHT: **EL REINO DE LA SANDIA**

UNTITLED (2010)

Collage

These four notebook pages intentionally
apply the Dadaist viewpoint that art
should be left to each individual viewer
to interpret as they wish. The artist
provides no implicit significance in the
choice of imagery leaving the assembled
collages to speak for themselves.

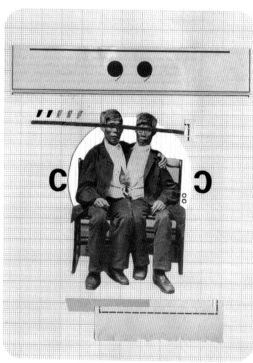

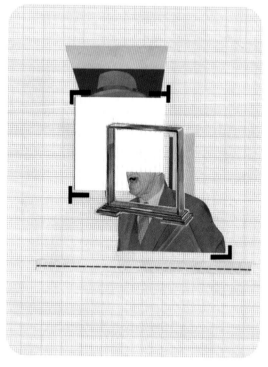

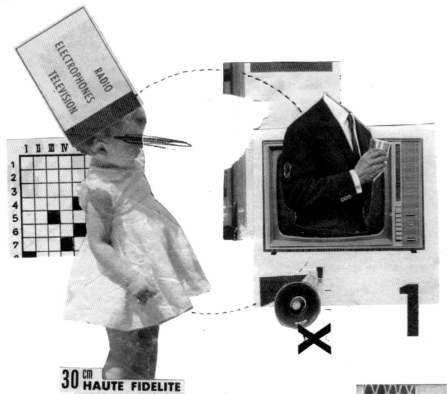

UNTITLED (2011)

Collage

The irrational temperament of Dadaist expression is captured here in a collage that, although typical in its nonsensical arrangement of its imagery, also gives the impression that there is some meaning to the grouping.

RIGHT: MICHAEL LEIGH
HI-FI CORNER FITMENT (1995)

Collage

Produced for a themed exhibition about 'Angels', this hand cut collage mixes vintage DIY magazine illustrations and medical journals from the 50s and 60s with the typical Dadaist freedom for the absurd.

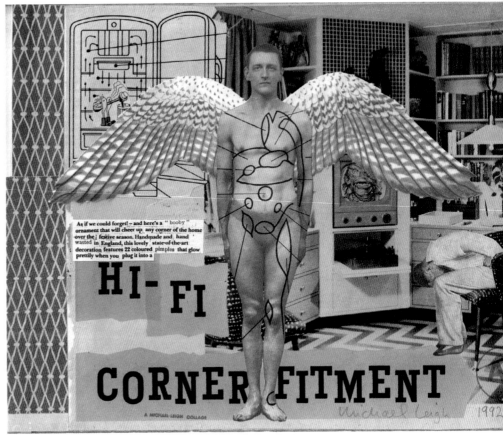

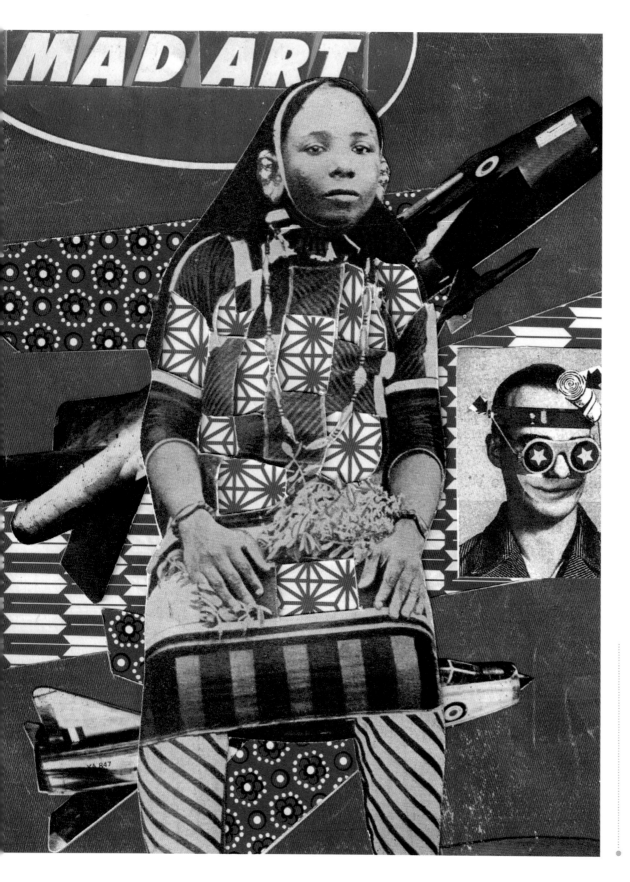

LEFT: MICHAEL LEIGH
MAD ART (2006)
Collage

Hannah Höch (1889–1978), who
continued to produce collages until
her death at the age of 89, is credited
with the invention of the technique of
photomontage. Despite later
acceptance in her own right, Höch
had an early struggle to gain the
same recognition afforded to the
male dominated Dada group.

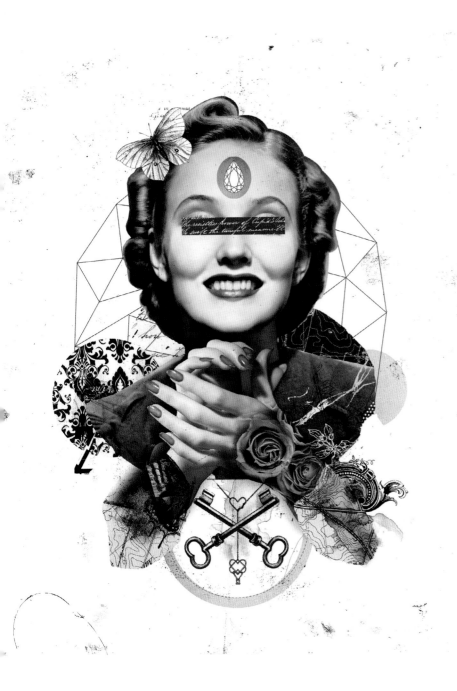

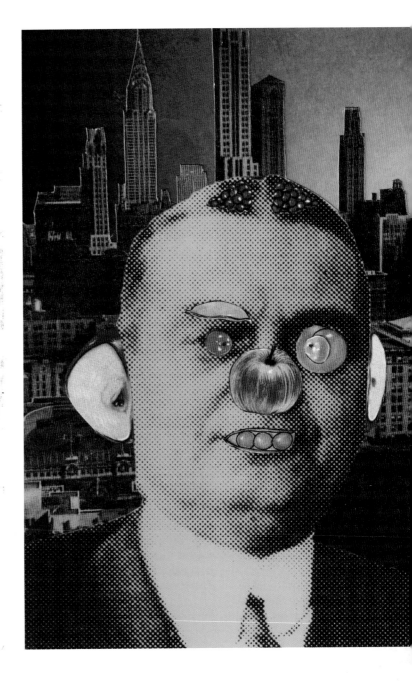

JOSÉ IGNACIO FERNÁNDEZ

KEYS (2011)

Adobe Photoshop

The disjointed memories of a bad dream formed the stimulus for this Dadaist collage.
In its illogical combination of imagery it is easy to identify the Dadaist movement as a
precursor for Surrealism.

MICHAEL LEIGH

MR ARCIMBOLDO (2007)

Collage

The composite portraits of Italian painter, Giuseppe Arcimboldo
(1527–1593), made up from assemblies of fruit and vegetables, are akin to
Renaissance Dadaist montage. The applied fruit in this collage makes for a
more menacing interpretation.

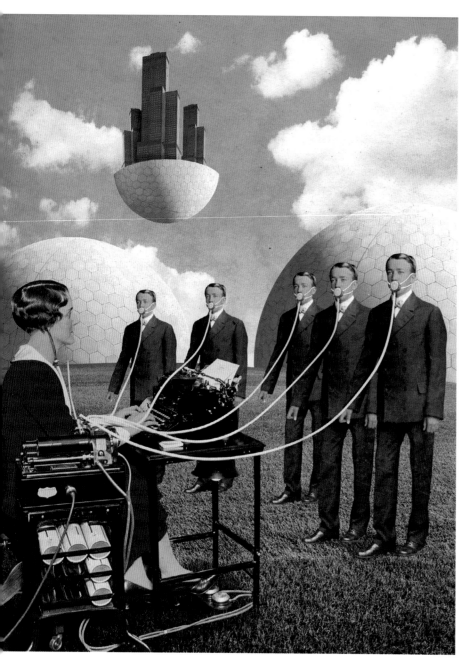

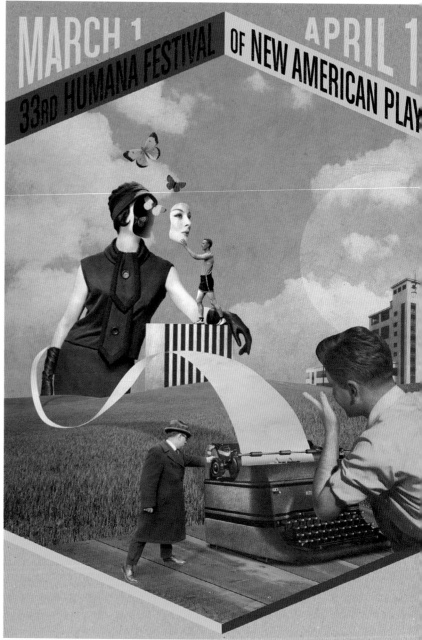

QUINTUPLETS NOVELISTS (2007)

Adobe Photoshop

The complexity of some Dadaist photomontages is repeated here with the artist's references to pop culture, sci-fi movies and Surrealism also contained within the anarchic composition.

HUMANA FESTIVAL POSTER (2009)

Adobe Photoshop

Responding to a commission from the Humana Festival of New American Plays in Kentucky, photomontage was used to create a typically irrational Dadaist response in the manner of the photographic collages of Austrian artist, Raoul Hausmann (1886–1971).

HEDWIG AND THE ANGRY INCH POSTER (2009)

Collage/Adobe Photoshop

Subversive Dada collage seemed relevant in this poster for John Cameron Mitchell's screen adaptation of his own off-Broadway rock musical, *Hedwig and the Angry Inch*. The off-kilter storyline is perfectly anticipated by the transsexual guitarist.

BELOW: **AIRE RETRO**

TE QUIERO FRIDA (I LOVE YOU FRIDA)

Adobe Illustrator/Adobe Photoshop/Pen & ink/Watercolour

A generous mixture of media is used to express the artist's admiration for the Mexican painter, Frida Kahlo de Rivera (1907–1954) best know for her self-portraits. The mixture of scales within the composition was an aspect of the freedom that Dadaists explored to evoke a sense of the absurd.

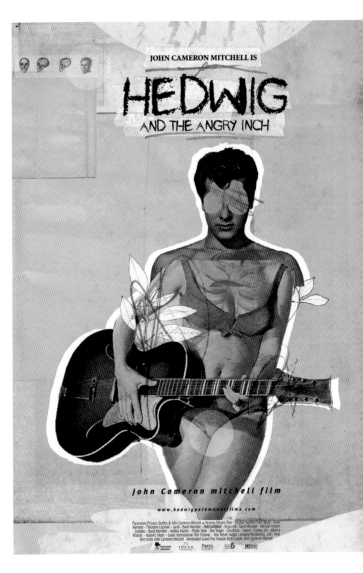

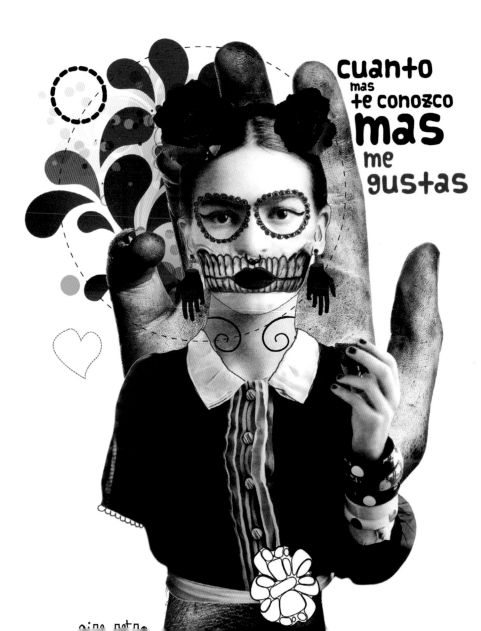

TOP AND BOTTOM:

ADRIEAN KOLERIC

UNTITLED 63 & UNTITLED 60

(2010)

Adobe Photoshop

With typical Dadaist flare this artist has
applied a digital software update to
their hand-cut photomontage technique
to provide satirical comment on (*top*) the
comparative ease of hoodwinking
people to take up a new religion, and
(*bottom*) socialism versus capitalism in
contemporary society.

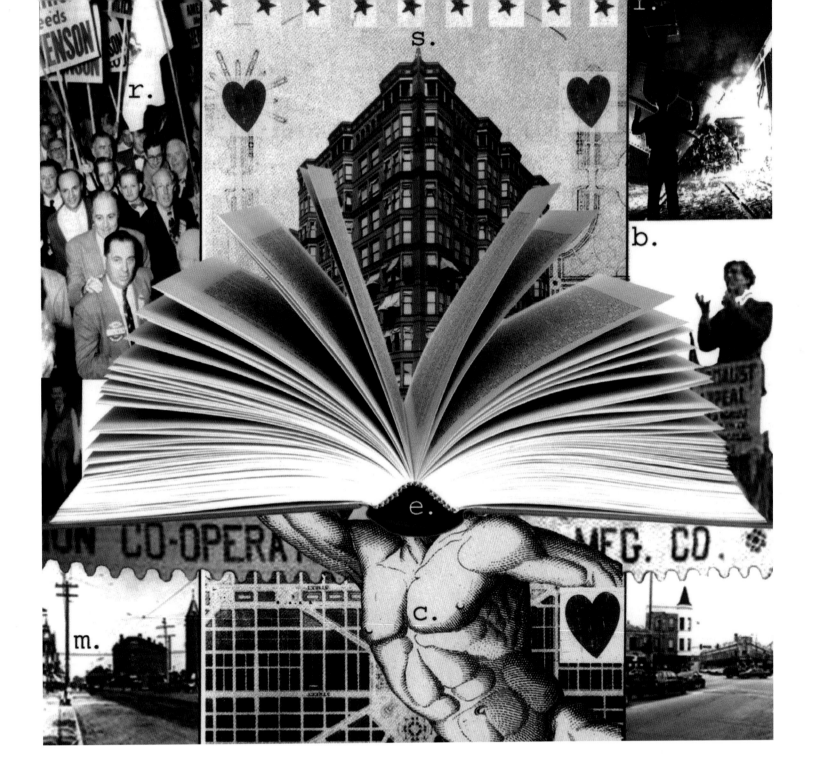

ABOVE: NICKY ACKLAND-SNOW

CHICAGO'S PAST (2006)

Collage

This commission for the *Chicago Tribune* uses a Dadaist language for an article discussing the city's history.

The photomontage articulates its message in the flexible and uninhibited manner of Raoul Hausmann.

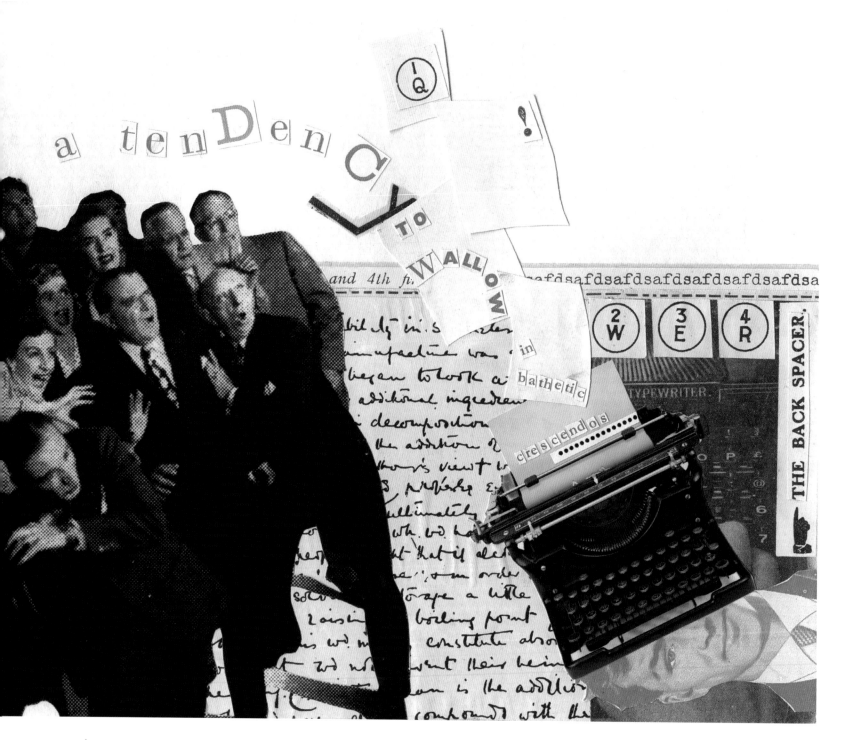

ABOVE: NICKY ACKLAND-SNOW

EDUCATION OF A CRITIC – A TENDENCY TO WALLOW (2009)

Collage

Commissioned by *Opera News*, the artist has responded with a typical Dadaist collage reminiscent of the cleverly balanced compositions

by Hannah Höch. The cascading type is fully integrated into the overall composition rather than as stand alone text.

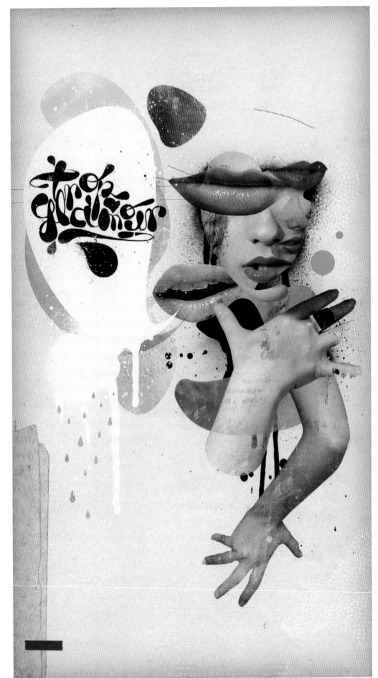

ABOVE: **DAMIEN VIGNAUX**

TROP GLAMOUR! (2007)

Adobe Photoshop

These two digital collages are part of a triptych in which the illustrator was experimenting

by mixing images from the fashion world with Dada aesthetics to create graphic concepts

that could be used in fashion photography.

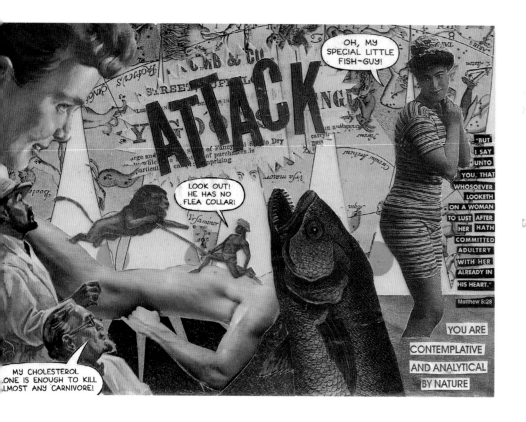

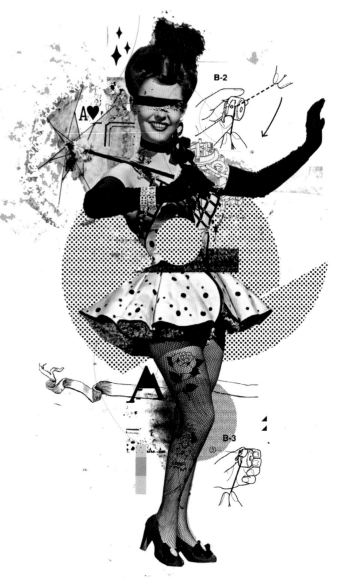

WHEN ANIMALS ATTACK (2009)

Collage

Rather than using downloaded imagery, here the artist compiled his collages in imitation of
the hand techniques of Hannah Höch and Raoul Hausmann. Once satisfied with the overall
composition, he overlaid the text and word balloons to provide the citizens of his imagined
collage world with their own voice.

LA HIJA DEL FLETERO (2010)

Adobe Photoshop

Taking his inspiration from a local rock band, the artist has mixed collage and
photomontage in the manner of the Dadaists to assemble a complex image that seems
more than the sum of its parts.

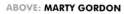

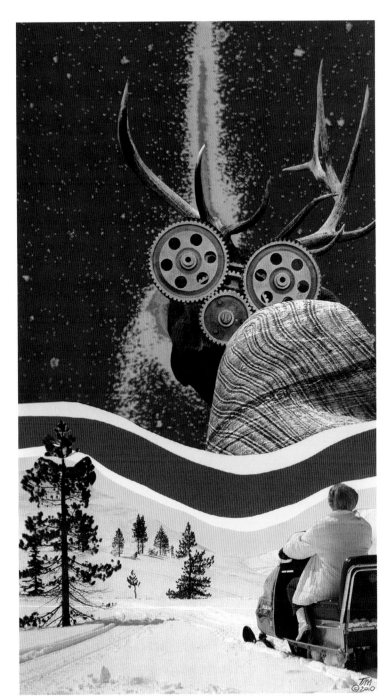

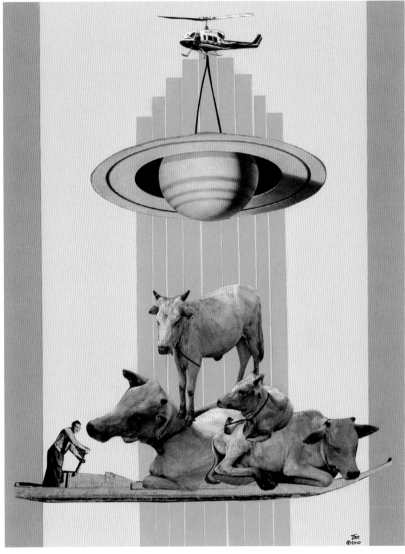

A BIT FURTHER NORTH (2010) & HEAVENS TO BETSY (2010)

Collage

These two hand cut collages are experiments with the Dadaist juxtaposition of retrieved imagery to create a nonsensical image that also provides an underlying message. Although the Dadaists did not invent collage – the term originated in 1912 with Pablo Picasso (1881–1973) and Georges Braque (1882–1963) – they hijacked it for their preferred language of visual communication.

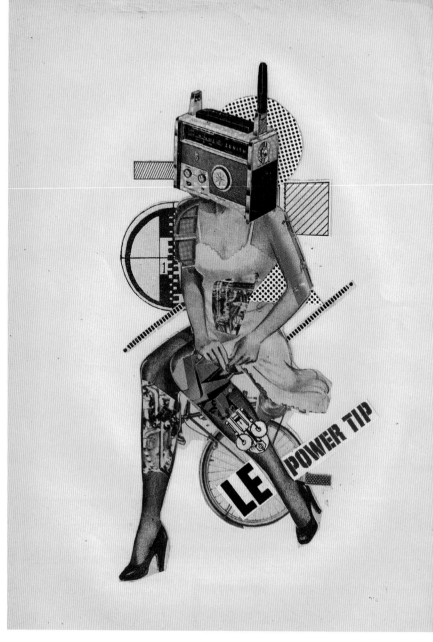

ABOVE: **EL REINO DE LA SANDIA**

UNTITLED (2011)

Collage

A juxtaposed assembly of magazine imagery and newspaper type that
clearly becomes an intriguing Dadaist visual pun.

ABOVE: **JOSÉ IGNACIO FERNÁNDEZ**

LE POWER TRIP (2009)

Collage

For this handmade collage the artist has mixed mechanical and figurative components
suggestive of Raoul Hausmann's cyborgic sculpture *'Der Geist Unserer Zeit – Mechanischer
Kopf* (1919–20), that fused a tailor's dummy head block with fragments from a typewriter,
camera and pocket watch.

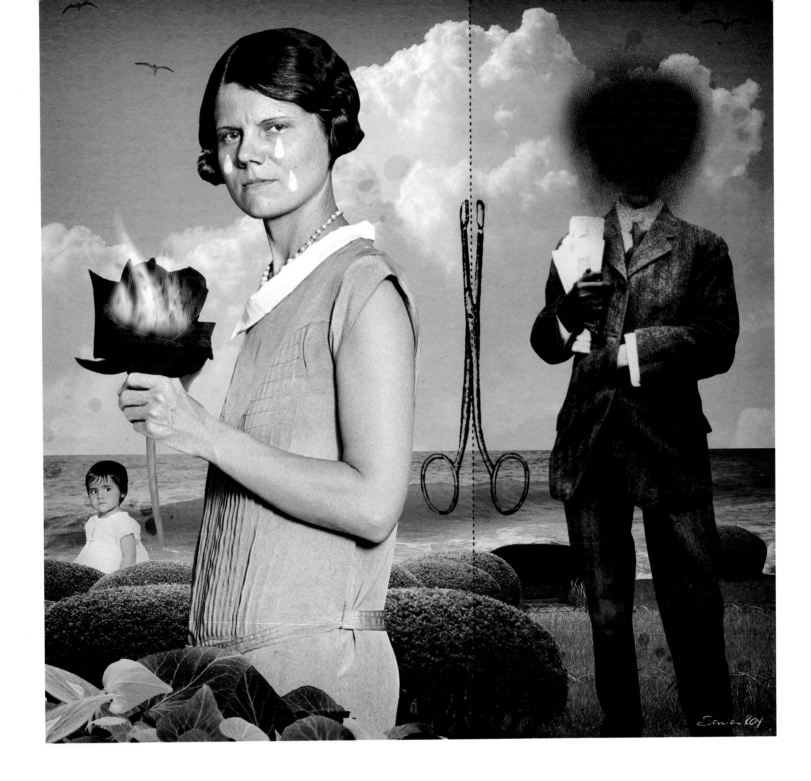

ABOVE: SONIA ROY

TROPICAL DIVORCE (2009)

Adobe Photoshop

The artist has responded in Dadaist fashion to a commission from the Canadian newspaper *The Globe and Mail* for an article about divorce

on the cheap. Her digital collage is akin to the photomontage work pioneered by John Heartfield and Hannah Höch.

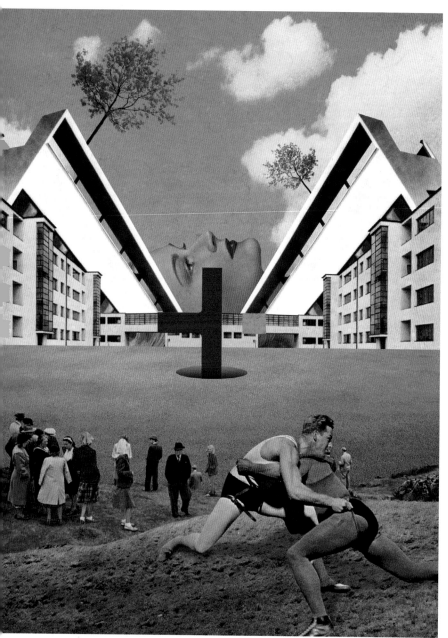

ABOVE: JULIEN PACAUD

COLAGENE EMERGENCY GUIDE (2009)

Adobe Photoshop

Working to a commission from his illustration agency the artist here benefits from the potential of digital software rather than traditional scissors and paste. The artist was given free reign, the client's only stipulation was the incorporation of the agency cross-logo, which here provides an central anchor to the collage.

ABOVE: NAZARIO GRAZIANO

MUSIC UNTITLED #3 (2008)

Pen/Adobe Photoshop/Adobe Illustrator

Part of a series of illustrations for Swiss Radio Toxic.fm. The typical Dadaist assembly of found scraps is brought up to date by the use of colourful and fashionable clippings that would be easily recognisable to a contemporary viewer.

ABOVE: NAZARIO GRAZIANO

MILK DECEMBRE (2010)

Pen/Adobe Photoshop/Adobe Illustrator

The artist is representing the problems surrounding immigration in this editorial illustration for *Milk Magazine*. The political argument of the collage is akin to the montage work of John Heartfield where his message was always more important than the aesthetic of the assembled art.

RIGHT: EZEQUIEL EDUARDO RUIZ

MUSICAL PERSONAGE (2007)

Pen/Adobe Photoshop

This Dadaist collage also embraces future Surrealist mannerisms by supplanting the lounge singer's head with an acoustic guitar that duplicates the outline of a skull and positions the gaping sound hole as an illusionary mouth.

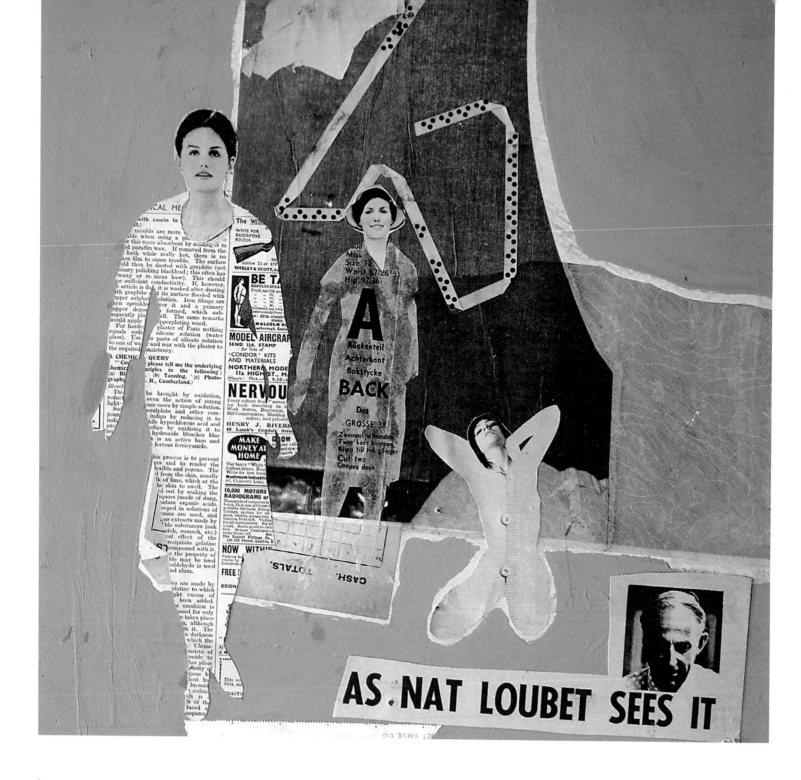

ABOVE: PETER QUINNELL & MARTIN O'NEILL

AS NAT LOUBET SEES IT (2009)

Collage/Paint

A collaborative venture for the *1067 Mind Invasion* project in Hastings that applies

the Dadaist language of montage to articulate its message with stylish wit and humour.

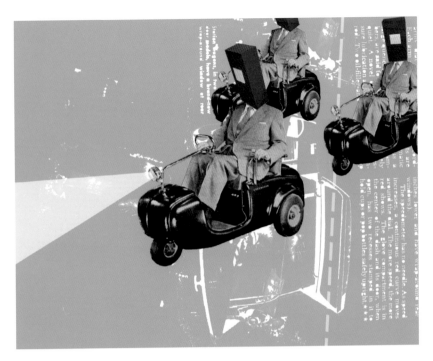
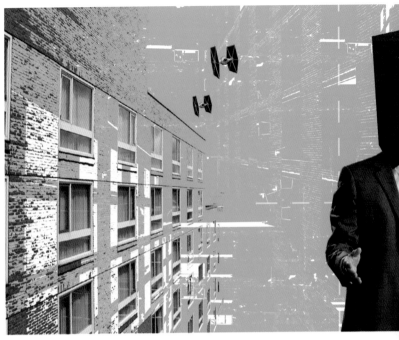
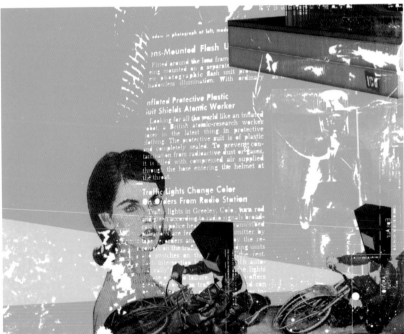

CLOCKWISE FROM BOTTOM LEFT: UNTITLED 50, UNTITLED 47, UNTITLED 55 & UNTITLED 42 (2010)

Adobe Photoshop

Part of a sequence of 1950s related illustrations that feed off the wide-eyed optimism of the decade to create a series of Dadaist photomontages that catalogue

a generation nearing its end. The artist has unified his downloaded retro imagery by the irrational single vision headwear of its society.

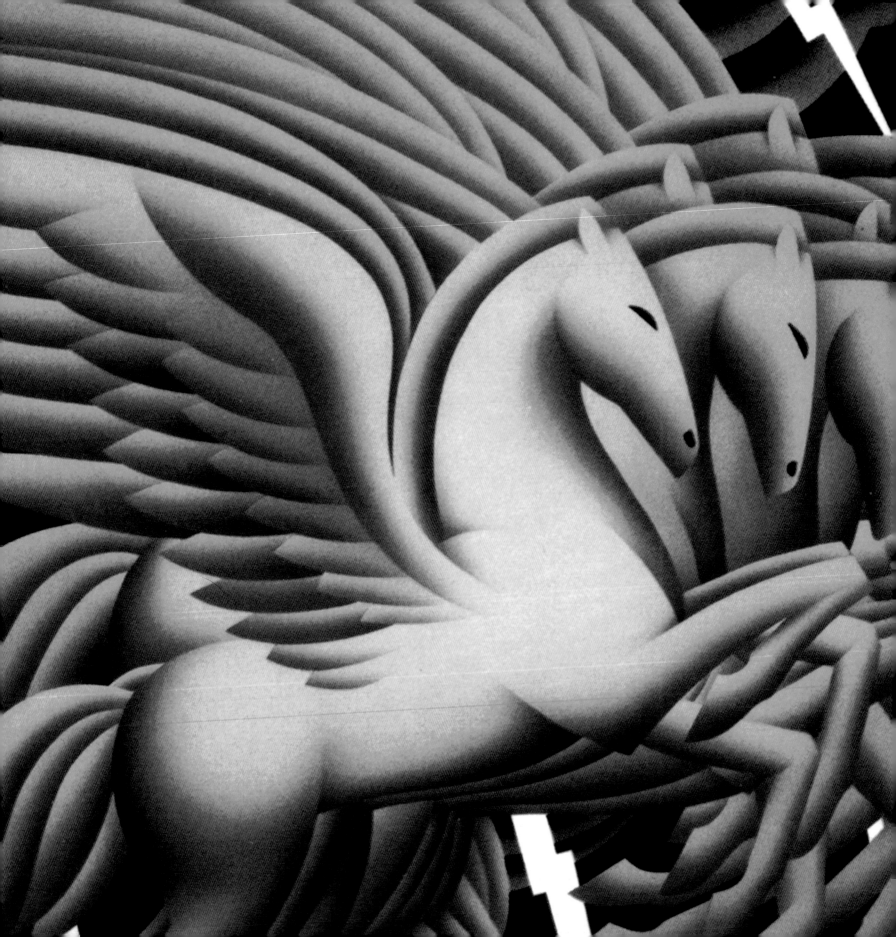

ART DECO

Art Deco, which was originally known as 'Style Moderne' or 'Modernistic', grew out of the social changes and technological advances that were happening during the early part of the twentieth century. Its striking and opulent style was in direct response to the austerity following World War I. The term Art Deco only came into existence decades later in 1966 following a retrospective exhibition at the Musée des Arts Décoratifs in Paris to celebrate the famous 1925 'Exposition Internationale des Arts Décoratifs et Industriels Modernes'.

Typical traits are the angular and geometric forms that appear to be constantly repeating and overlapping. Egyptian zig zags, chevrons, lightning bolts and the 'sunburst' motif are distinctive features that became synonymous with its highly stylized appearance.

New materials, like chrome and plastic, emphasized its modern appeal and made it the height of sophistication and glamour.

Easily identifiable through its use of strong clean lines and sweeping curves, its distinctive elegance was used across a wide spectrum of design. It had a strong influence on architecture, particularly in America, where the auditorium of the Radio City Music Hall and the spire of the Chrysler Building in New York represent pinnacles of Art Deco style.

During the 1930s the movement evolved into 'Streamline Moderne' in reaction to the progress in aerodynamics that romanticized the appeal of aviation and ocean travel.

Mass production eventually brought its influence into the home with everything from toasters and refrigerators, to furniture and clothes echoing the Art Deco style.

(1910–1939)
WILLIAM VAN ALEN • ADOLPHE-JEAN-MARIE MOURON CASSANDRE • CLARICE CLIFF • JEAN DUPAS • ERTÉ • PAOLO GARRETTO • ERIC GILL • RAYMOND HOOD • RENÉ JULES LALIQUE • TAMARA DE LEMPICKA

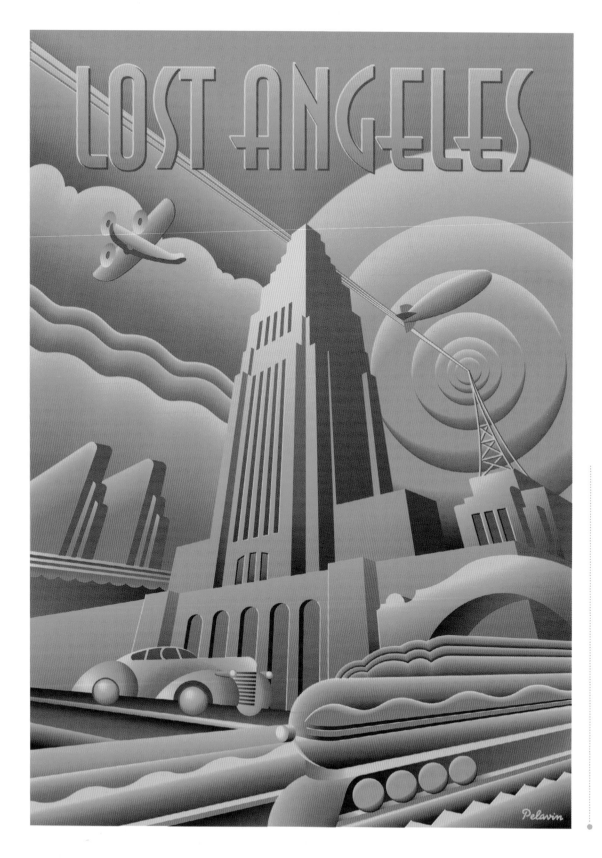

LOST ANGELES

Pelavin

WINGED SPEED (1998)
Airbrush acrylic
This commission for a trade magazine
uses the image of flying horses and
lightning to convey the speed of the
internet. Horses were a familiar motif in
Art Deco as demonstrated at Toronto's
'The Horse Palace' which had detailed
relief masonry horses carved across its
exterior walls.

LEFT: DANIEL PELAVIN
LOST ANGELES (1990)
Adobe Illustrator
An Art Deco styled book cover that
chronicled the history of Los Angeles,
CA in the 1920s and 30s. It takes it
inspiration from bas-relief murals and
panels of the period.

LEFT: RODOLFO REYES

MERCURY ON THE RUN (2010)

Adobe Illustrator/Adobe Photoshop

As well as exploiting Egyptian and Asian culture, Art Deco artists took their inspiration from mythology. Roman gods such as Mercury – the Window Messenger – mirrored their increasing fascination with the speed of travel.

BOTTOM LEFT: BOB SCOTT

READ ALL ABOUT IT! (2002)

Adobe Illustrator

The artist here has employed an Art Deco treatment to provide a more nostalgic mood in his illustration for an IBM tech-heavy magazine article on server software. The simplified airbrushed urban landscape is typical of the Art Deco period.

BOTTOM RIGHT: DANIEL PELAVIN

MANHATTAN (1986)

Pre-separated mechanical art

Pre-World War II Manhattan was the inspiration for this striking Art Deco treatment that also pulls in elements of Cubism in its abstracted depiction of the city.

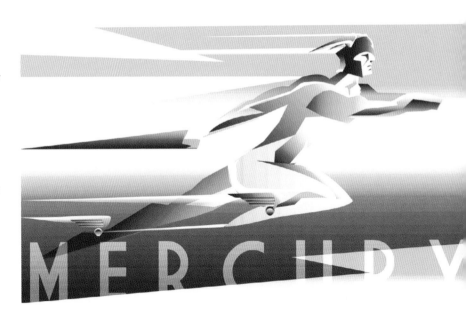

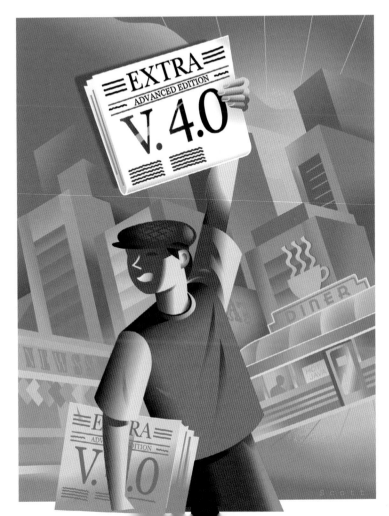

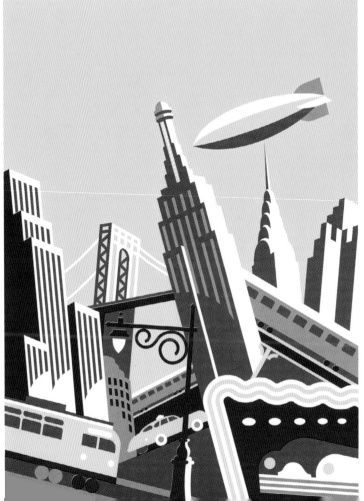

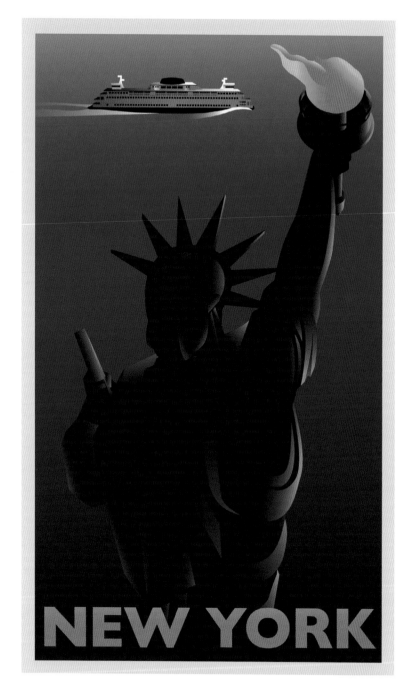

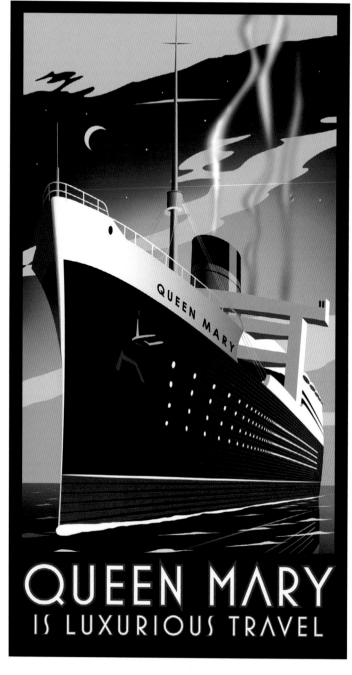

JOHN W TOMAC

STATUE OF LIBERTY (2008)

Adobe Illustrator

Frédéric Auguste Bartholdi's (1834–1904) inspirational Statue of Liberty, dominating Liberty Island in New York Harbour, remains one of the most iconic statues in the world. Officially titled *Liberty Enlightening the World* it easily lends itself to reinterpretation as an art deco emblem of freedom and democracy in America.

ABOVE: RUDY GARDEA

THE LUXURIOUS QUEEN MARY (2009)

Adobe Illustrator

Art Deco artists used the symbol of vast ocean liners to evoke the streamline characteristics that reflected the new spirit of modernity. RMS Queen Mary, launched in 1934 as part of Cunard's White Star Line, was Britain's Art Deco answer to the French SS Normandie.

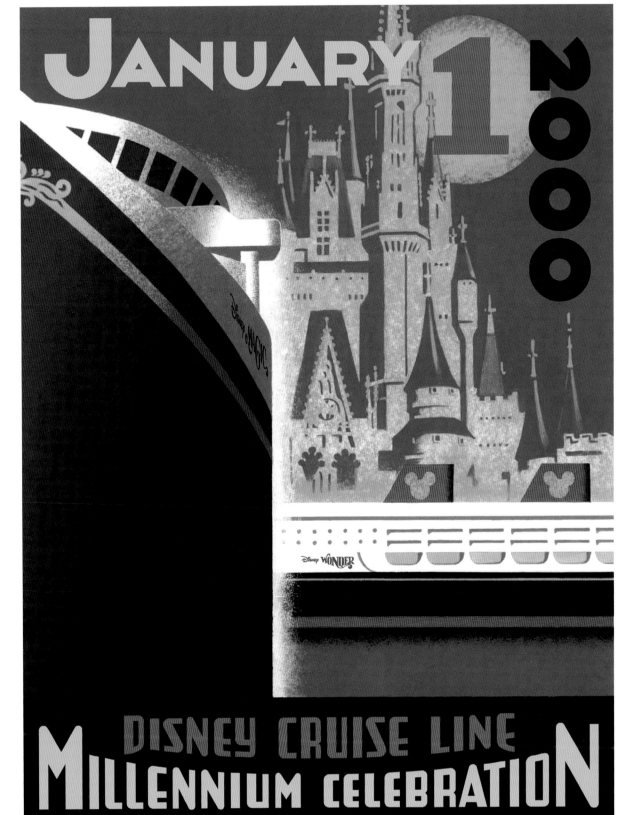

JANUARY 1 2000

DISNEY CRUISE LINE
MILLENNIUM CELEBRATION

RIGHT: LAURA SMITH

MILLENNIUM CELEBRATION

(1999)

Acrylic

This poster was a joint commission with the artist's husband, Michael Doret, for Disney. It replicates the simplified reduction of the image that Adolphe Cassandre (1901–1968) developed as his own. Cassandre's Art Deco travel posters supported the illusion and romance of mechanical progress particularly in ocean travel.

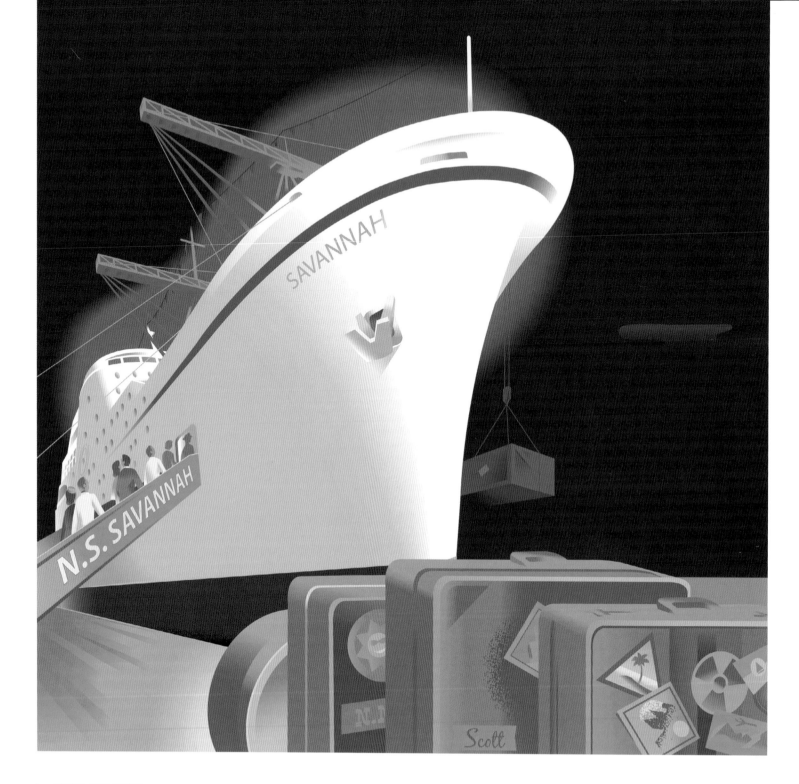

N.S. SAVANNAH (2006)

Adobe Illustrator

This commission for *Virginia Living* magazine, about a nuclear powered passenger ship, owes its impressive visual

impact to the distinctive travel posters of the period by Adolphe Cassandre and Jean Carlu (1900–1997).

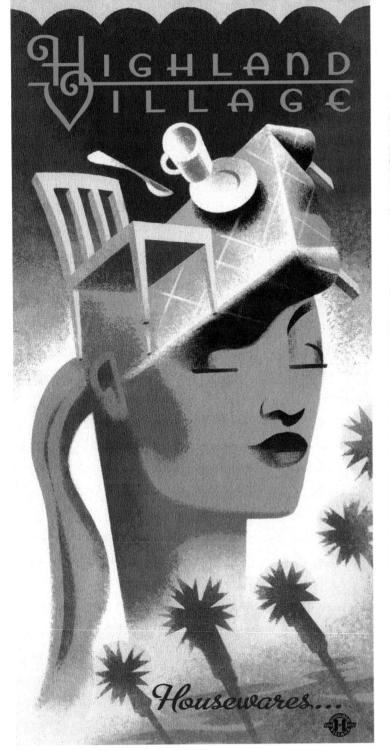

ABOVE: **LAURA SMITH**

HIGHLAND VILLAGE/HOUSEWARES (2009)

Acrylic

This poster trades on the Art Deco mannerism of creating an elegant and sophisticated
aspect with airbrushed surfaces and reduced detailing. There is more desire to integrate
both text and image to evoke a desirable ambience rather than to depict an actual product.

ABOVE: **LAURA SMITH**

ART DECO WEEKEND (2005)

Acrylic

The artist has been inspired by the tongue-in-cheek approach of Italian caricaturist, Paolo
Garretto (1903–1989) whose celebrated airbrushed caricatures of the rich and famous
epitomised Art Deco styling. During the 1930s, Garretto's unique style was often seen on
the covers of *Vanity Fair*.

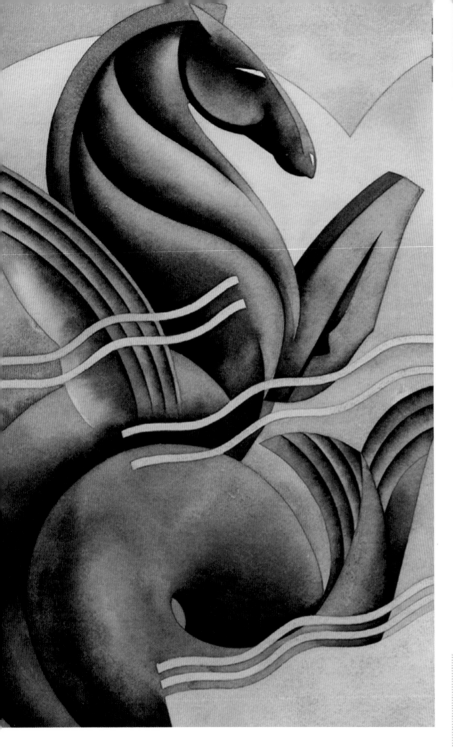

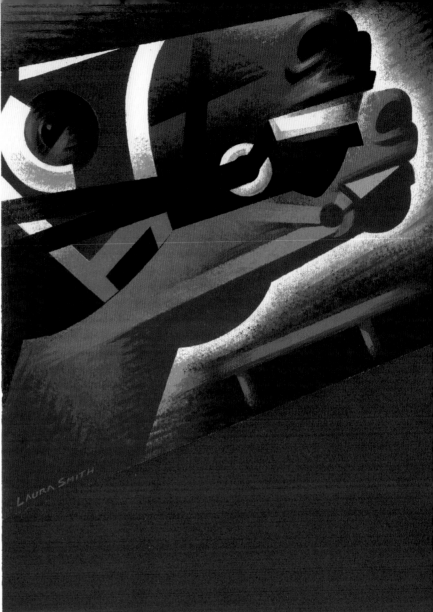

ABOVE RIGHT: LAURA SMITH

SEABISCUIT (2008)

Acrylic

The artist has taken her inspiration from the 1928 poster *L.M.S. Best Way* by Adolphe Cassandre. The delineation of the speed of the locomotive that Cassandre captured on his poster has here been transferred to the depiction of the racing

ABOVE LEFT: NICK GAETANO

SEAHORSE (1986)

Watercolour

An elegant colour sketch that imitates the distinctive Art Deco airbrushing technique via watercolours. The characteristic curved motion lines equally suggest both speed and water.

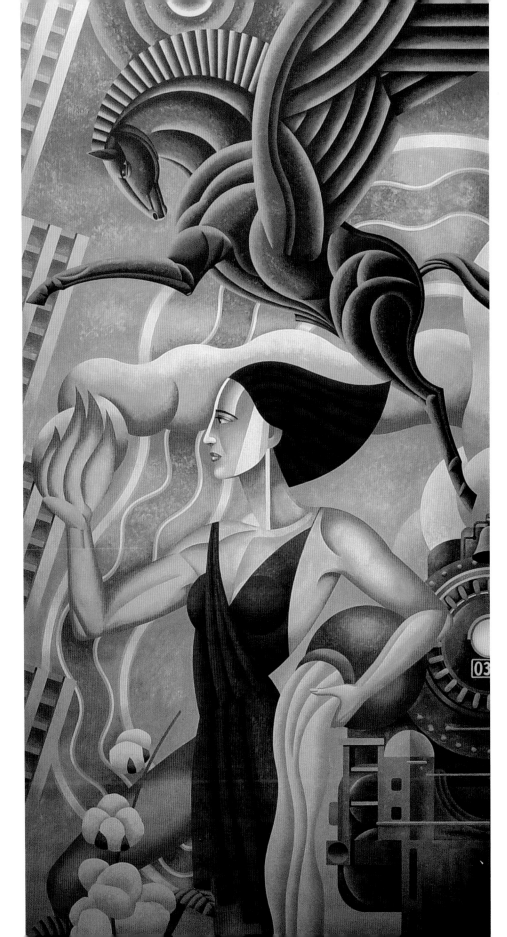

RIGHT: NICK GAETANO

DALLAS RISING (2003–2004)

Acrylic

A large painting for the lobby of a luxury loft building that took its inspiration from the Art Deco Fair Park in Dallas, Texas. Restored in 1936, for the Texas Centennial Exposition, by architect George Dahl (1894–1987), the 277-acre complex offers a unique display of architecture, statues and frescos.

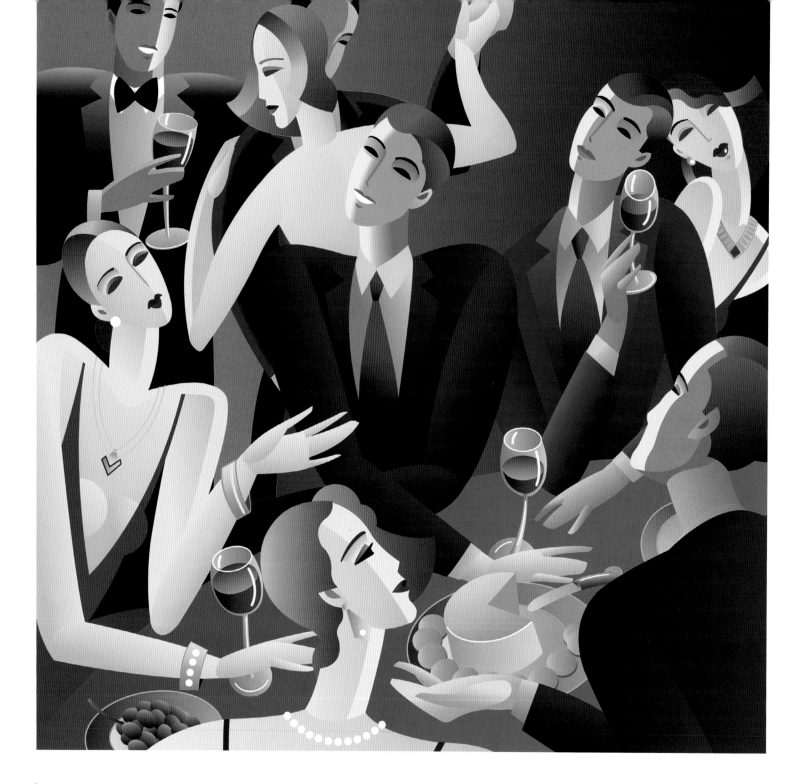

ABOVE: **NICK GAETANO**

DECO PARTY (1996)

Adobe Illustrator

A response to a stationery commission that invokes the extravagance and sophistication of 1930s glamour. There is a lessened detailing

throughout the scene and the figures are digitally airbrushed to reduce them to Art Deco geometric shapes.

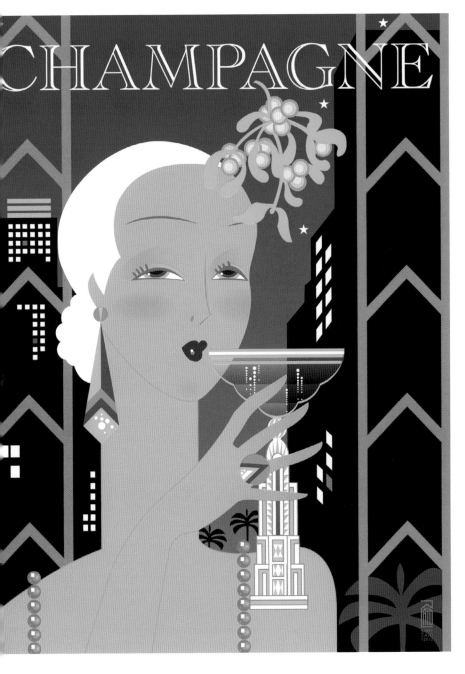

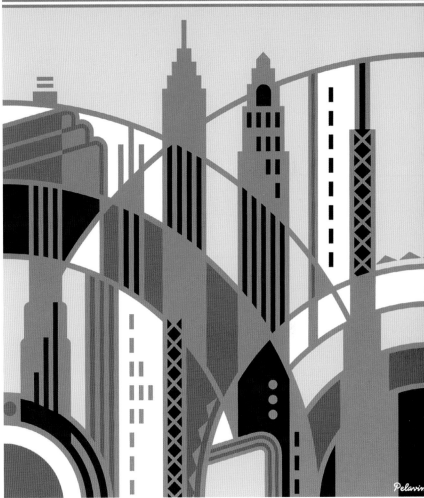

ABOVE: **BARRY ZAID**

CUISINE CHAMPAGNE (1972)

Gouache/Restored with Adobe Illustrator

The illustrator took his inspiration from a 1923 folio of pochoir prints by Georges Barbier (1882–1932) for this commissioned cover by New York Magazine. The strong vertical lines and the reduction of detailing are all part of the Art Deco lexicography of design and heighten the sophistication of the scene.

ABOVE: **DANIEL PELAVIN**

MANHATTAN 45 (1985)

Pre-separated mechanical art

Typical Art Deco geometrics articulate the glory of Manhattan as the ultimate city of the Machine Age using generous sweeping motifs that suggest the allure and extravagance of city life in 1945.

LEFT: JEFF FOSTER

MELVYN EINSTEIN (1999)

Airbrush/Colour pencil/Watercolour

A fun Art Deco commission for
Sandstrom Design, Portland
Oregon that complements the skills
and techniques of the original period
given that it would have been created
by hand rather than by computer.

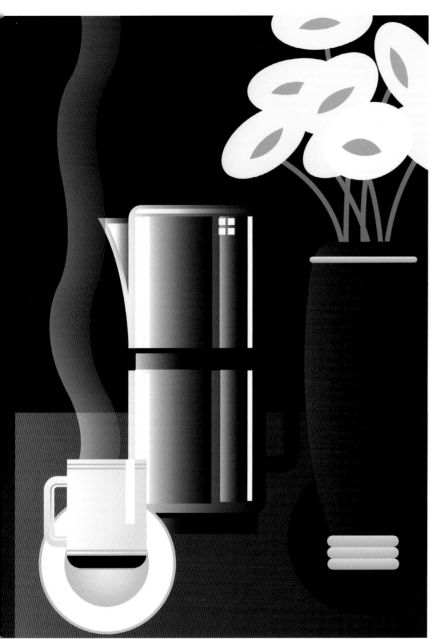
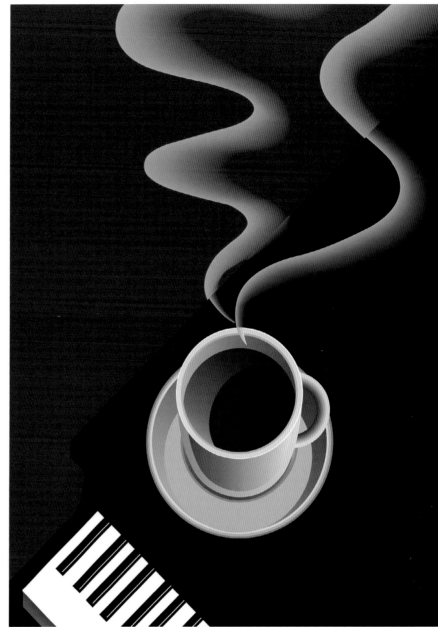

ESPRESSO (1998) & COFFEE (1997)

Adobe Illustrator

These two illustrations follow the Art Deco trait of selling more than just the product. They instantly promote a simple drink as part of a desirable lifestyle. The characteristically reduced detailing of the objects imbues them with an appealing elegance.

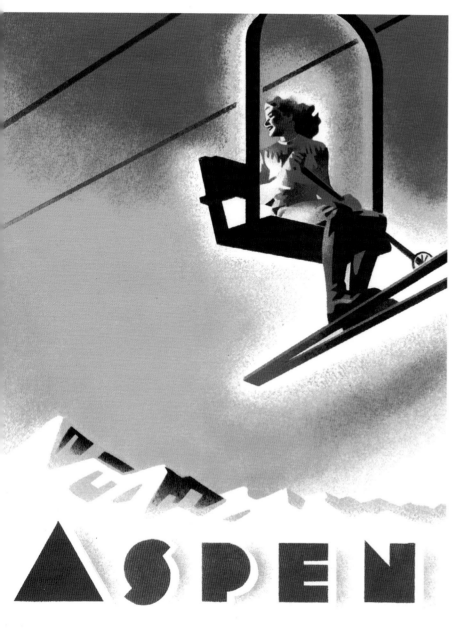

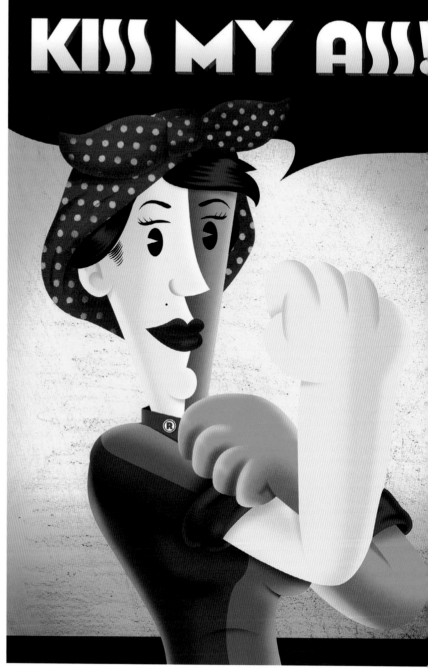

ABOVE: **LAURA SMITH**

ASPEN (2008)

Acrylic

This illustration was inspired by the often-imitated style of Austrian poster artist, Joseph

Binder (1898–1972), who used the simplest of geometrics in his compositions to develop

an approach that helped shape the pictorial graphic look of Art Deco.

ABOVE: **ROBERLAN BORGES PARESQUI**

ROSIE THE RIVETER – KISS MY ASS (2011)

Adobe Freehand/Adobe Photoshop

A spoof digital rendition of the famous *Rosie the Riviter* poster designed in 1942

by J. Howard Miller (1918–2004). The original 'We Can Do It!' slogan has been

replaced to offer a more contemporary message.

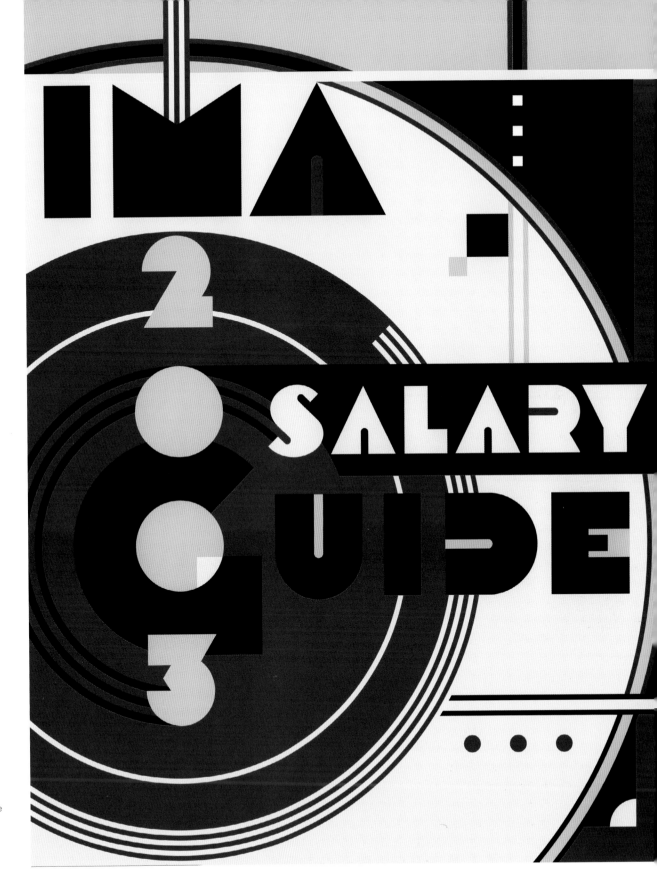

RIGHT: **DANIEL PELAVIN**

IMA SALARY GUIDE (2004)

Adobe Illustrator

A magazine cover that magnifies type into Art Deco geometric symbols that also mimic the vertical lines of the period's architecture.

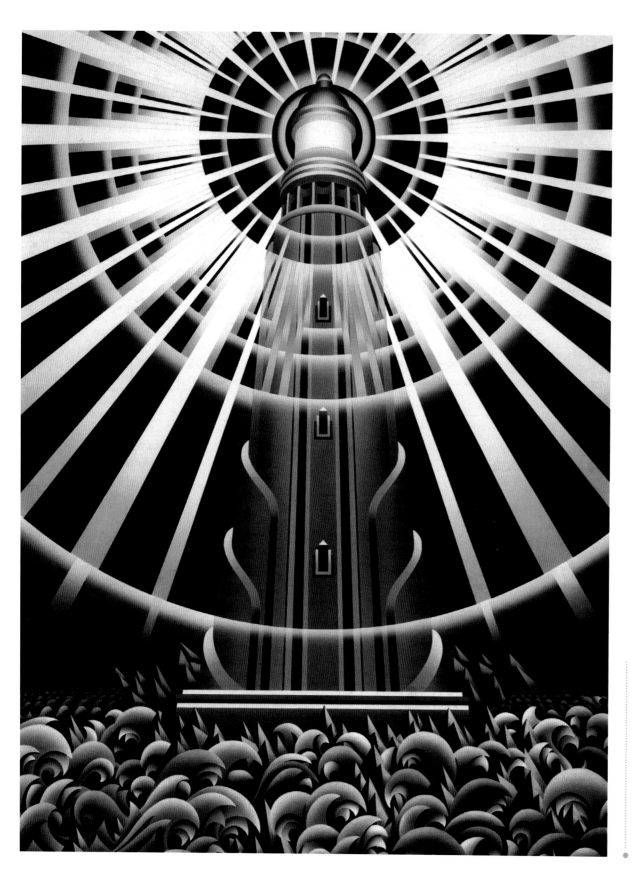

LIGHTHOUSE (1990)

Airbrush/Gouache

An image prepared for a
pharmaceutical company that uses a
representational lighthouse as a symbol
for their drug. The image is made up
from typical strong Art Deco geometric
shapes and lines and takes advantage
of the usual sunburst motif to signify the
healing light from the lamp tower.

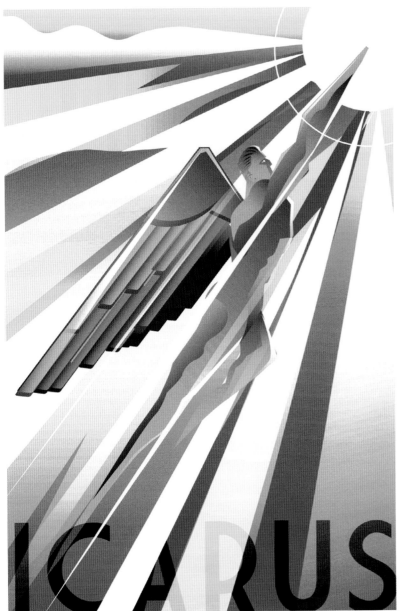

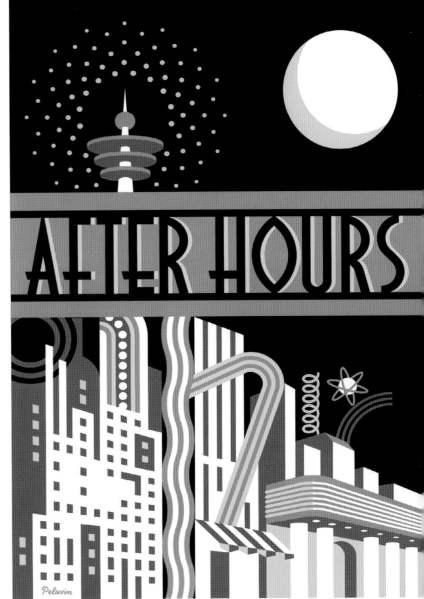

RODOLFO REYES

ICARUS TOWARDS THE SUN (2010)

Adobe Illustrator/Adobe Photoshop

This is part of the artist's Mythological Collection of digital illustrations. The simplified shaping of the tragic figure of Icarus flying into a dazzling sun of reduced geometric rays takes advantage of typical Art Deco motifs.

DANIEL PELAVIN

AFTER HOURS (1996)

Adobe Illustrator

An entertainment guide illustration that moderates an urban landscape to Art Deco geometric patterns. The elongated typeface is typical of its appearance during the period.

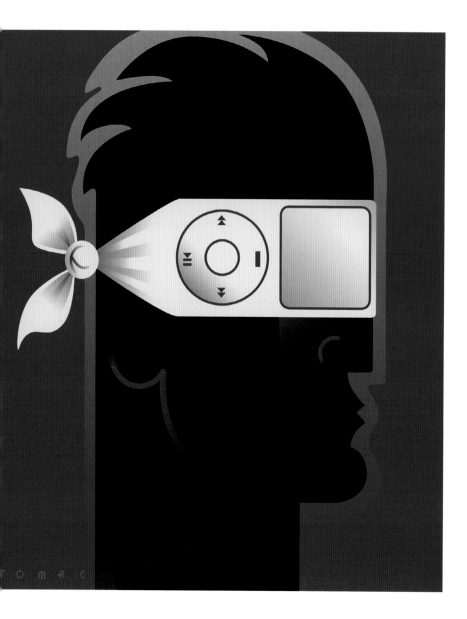

THE FUTURE IS RISING

ABOVE: **JOHN W TOMAC**

IGNORE (2010)

Adobe Illustrator

This digital illustration makes use of a blindfolded profile to comment on the oblivion of today's iPod-wearing joggers to anyone else other than themselves. Its shadowed outline reiterates the bas-relief sculptures by Art Deco artist, Eric Gill (1882–1940).

ABOVE: **RODOLFO REYES**

FUTURE IS RISING (2009)

Adobe Illustrator/Adobe Photoshop

The illustrator has vividly brought to life the creation of a robot by using the strong vertical lines and lightning flashes of the Art Deco period. Its imposing elevation is reminiscent of the statue of Christ the Redeemer in Rio de Janeiro, one of the largest Art Deco statues in the world.

RIGHT: RODOLFO REYES

MUSEO MEXICANO (2010)

Adobe Illustrator/Adobe Photoshop

Produced for a competition at
the Mexican Museum of Design,
this poster imports their national symbol
of an eagle clutching a
snake into a powerful Art Deco
landscape of geometric shapes
and airbrushed surfaces.

> You have to systematically create confusion, it sets creativity free. Everything that is contradictory creates life.
>
> **Salvador Dalí**

S U R R E A L I S M

When it comes to Surrealism it's all in the mind. Officially founded in 1924 when André Breton, who was celebrated as the 'Pope of Surrealism', wrote his First Surrealist Manifesto – *Le Manifeste du Surréalisme*. It was the century's most organized artistic movement and is now recognised as the most influential artistic movement of the 20th century.

With their love of the incongruous, the Surrealists set about breaking every rule in the book. They created absurd eye-grabbing visuals by juxtaposing mundane objects into disturbing metaphoric compositions that were both puzzling and disturbing. A development from Cubism and Dada, the Surrealists sought to unlock the power of imagination by articulating the weird and the fantastic. Surrealist artists were divided into two distinct groups: Automatists, who created abstract, non-representational organic forms, and the Veristic (or representational) Surrealists who depicted the dream world of the subconscious.

Their impact was not just restricted to the world of avant-garde art. Involvement with fashion (Elsa Schiaparelli), photography (*Vogue* and *Harper's Bazaar*), advertising (Shell and Ford) and cinema (Luis Buñuel and Alfred Hitchcock) helped to style the popular culture of the day.

Salvador Dalí (1904–1989) was the best-known practitioner of representational Surrealism. He made his first Surrealist paintings in Paris in 1929 and employed Freudian symbols to create a totally new visual language. His eccentric 'liquid shapes' trademark have secured him artistic immortality.

(1924 – LATE 1966)
JEAN ARP • SALVADOR DALÍ • MARCEL DUCHAMP • MAX ERNST • RENÉ MAGRITTE • JOAN MIRÓ • MAN RAY • PIERRE ROY • YVES TANGUY

DANNY CASTILLONES SILLADA

THE FLIGHT OF JANET (2006)

Oils

The artist has drawn upon a personal loss with this abstract Surrealistic treatment of his feelings and emotions that juxtaposes unexpected objects in the symbolic manner of Giorgio de Chirico (1888–1978).

LARS JULIEN MEYER

THE MASK OF IRAHS (2008)

Pen & ink/Photography/Adobe Photoshop

Surrealists concerned themselves with a direct expression of the unconscious mind rather than the lack of instant comprehension by the viewer. Surrealist artists were heavily influenced by the findings of Sigmund Freud (1856–1939) and Carl Jung (1875–1961) into psychoanalysis and the interpretation of dreams.

MAXIM MITENKOV

WARMING (2008)

Adobe Photoshop

The cycle of time represented here became an important metaphor in surrealist art. *The Persistence of Memory* (1931) was the painting that introduced Salvador Dali's often-imitated image of the melting pocket watches. The accuracy and reality of the objects in this digital illustration make the overall composition all the more enigmatic.

RIGHT: **STEVAN JACKS**
WHERE RAINBOWS BLEED OIL
(2009)
Oils

A turbulent surrealist illustration that uses memory and folklore to express the artist's concern for the environmental changes that consumerism and greed are placing on the planet.

ABOVE: **JÜRGEN GEIER**

CONQUEST OF PARADISE (2004)

Oils

The artist rose to the challenge of painting this surreal metal body after working on the construction of a steel schooner.

Relishing different working methods, he eventually supported the metal torso on slender stalks in similar guise to Salvador Dalí's

1937 painting, 'Sleep' commissioned by his then patron, Edward James (1907–1984).

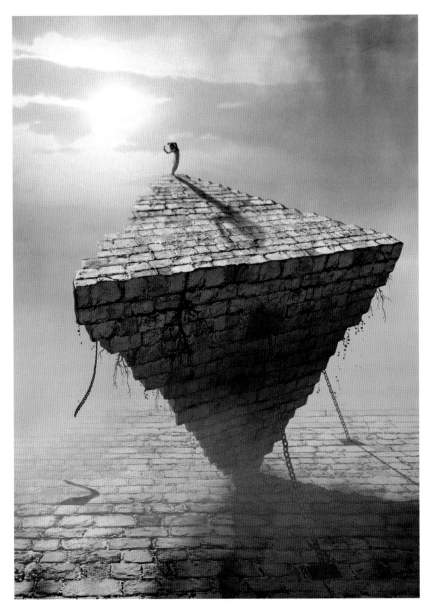

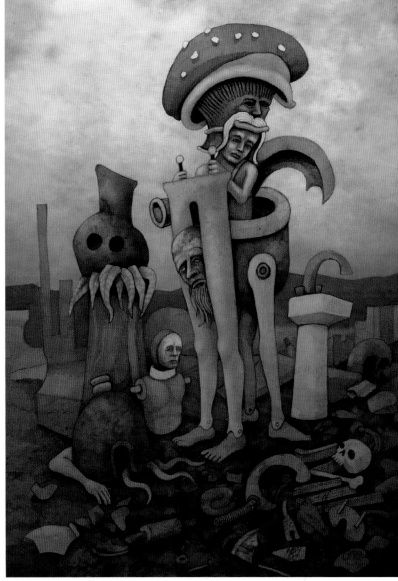

ABOVE: **MAXIM MITENKOV**

BALANCED ON THE EDGE (2008)

Adobe Photoshop

Because of his skilled technical ability and visual precision, Salvador Dalí repeatedly referred to his paintings as 'hand-painted dream photographs'. Today's digital software, as used here, is also able to bring a disquieting realism to the dreamlike.

ABOVE: **DAVID WHITLAM**

SMALL STEPS FORWARD (2009)

Adobe Photoshop

The artist has based this digital illustration around a previous sketch using the technique of automatic drawing as devised by the Surrealists to express the subconscious. Identified by André Masson (1896–1987) in his Manifeste du Surréalisme published in 1924, the practice was soon taken up by both Salvador Dalí and Joan Miró.

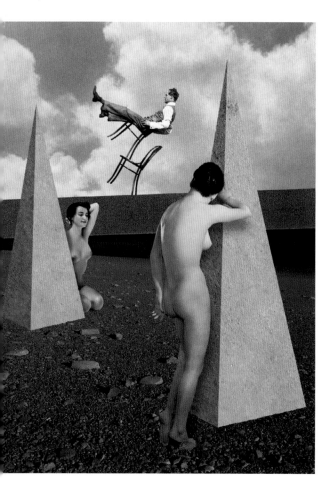

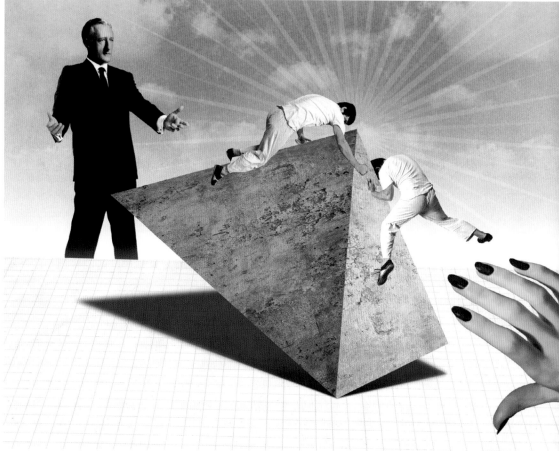

REVERSING THE MAGNETIC POLE (2010)

Adobe Photoshop

The Surrealist painters used architecture as a means of disorientating the viewer by its questionable appearance as depicted here. Shadows were often applied to add further confusing realism within the composition. Pyramids with deep shadows are the subject of Salvador Dalí's 1954 painting, 'The Pyramids and the Sphinx of Gizeh'.

CEREMONY (2010)

Adobe Photoshop

The realism of the imagery in this digital montage enhances the feeling of unease within the irrational composition. The illustration is typical of the Veristic school of Surrealism with its puzzling insertion of disassociated imagery.

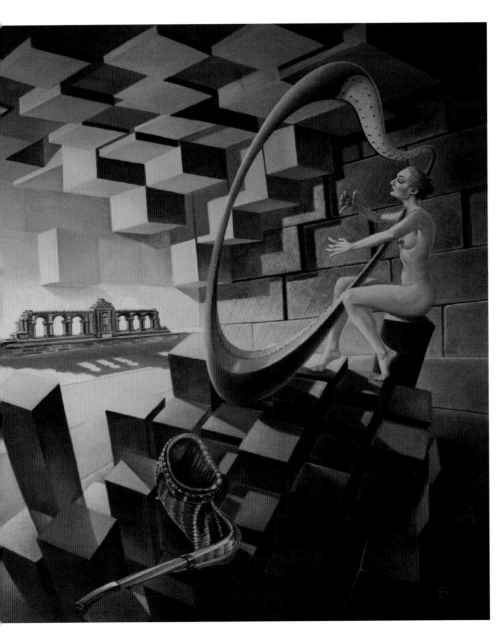

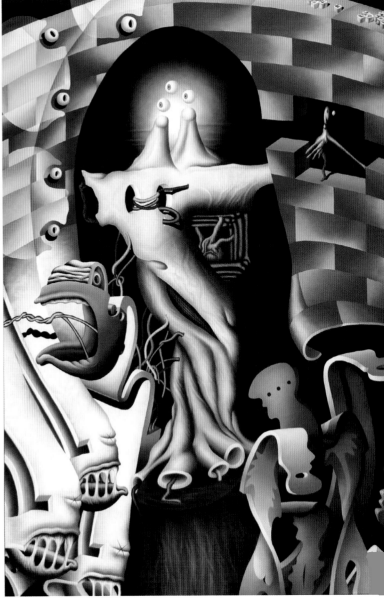

RUSS REVOCK

CONSIDERING THE MINISTER OF EYES (2007)

Alkyd/Oils

The use of ambiguous anatomical forms is akin to those Surrealists artists who toyed with the viewer by hinting at

a human presence rather than giving it a literal representation within the actual composition.

GYURI LOHMULLER

JERICHO ECHO (2011)

Oils

This image uses a surrealist language to present an allegory based upon the Bible story of the Israelites bringing down the Walls of Jericho by

the sound of their trumpets (Joshua 6:20). The elements within the composition are all symbolic of perseverance of the spirit.

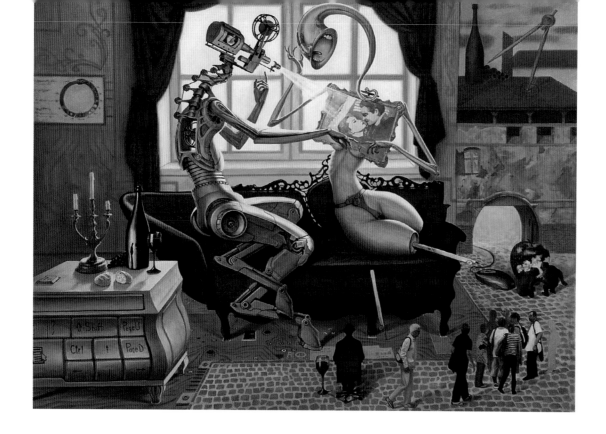

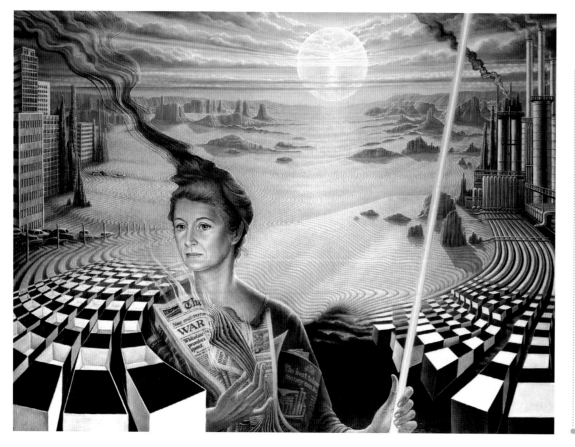

ABOVE LEFT: ADRIAN BORDA
THE FORBIDDEN SPARK (2008)
Oils

The voyeurism repeated within this
painting is an intentional subtext of
its sexual narrative. In his autobiography,
Salvador Dalí confessed to being a
child obsessed with voyeurism and
autoeroticism.

LEFT: BRIGID MARLIN
THE ROD (1978)
Mische technique (oil and egg tempera)

This is an attempt by the artist to realise
her own interpretation of the struggles
and conflicts of Life by using the symbolic
language of the Surrealists. The
metaphorical desert-like expanse echoes
similar barren landscapes in the paintings
of Salvador Dalí.

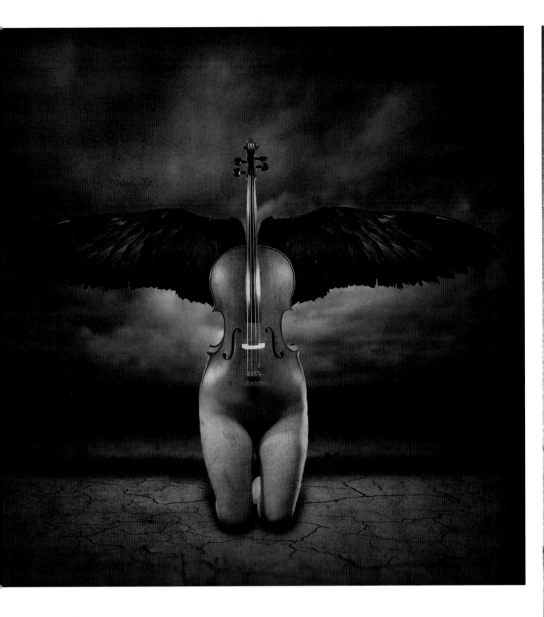

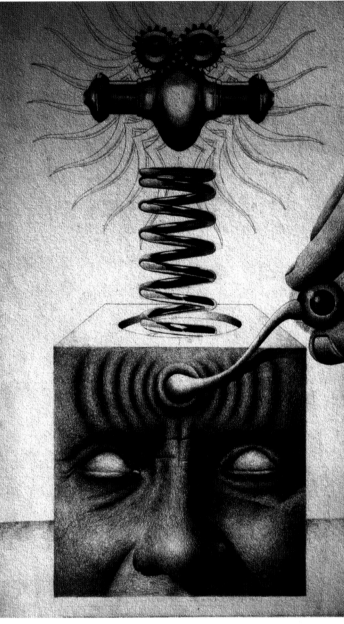

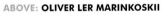

ABOVE: OLIVER LER MARINKOSKII

FAIRY (2009)

Adobe Photoshop

This photo-manipulation was inspired by the Polish surrealist artist, Zdzisław Beksininski (1929–2005) who famously worked while listening to classical music. He is best known for his disturbing dreamlike paintings, described as his 'fantasy period', that he executed with the clarity and precision of photography.

ABOVE RIGHT: ADAM PINSON

CRANK (2010)

Coloured pencil

The artist has embraced the language of the Surrealists to help portray a friend who is always full of surprises. The jack-in-the-box metaphor seems to support Salvador Dalí's assertion that 'people love mystery, and that is why they love my paintings'.

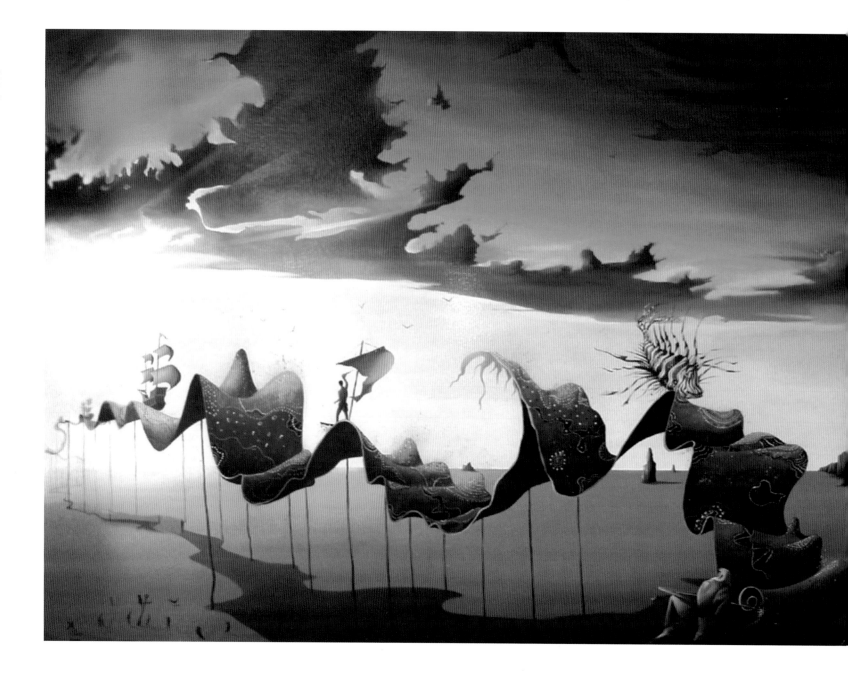

ABOVE: **STEVAN JACKS**

THE SEA GHOST (2008)

Oils

The artist uses his own distinctive style to import the Australian landscape into this surrealistic

dreamscape using a dramatic blood red sky that also takes its inspiration from Claude

Monet's *Impression, Sunrise* of 1872.

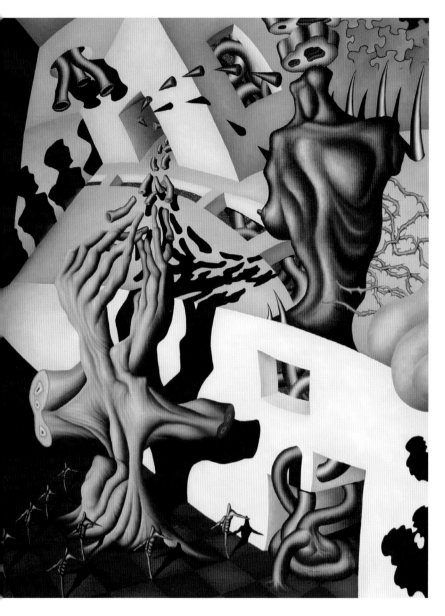

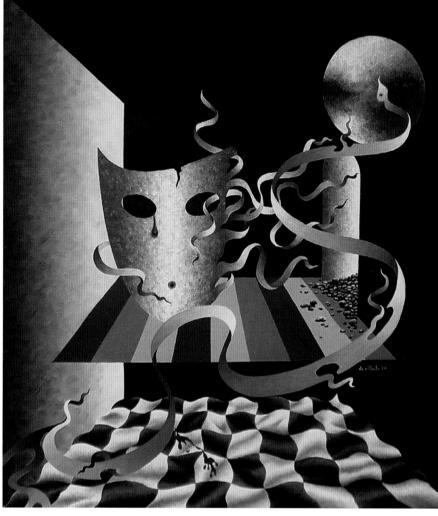

ABOVE: **RUSS REVOCK**

A MIDSUMMER'S NIGHTMARE OF A DREAM COME TRUE (2000)

Alkyd/Oils/Acrylic

This painting exploits both biomorphic and architectural ingredients in the same symbolic manner that the Chilean artist, Roberto Matta (1911–2002) and Spanish Catalan painter, Joan Miró (1893–1983) used in their surrealist compositions.

ABOVE: **DANNY CASTILLONES SILLADA**

CECILIA'S RED TEARS (2006)

Oils

This painting is a Surrealist theatrical assemblage symbolising the suffering of women under the domination of men. The poignant falling tears of blood are the artist's intentional metaphor to create dramatic tension set against a monochromatic canvas.

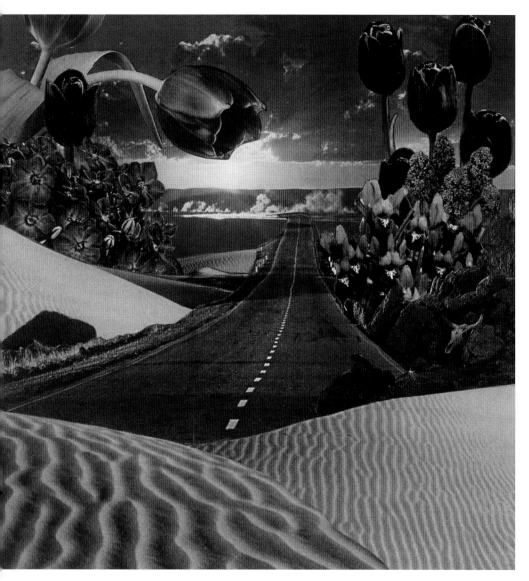

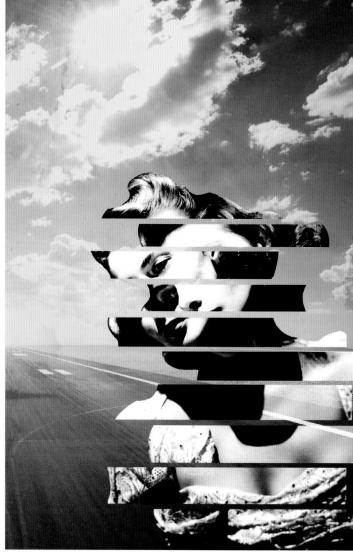

THE ONLY WAY (2004)

Collage

This symbolic surreal landscape charts the passage of life from the spring of youth to the sunset of old age. The use of collage by the artist mimics the language of dreams in reassembling images from daily life into a warped perspective.

MORFOLOGÍA DE UN SUEÑO (2009)

Adobe Photoshop

The fragmentation of the female figure cut into slices echoes the opening sequence of the Salvador Dalí and Luis Buñuel (1900–1983) Surrealist silent movie *Le Chien Andalou* (1929) with its notorious close-up image of a razor slicing an eyeball.

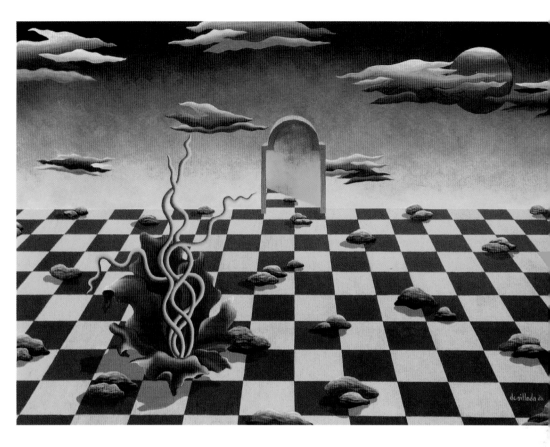

ABOVE RIGHT: DANNY CASTILLONES SILLADA

UTOPIA (2002)

Oils

A surrealistic landscape that the artist intended as a metaphor for the sublime state of beauty and harmony of his childhood memories of the Philippines. The duality of the viewpoint, offering both interior and exterior perspectives, is indicative of the ambiguity of Surrealism.

RIGHT: JÜRGEN GEIER

HELGOLAND (2003)

Oils

The artist gained inspiration for this seascape after watching the German island of Helgoland emerge on the horizon as he sailed towards it. By supporting the island out of the sea on Salvador Dalí's much-used 'crutches of reality' he inevitably evokes Surrealist symbolism within the composition.

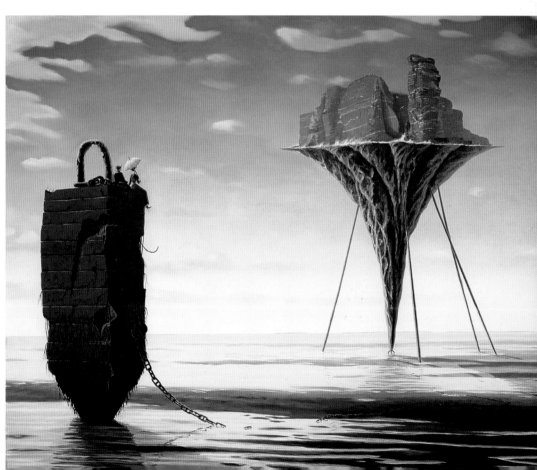

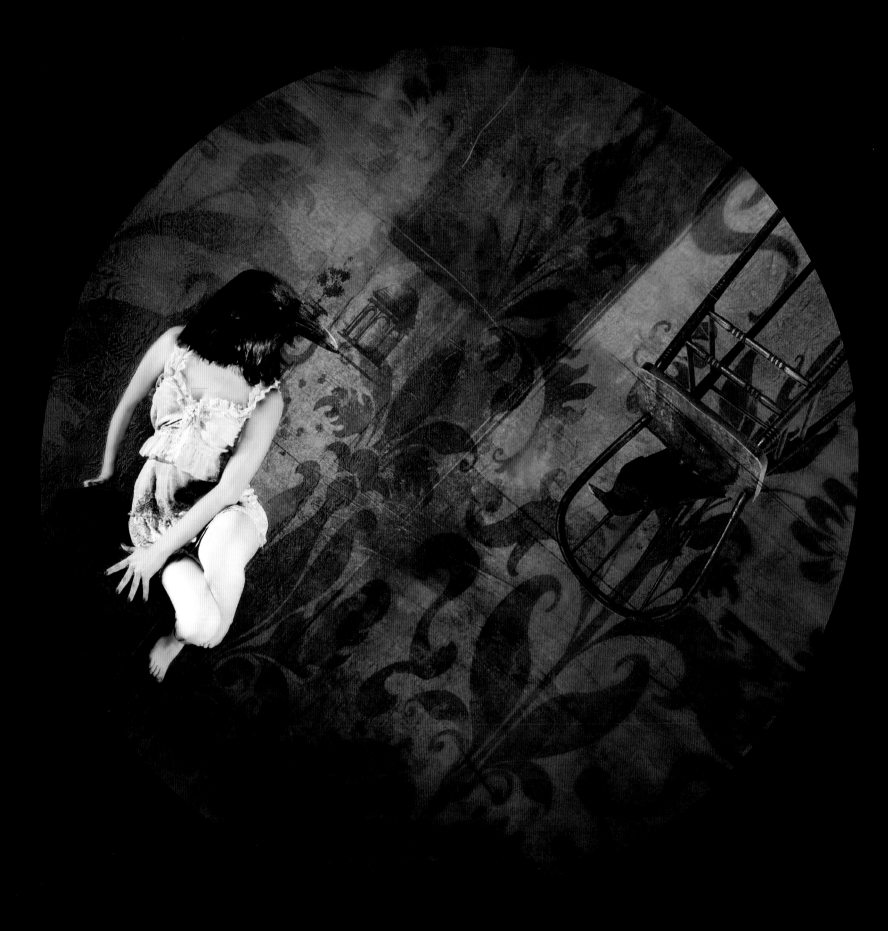

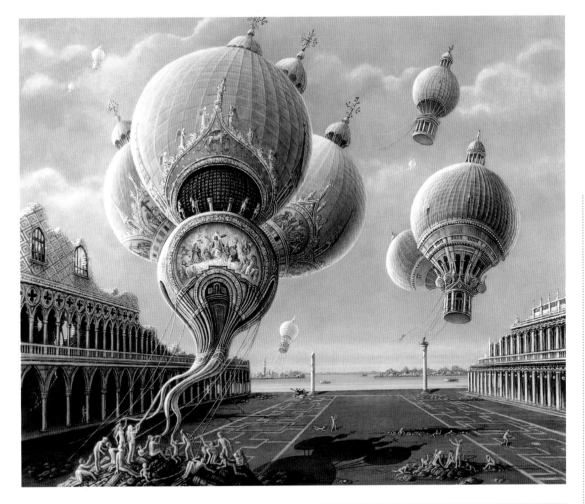

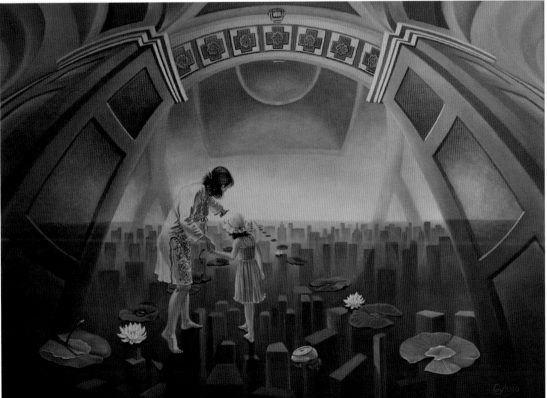

OPPOSITE PAGE:

MARIANA PALOVA
PRECIOUS DISTANCE (2009)
Adobe Photoshop

Taking the stories of Edgar Allan Poe
(1809–1849) as her starting point,
this illustrator has created a digital
photo-manipulation that employs a
Surrealist setting to express the equally
irrational nature of Poe's *Tales of
Mystery and Imagination*.

ABOVE LEFT: BRIGID MARLIN
FLIGHT OF CHURCHES (1999)
Mische technique (oil and egg tempera)

To convey the steady disappearance of
the old religions of the world the artist
has adopted Surrealist art's symbolism
and metaphors. The detailing within the
painting is typical of the Surrealist's trick
of using a photorealistic expression that
ultimately questions the viewer's
understanding of logic when contrasted
with the reality of the scene.

LEFT: GYURI LOHMULLER
JERICHO ECHO (2011)
Oils

By placing his own wife and daughter
within a surrealist landscape the artist is
attempting to express the current lack of
perspective in today's education of the
young. The limitless grey palette
becomes his metaphor for the uncertainty
of the future.

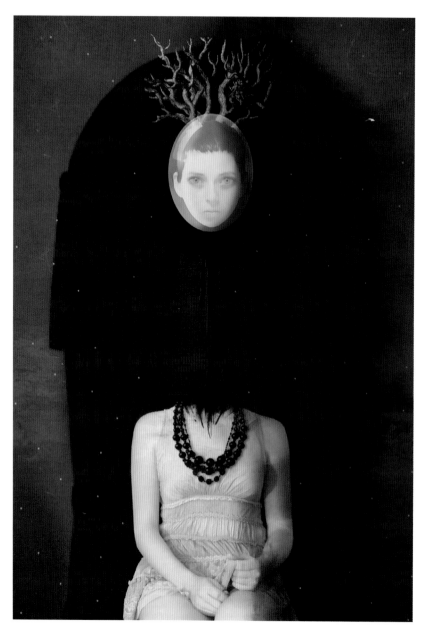

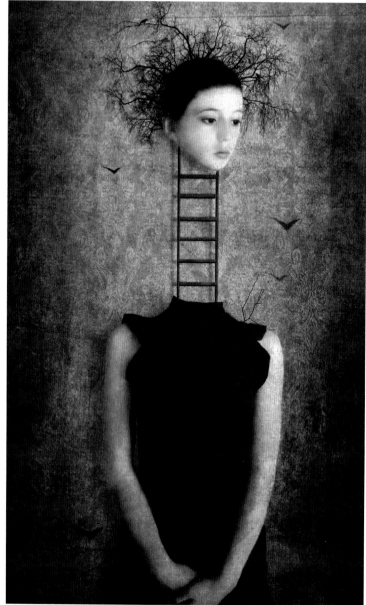

MARIANA PALOVA

THE WAIT AND THE NOOSE (2010) & SOGNATORE (2008)

Adobe Photoshop

These two digital illustrations use the hallucinatory language of the Surrealist's dream imagery to tap into the viewer's unconscious. They establish irrational situations that are chillingly expressed with the disturbing clarity and realism of photo-manipulation.

JULIEN PACAUD

CEREMONY (2010)

Adobe Photoshop

The disquieting image of a horizontally floating Victorian female in a non-Victorian landscape is typical Surrealist territory. The inverted pyramid shaped obelisk that hangs suspended over the body is like an alien dream catcher.

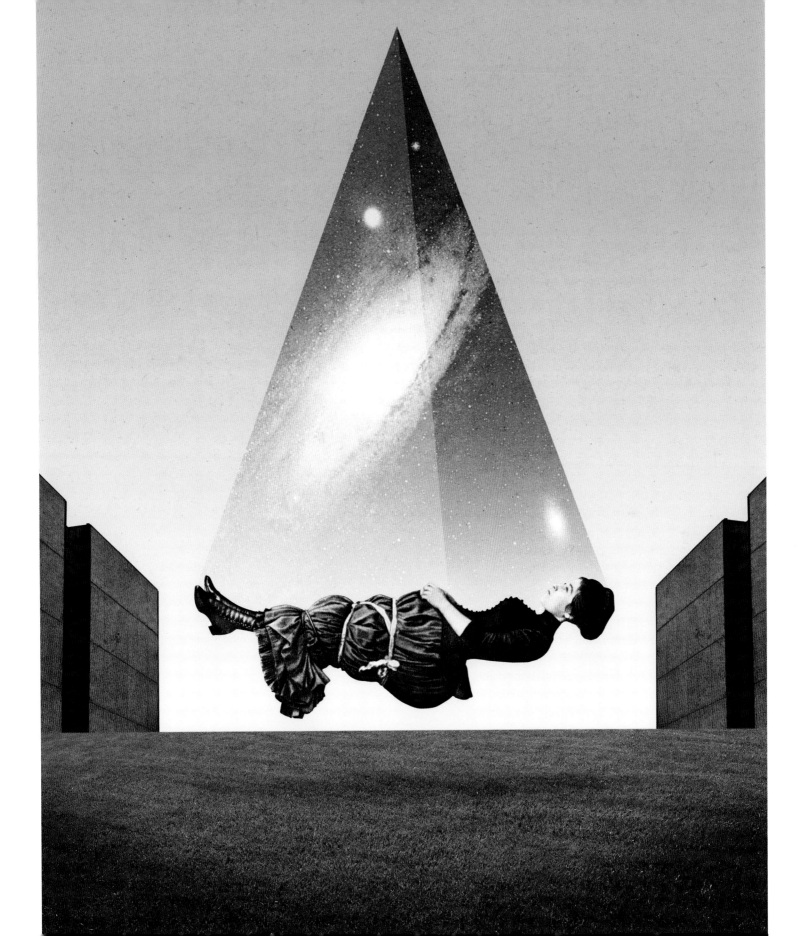

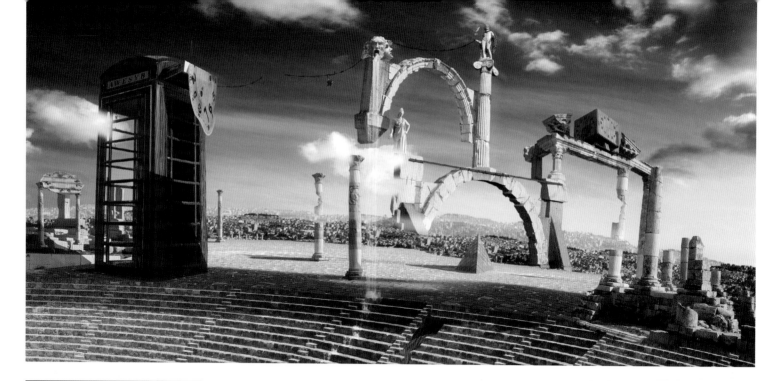

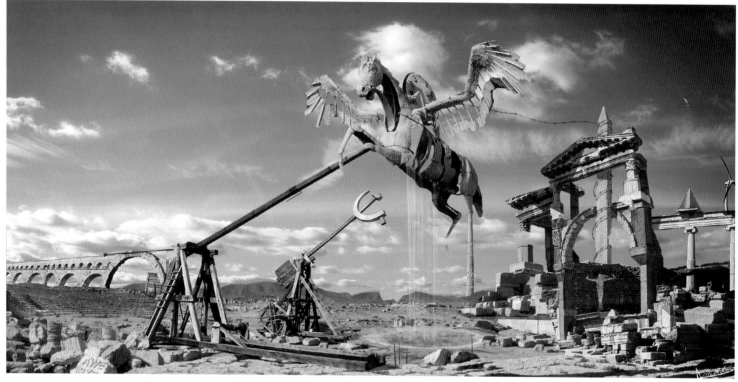

ABOVE, TOP & BOTTOM: **LARS JULIEN MEYER**

LE FOULARD ROUGE (2009) & ERDBEERKORBCHEN (2010)

Pen & ink/Photography/Adobe Photoshop

The artist has identified these two illustrations as examples of his own Digital Surreal Photorealism technique. As with most surrealist artists, he has taken his own inspiration from the irrational language of dreams. André Breton first extolled the artistic freedom to be gained by using dreams and the unconscious mind in *Le Manifeste du Surréalisme* of 1924.

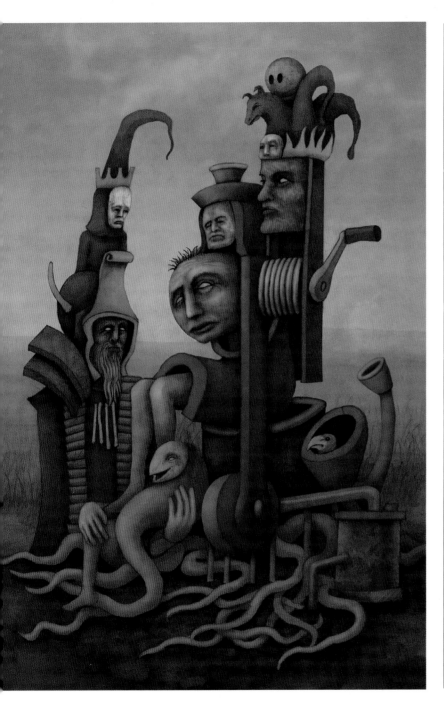

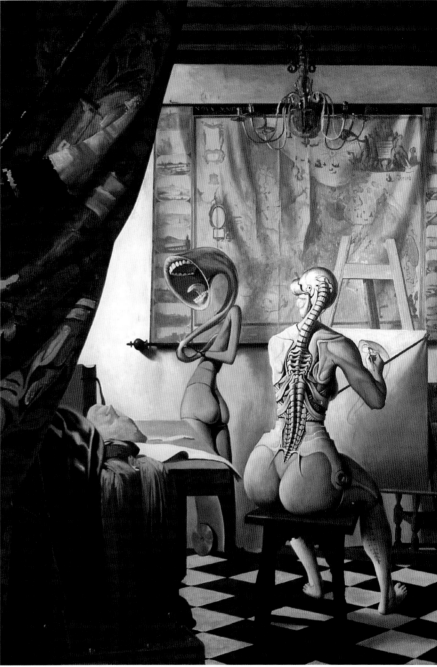

ABOVE: **DAVID WHITLAM**

A DIET OF WORMS (2008)

Adobe Photoshop

Taking his inspiration from Martin Luther's (1483–1546) justification against the charges of
heresy at the Diet of Worms in 1521, the artist has exploited the absurdist imagery of the
Surrealists to match his personal interpretation of historical events.

ABOVE: **ADRIAN BORDA**

THE ALLEGORY OF PAINTING (2007)

Oils

A modern surrealist re-vamp of Dutch painter, Johannes Vermeer's 1666 canvas that had
previously been the inspiration in 1934 for Salvador Dalí's *The Ghost of Vermeer of Delft
Which Can Be Used As A Table*.

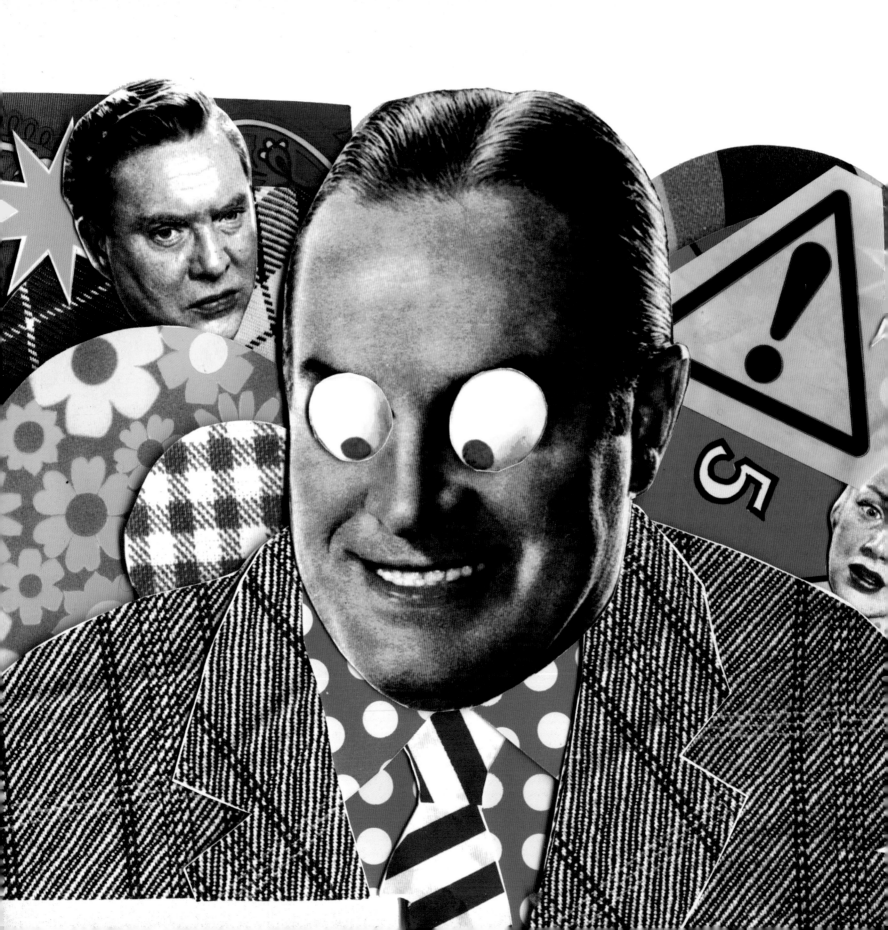

50s AMERICANA

After the radicalism of the Surrealists, 1950s America saw a return to conservatism and homespun family values. The end of World War II secured a new optimism that generated a nationwide boom in consumerism.

The decade is best remembered not by the art it produced but from a popular design style as eye-catching as any Art Deco travel poster or Dalí melting clock. Its approach was predominantly clean-cut and minimal in an attempt to erase the recent past. As affordable mass-produced housing sprang up, suburbia was born, and women exited their wartime factory jobs to return home as the apron clad matriarchs of domestic security.

With more leisure time than ever, escaping to pursue 'The Dream' became the norm: vacationing at the new Disneyland resort; shopping in the vast shopping malls; watching drive-in movies; cheering a sports teams to victory or watching the skies for flying saucers.

The 50s were also the Golden Age of American television. The medium took over from both theatre and cinema as the principal form of popular entertainment. Vaudeville was reinvented into X-Factor styled TV variety shows. While younger family members played with Barbie Dolls and wore Davy Crockett raccoon skin hats, teenagers came of age during the decade with the arrival of idols like James Dean and Elvis Presley who caused an overnight sensation.

HOT-RODS • DINERS • KINSEY REPORT • HULA HOOPS • TV ADVERTISING • MICKEY MOUSE CLUB • THE COLD WAR • ROCK 'N' ROLL • EXPLORER SATELLITE • DRIVE-IN MOVIES • TAIL-FINNED CARS

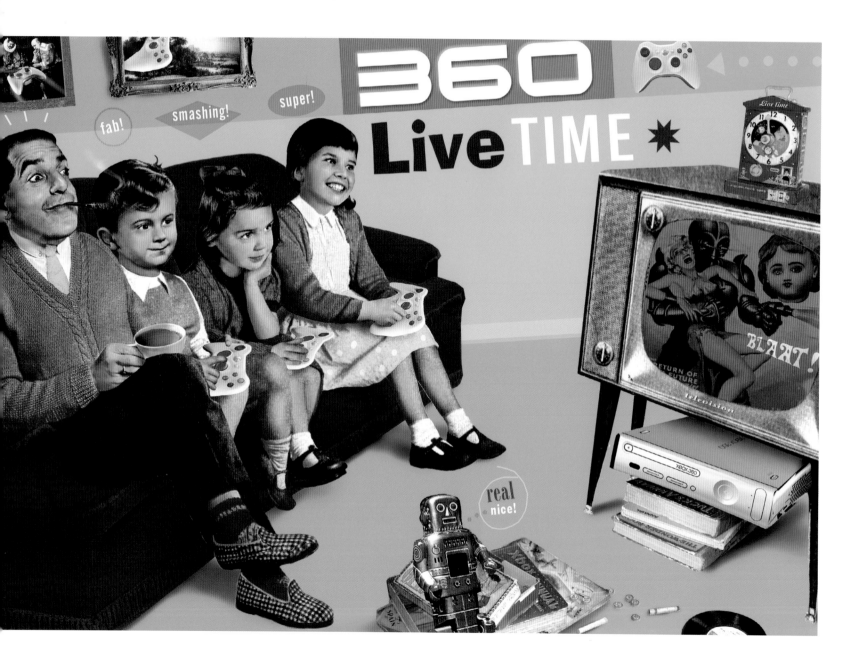

PREVIOUS PAGE: **PETER QUINNELL**

CLASHING TIE (2010)

Collage/Adobe Photoshop

A commission for *GQ* magazine's Styleshrink Letters Page, this digital assembly celebrates the buffoonery of American comedic actor, Bob Hope (1903–2003) in a fifties TV games show skit about wearing clashing colours.

ABOVE: **MARC ARUNDALE**

IT'S BRAND NEW! (2000)

Adobe Photoshop

A commission for a gaming console that recognises the invasion of television into the home in the 1950s. With the increase in leisure time, watching TV became a new domestic pastime with a steady escalation in participation programmes aimed at the entire family.

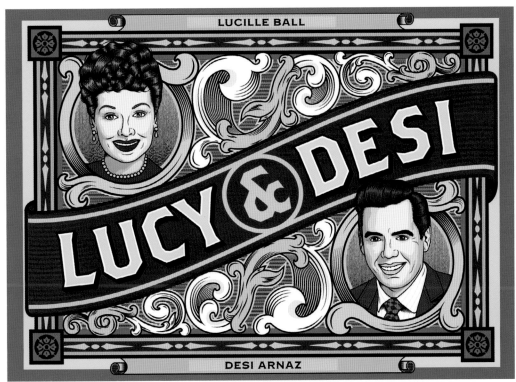

ABOVE: MARTY GORDON
THE DEADLIEST CATCH (2009)
Collage

The artist built up this collage from typical fifties retro imagery. The interior decor is typically retro fifties in its clean-cut and minimal treatment.

LEFT: ROBERLAN BORGES PARESQUI
LUCY & DESI (2009)
Adobe Illustrator

Husband and wife stars, Lucille Ball (1911–1989) and Desi Arnaz (1917–1986) are here rebranded in the style of old cigar boxes. The duo gained international fame during the 1950s with their American sitcom *I Love Lucy* which dominated TV ratings from 1951 to 1960.

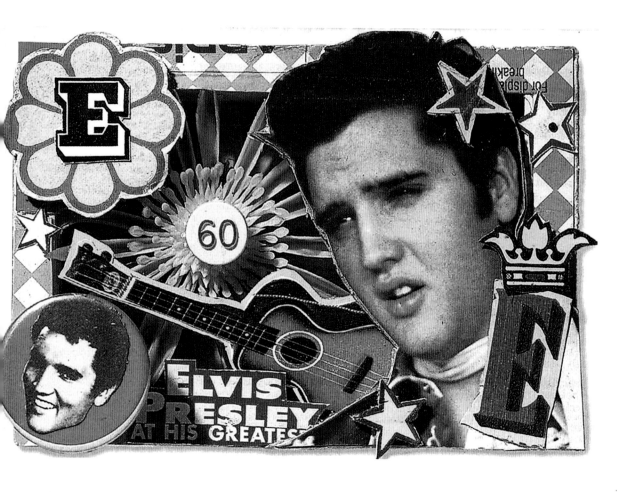

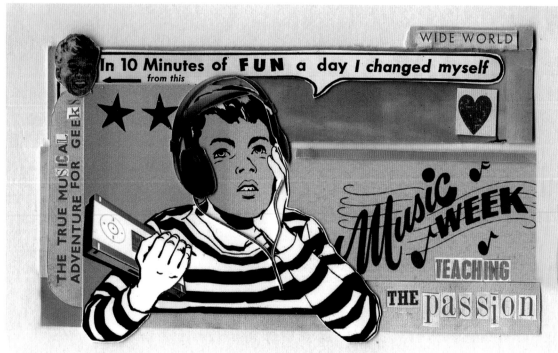

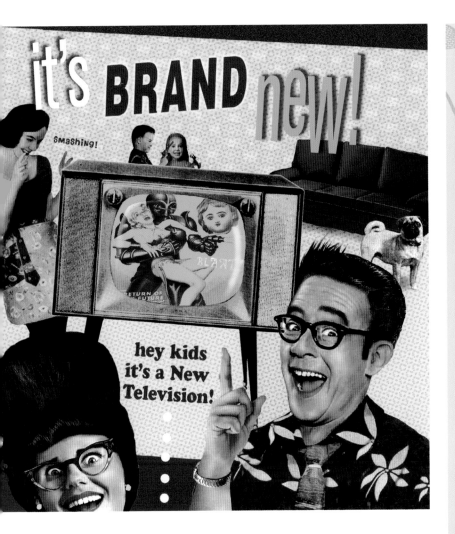

it's BRAND new!

smashing!

RETURN OF FUTURE

BLAST

hey kids
it's a New
Television!

GRANITE GIGS
"SOUNDS OF SUMMER" 2008

Country Sunshine Friday 6/6

NRG Krysys Friday 6/13

Cashmere Jungle Lords Friday 6/20

Day Of Mirth Saturday 6/21 (11am - 9:30pm) w/ Bio Ritmo
Billy Ray Hatley + the Showdogs, The Demi Johns, OPM, plus Kids' Karaoke.
Extended pool hours for this evening.

The Big Payback Friday 6/27

Antero Friday 7/11

No BS Brass Band Friday 7/18

Blue Line Hwy Friday 7/25

Reggae Day 8/3
All Day

Typical show times will
be 6pm - 8:20pm

Stereo
HI-FIDELITY

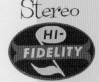

"IT SOUNDS LIKE NO OTHER POOL..."

ABOVE: **MARC ARUNDALE**

FAMILY TV TIME (2006)

Adobe Photoshop

The artist has exploited the then new medium of television in this crazy pastiche
commissioned for an editorial feature that exaggerates the typical facial expressions of 50s
advertising through its heightened vibrant colouring.

ABOVE: **BOB SCOTT**

SOUNDS OF SUMMER (2004)

Adobe Photoshop

This poster for a series of summer concerts at a community pool uses the tones of 1950s
Atomic Age design intermixed with the playfulness of summer beach parties and vinyl LP
sleeve typography.

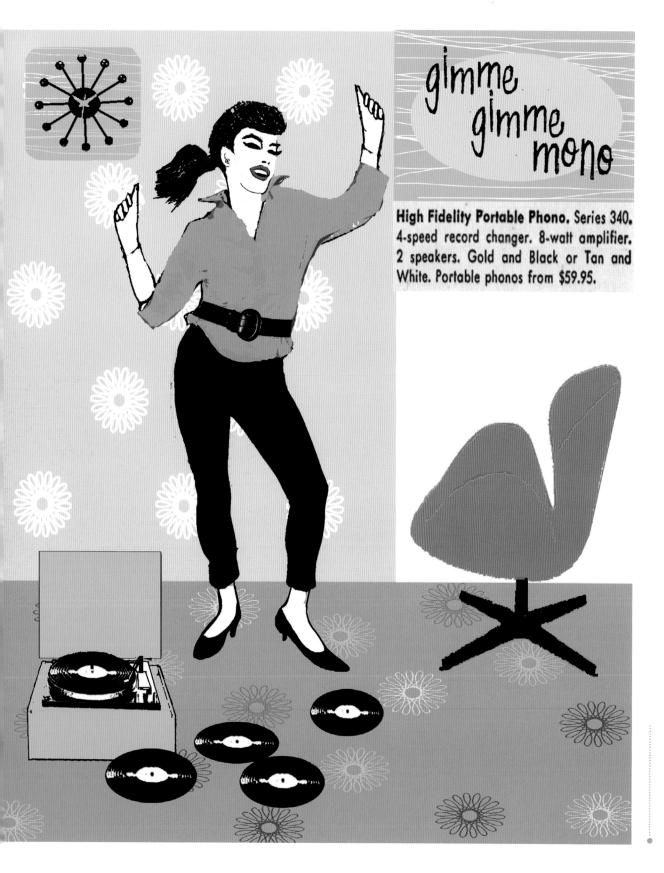

gimme gimme mono

High Fidelity Portable Phono. Series 340. 4-speed record changer. 8-watt amplifier. 2 speakers. Gold and Black or Tan and White. Portable phonos from $59.95.

RIGHT: MARTY GORDON

PARADISE LOST (2008)

Collage

American home life in the fifties centered around television and its family orientated programming. The transition from broadcasting in black and white to colour began in 1954. The world depicted on the TV screen was often received as the accepted norm by most American families despite its obvious lack of anchorage in the real world.

BELOW: LORNA SIVITER

THE FIFTIES (2009)

Adobe Photoshop

The coolness of two tone, tail-finned cars and the prospect of future space travel were part of the American Dream in the fifties. Both were representative of the prosperous outlook of the age.

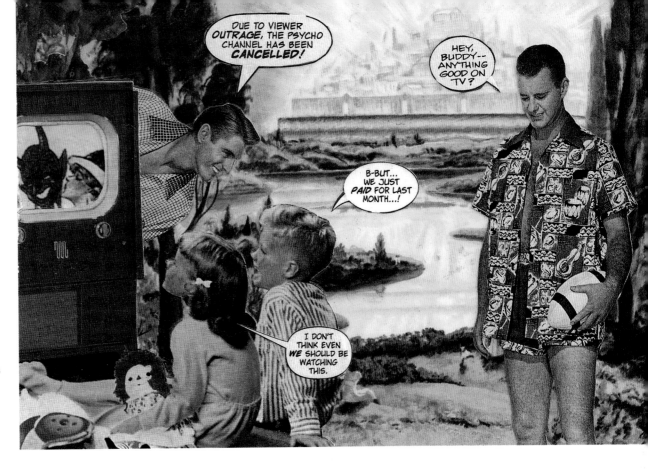

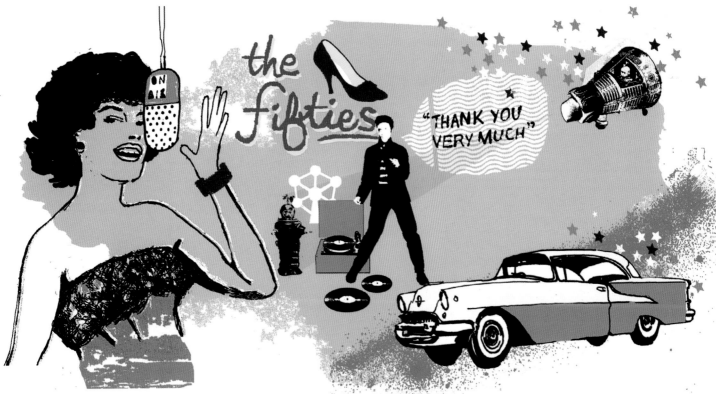

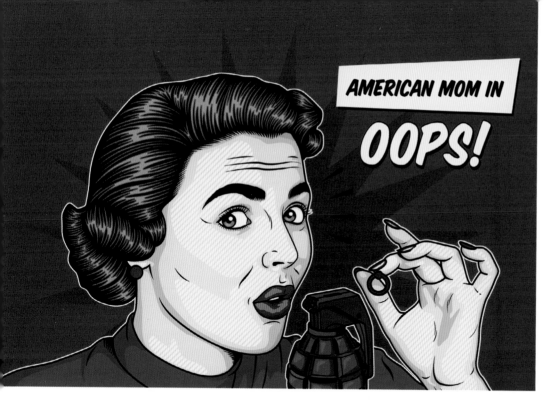

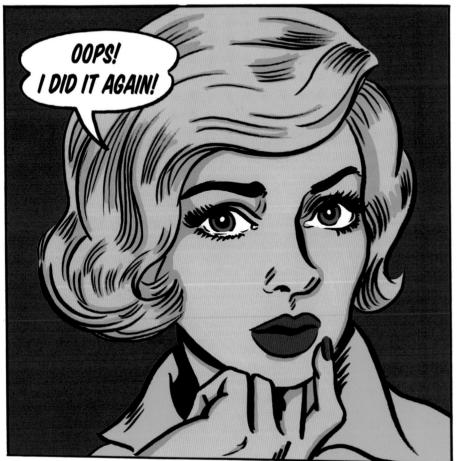

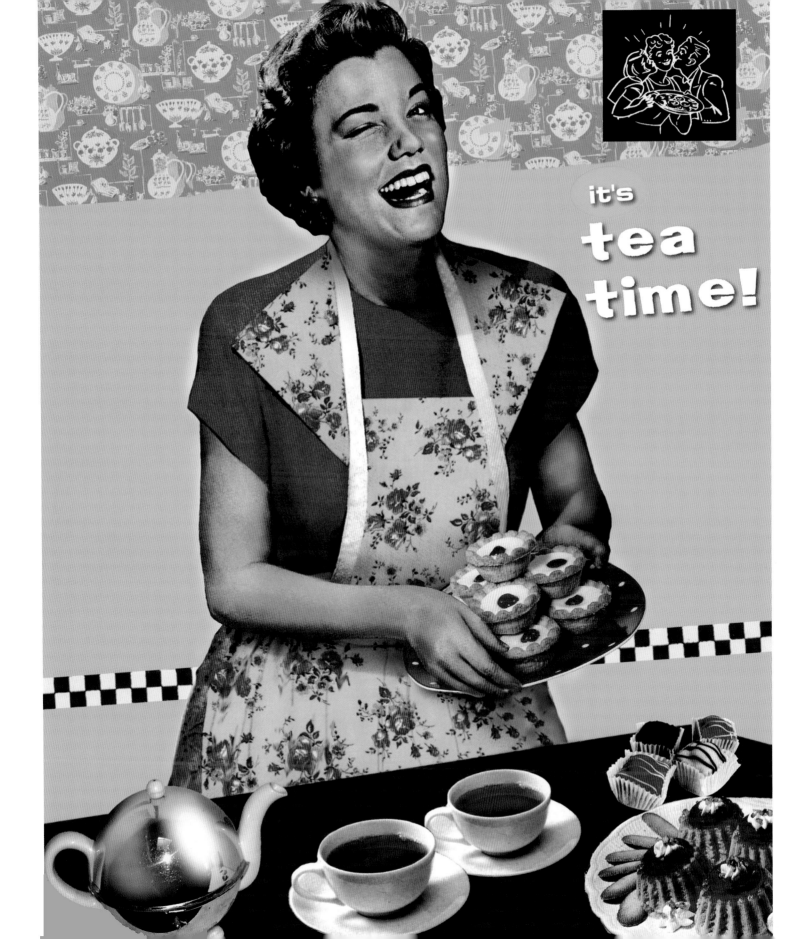

it's **tea time!**

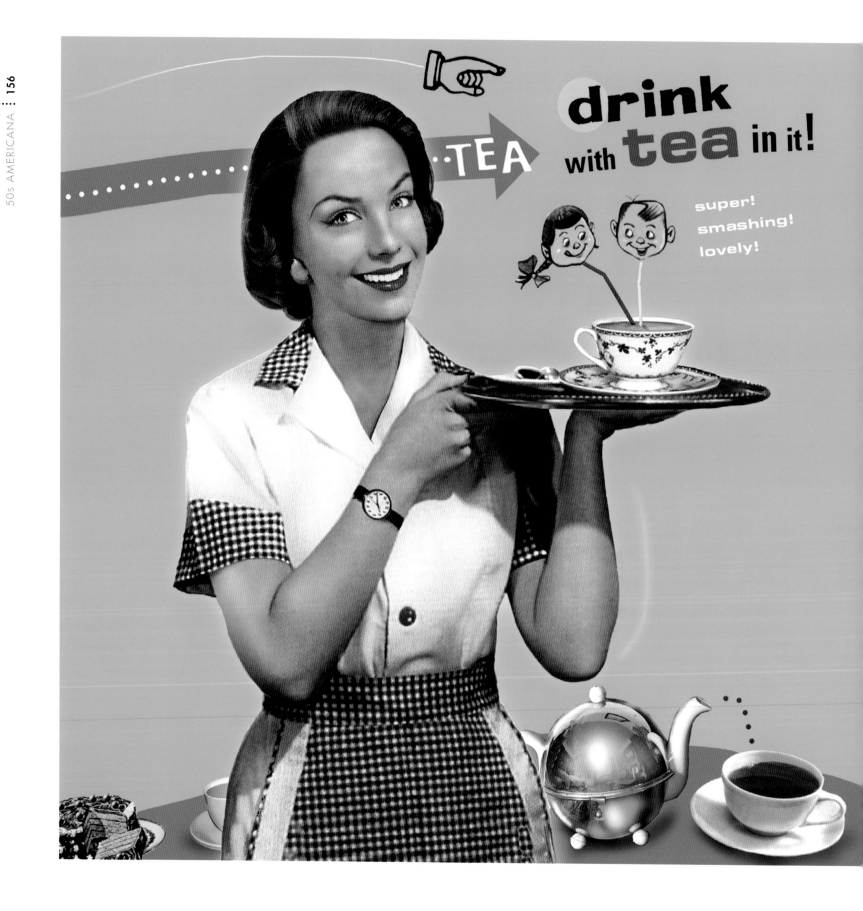

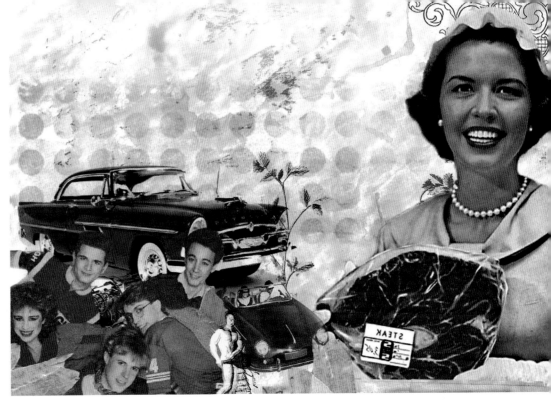

OPPOSITE PAGE: MARC ARUNDALE

DRINK TEA WITH TEA IN IT! (2009)

Adobe Photoshop

Before the advent of fast food, the drive-in diner of the fifties was a popular attraction in America. It had a nostalgic appeal for the customer who would be served their food by carhops sometimes appearing on roller skates. The uniform remains an instantly recognisable emblem of the period.

ABOVE RIGHT: EZEQUIEL EDUARDO RUIZ

CONSUMISMO (2007)

Collage/Ink/Adobe Photoshop

Although the key ingredients of this illustration reinforce the stereotypical retro American values of a healthy lifestyle, good teeth and hot cars, the introduction of the muscle builder from Richard Hamilton's *Just what is it that makes today's homes so different, so appealing?* (1956) suggests that it isn't taking itself too seriously.

RIGHT: PETER QUINNELL

CURES ALL KNOWN ILLS (2010)

Collage/Adobe Photoshop

In this commission for the *Radio Times* for an article on the health factors in food, the artist is looking back to 1950s American advertising mindset by exploiting the obsession with pearly white teeth and the stereotypical over-egging claims by advertisers.

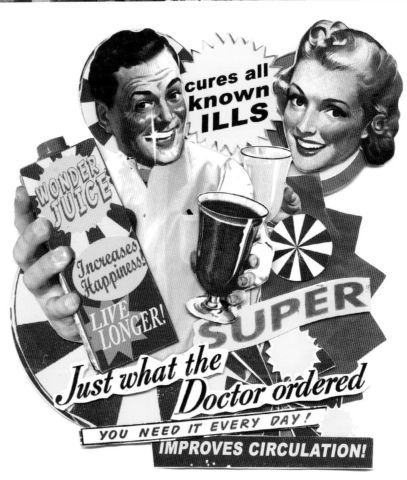

PETER QUINNELL
ELECTRO SWING REPUBLIC (2011)
Collage/Adobe Photoshop

In this CD cover artwork for Brighton based independent record label Freshly
Squeezed Music, the artist has digitally faked a vintage image reminiscent of
the golden age of fifties' girlie magazines that paraded swim-suited pinups like
Pier Angeli, Sandra Dee, Kim Novak and Marilyn Monroe.

MICHAEL LEIGH
GUY MITCHELL SERENADES
(2007)
Collage

Guy Mitchell (1927–1999) was a
popular American recording star who
became a household name in 1950s.
He epitomized the clean-cut, boy next-
door image that typified the retro male
image of the fifties.

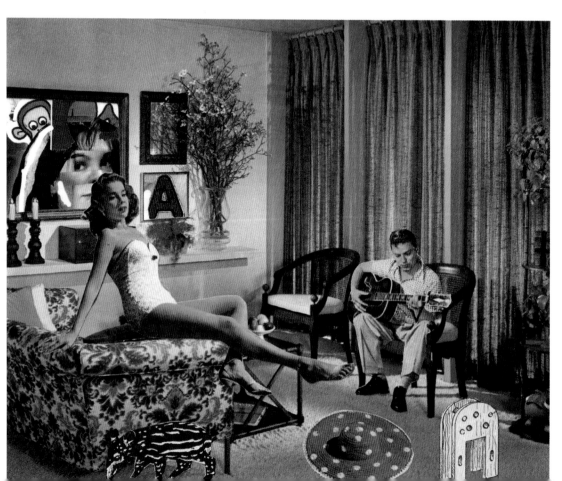

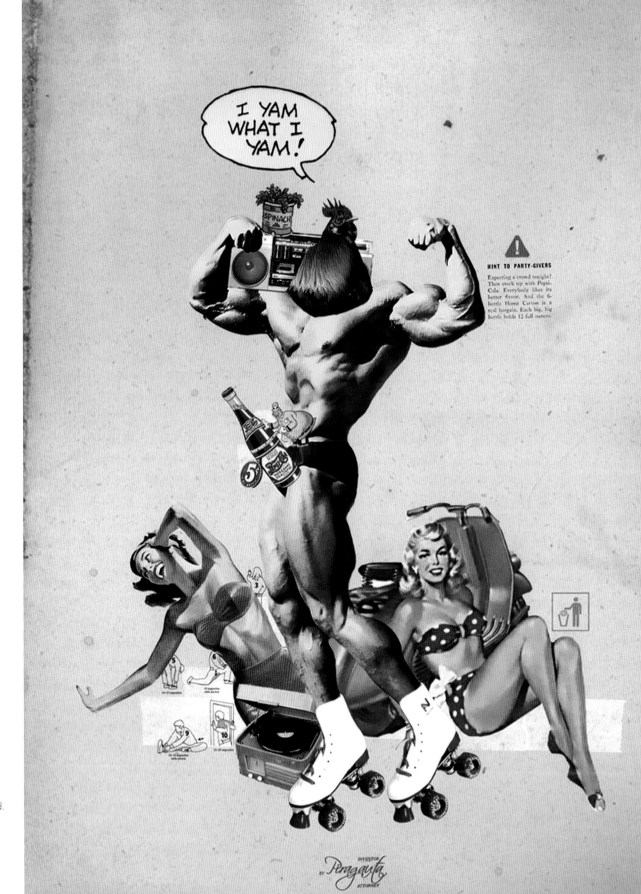

RIGHT: **JAVIER EDUARDO PIRAGAUTA MORA**
CANSEI DE SER SEXY (2008)
Adobe Photoshop

The artist here is satirising the male build that was hyped in the archetypal health and fitness magazines of the fifties as the ideal of American manhood. The pumped up beefcake image soon established itself as the ultimate in male physique of the time.

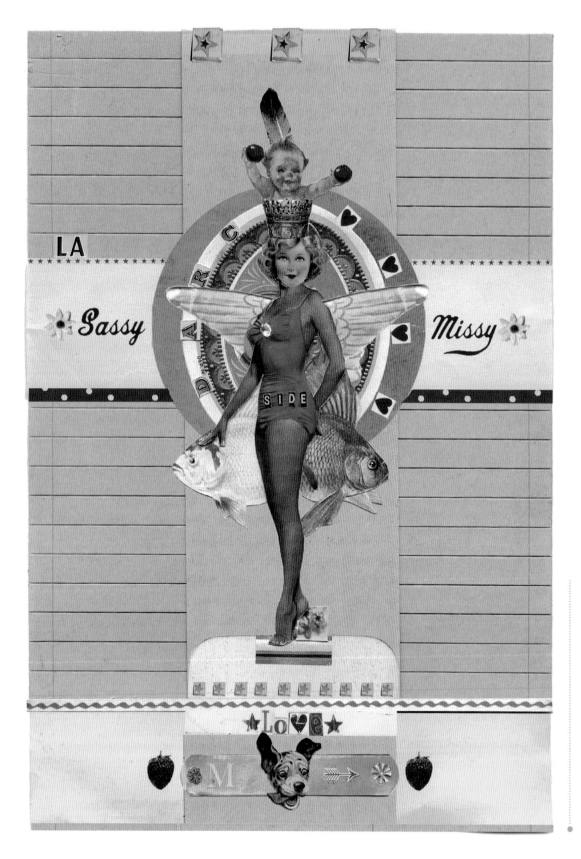

LEFT: **NICKY ACKLAND-SNOW**
SASSY MISSY (2010)
Adobe Photoshop

Sampled fifties imagery is here
assembled into a typical beauty queen
of the period. The archetypal American
pin-up was established during the 1940s
by Peruvian painter, Alberto Vargas
(1896–1982). By the fifties beauty
pageants, like the celebrated Miss
World and Miss Universe competitions,
elevated the bathing beauty to
international appeal through their
exposure on television.

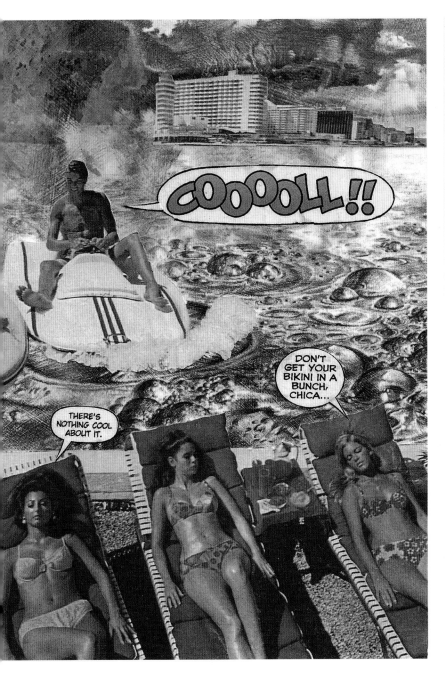
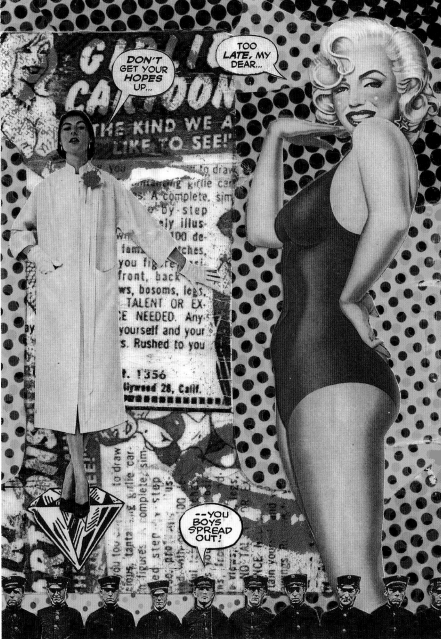

HEAT WAVE (2009) & A GIRL'S BEST FRIEND (2010)

Collage

These two collages emphasise the stereotypical image of swim-suited glamour in the fifties. One-piece bathing suits used the latest synthetic fabrics to help accentuate a perfect hourglass figure. Although the bikini had made its first appearance back in the mid-forties, it wasn't until Brigitte Bardot appeared in the 1956 movie, *And God Created Woman* sporting a gingham bikini, that it became widely accepted.

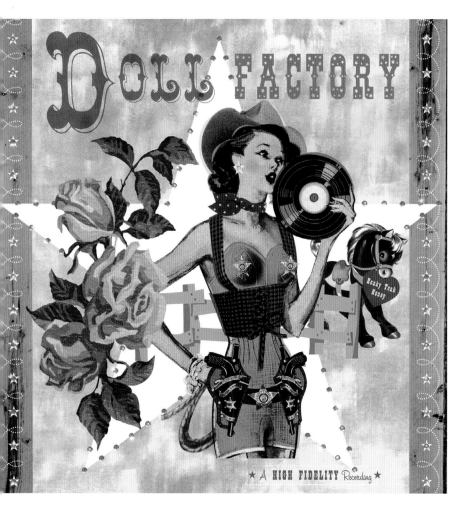

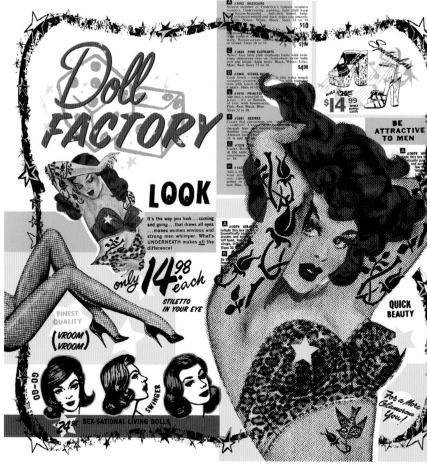

DOLL FACTORY HONKY TONK HONEY & DOLL FACTORY RENEGADE ROSE (2005)

Collage/Adobe Photoshop

For these two digital collages the artist mashed up found imagery discovered out on the net, including vintage lingerie ads, vintage valentines and childrens' toy catalogues. She conjured up a pair of faux vinyl sleeves reminiscent of the rockabilly music scene. Rockabilly emerged out of America in the fifties as a combination of the new rock 'n' roll with hillbilly music.

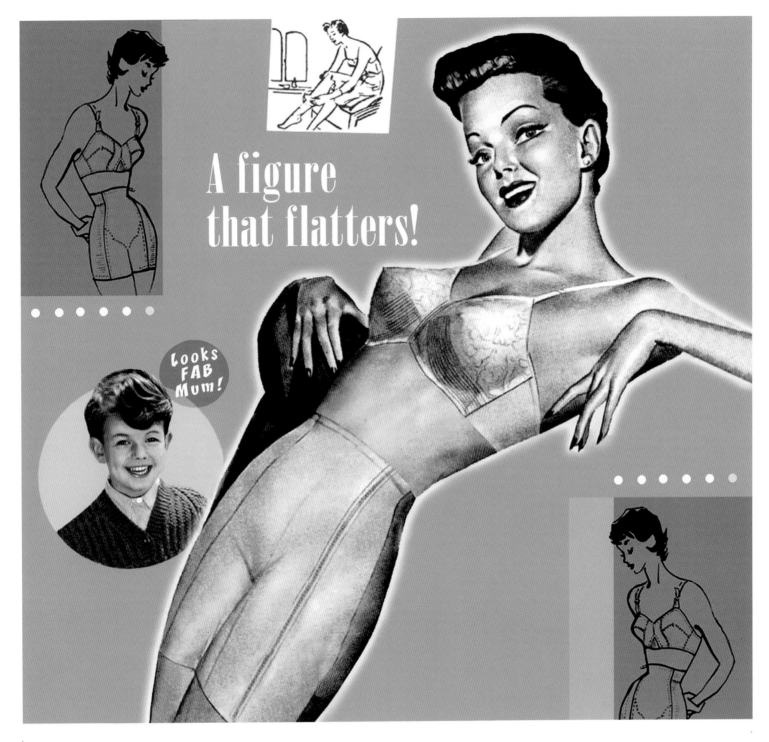

A figure
that flatters!

Looks FAB Mum!

ABOVE: MARC ARUNDALE

1950S LINGERIE (2009)

Adobe Photoshop

The artist's muse here is typical of the 1950s advertisements that allowed lingerie to be photographed in the way that had once been the reserve of Hollywood stars. It was all about overt sexuality and glamour although developments in fabrication, like nylon, allowed everyone to emulate 'sweater girls' like Jane Russell (1921–2011) and Lana Turner (1921–1995).

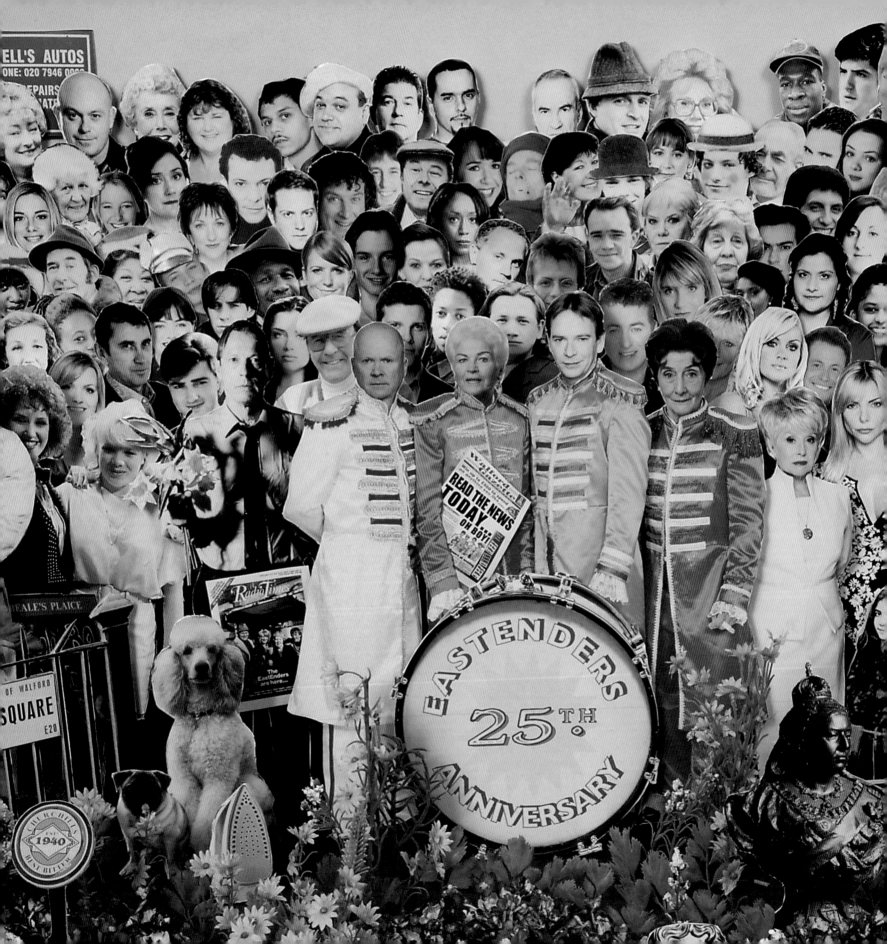

> In the future everybody will be world famous for fifteen minutes.
>
> **Andy Warhol**

POP ART

Art is always a reflection of the society that surrounds it. From the mid-fifties onwards, Pop Art appropriated the everyday and mundane and repackaged it as serious 'Art'. The critic Lawrence Alloway first coined the phrase 'Pop Art' in 1956 to describe the exhibition 'This is Tomorrow' at the Whitechapel Gallery in London. Although sharing a common language, the individual characteristics of Pop Art were divided by the Atlantic Ocean.

British Pop Art erupted onto the swinging London scene in 1952 with the formation of The Independent Group headed by Eduardo Paolozzi (1924–2005) and Richard Hamilton (born 1922). Its progress mirrored parallel revolutions in pop music and fashion.

Peter Blake (born 1932), a graduate from the Royal College of Art, recycled the ephemera of popular culture within his paintings and also continued his technique on LP cover designs for The Beatles and Elvis Presley.

Across in America, Pop Art was centered on a cluster of New York artists who took elements of contemporary American life away from their context and by duplication and repetition transformed them into a visual commentary on their consumer led society.

The father figure of American Pop Art, Andy Warhol (1928–1987) who in 1962 established his own groundbreaking studio – 'The Factory' in midtown Manhattan – had a lifelong fascination with Hollywood and fame and brought both to bear in his celebrated silkscreen portraits of Marilyn Monroe and Elizabeth Taylor.

(EARLY 1950S – EARLY 1970S)
PETER BLAKE • JIM DINE • RICHARD HAMILTON • JASPER JOHNS • ALLEN JONES • CLAES OLDENBURG • EDUARDO PAOLOZZI • ROBERT RAUSCHENBERG • JAMES ROSENQUIST • ANDY WARHOL

PREVIOUS PAGE: PETER QUINNELL

SGT ENDERS (2011)

Collage/Adobe Photoshop

A pastiche of Peter Blake's iconic 1967 cover art for the Beatles' *Sgt. Pepper's Lonely Hearts Club Band* album replacing the original celebrities with characters from the BBC television soap opera, EastEnders.

ABOVE: PETER QUINNELL

ZAFIRA (2004)

Collage/Adobe Photoshop

The bodywork of this Opel Zafira car has been collaged in exuberant Pop Art style for an advertisement image by the company. During the sixties, collage was a key medium of expression in Pop Art as demonstrated by Richard Hamilton (1922–2011) and Eduardo Paolozzi (1924–2005).

LEFT: DAREK LISZEWSKI

UNTITLED (2007)

Adobe Photoshop/Corel Draw

Commissioned for yet another poster in support of his local HC/Punk music scene, the artist has responded by adopting the direct and satirical style of Pop Art culture to render the necessary information with striking visual impact matched to an abstracted and arresting image.

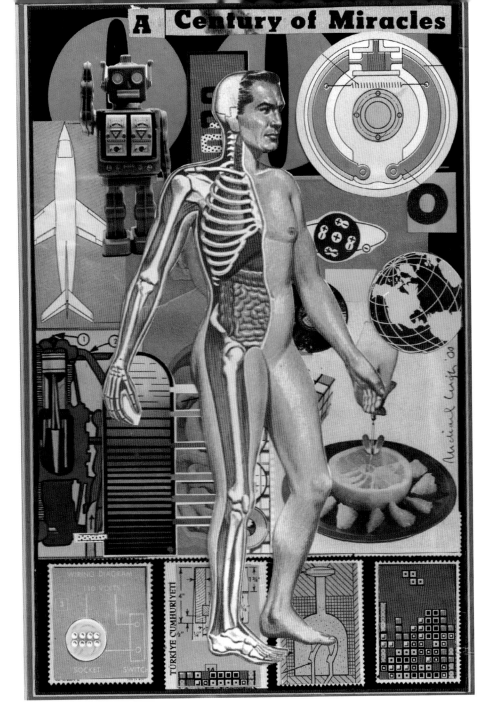

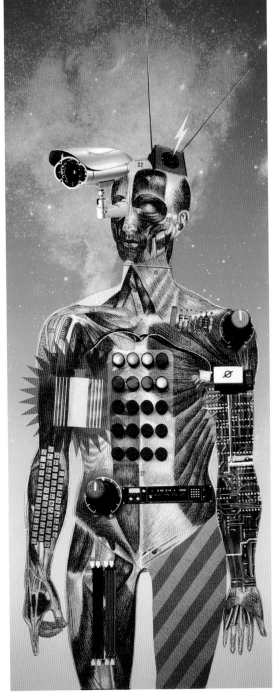

ABOVE: MICHAEL LEIGH

A CENTURY OF MIRACLES (2000)

Collage

This image uses the distinctive style of Pop Art collagist, Eduardo Paolozzi, in its clinical reference to the science and technology that became a feature in his own work. During the fifties Paolozzi famously created a series of robotoid sculptures built from cast-off machinery.

RIGHT: JULIEN PACAUD

USBEK-ET-RICA (2010)

Adobe Photoshop

A commission from the French magazine *Usbek & Rica* has resulted in a composite illustration that plays with Pop Art's assimilation of pulp science fiction imagery.

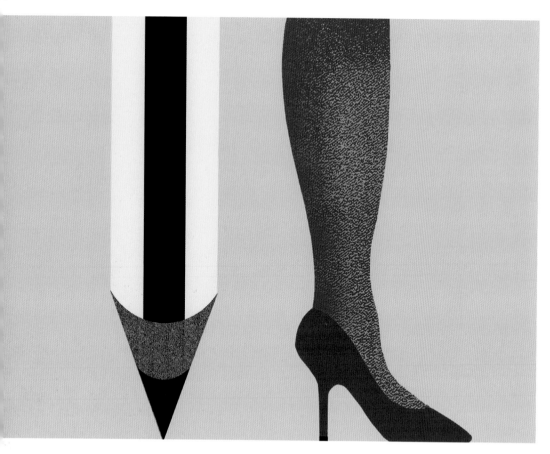

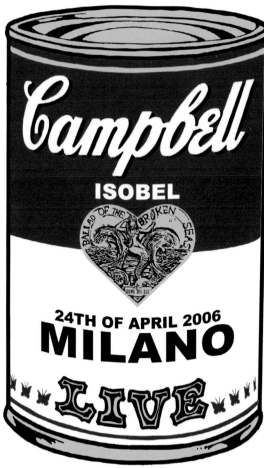

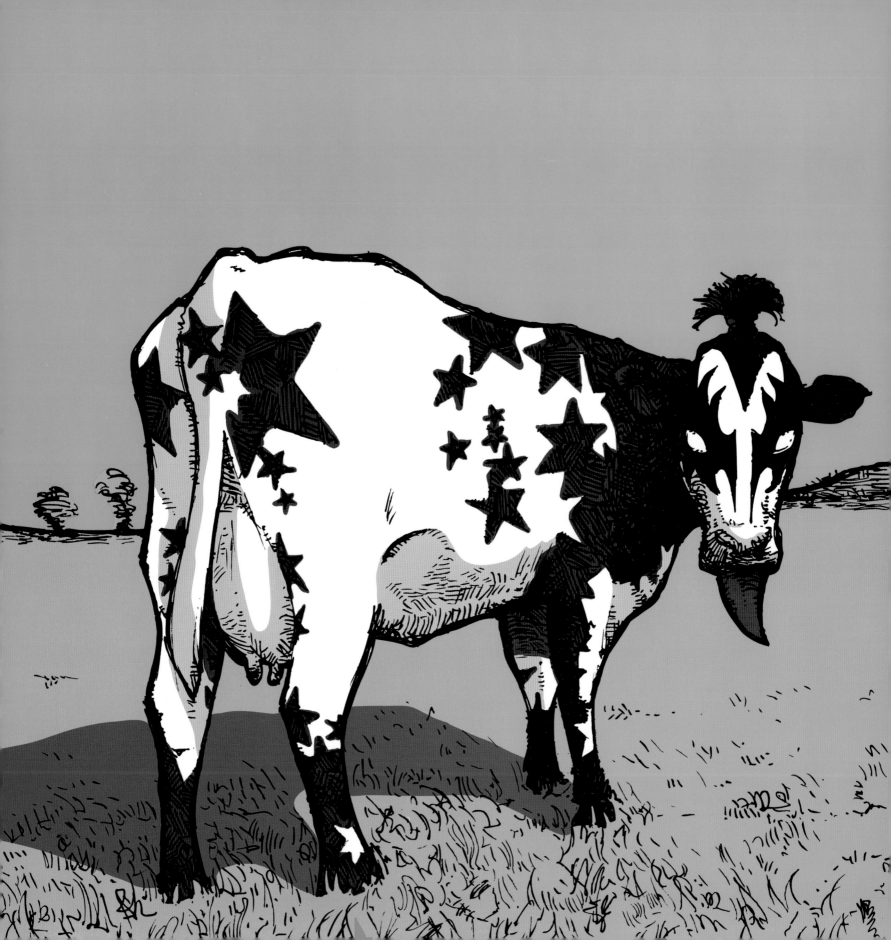

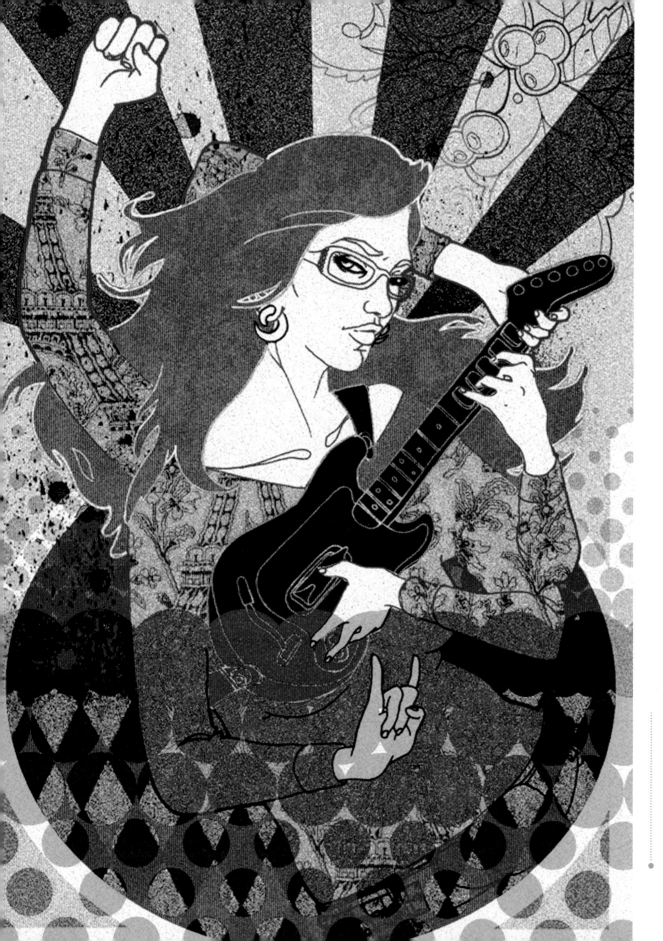

LEFT: TARA PHILLIPS
SELF PORTRAIT (2009)
Pen/Adobe Photoshop
As with most Pop Art, this digital
illustration uses elements from popular
culture by suggesting Activision's *Guitar
Hero* music video game and cloaking
the controller as a Hindu-like figure to
generate its own modern day mythology.

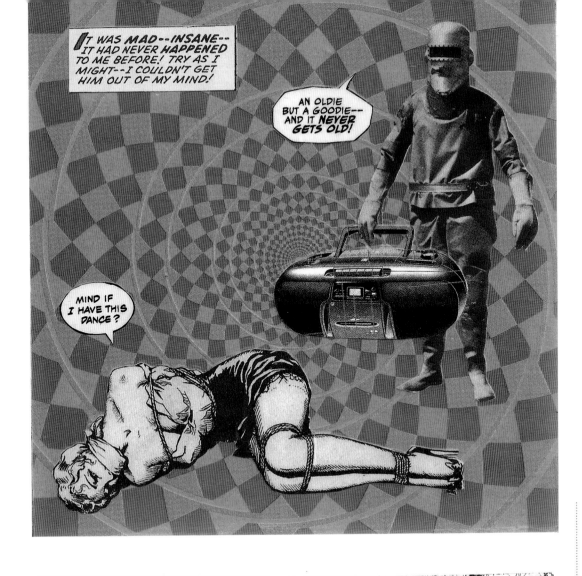

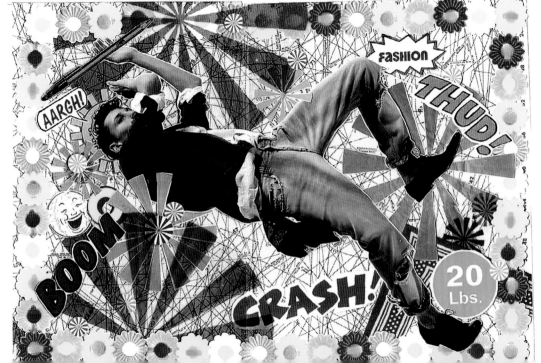

ABOVE LEFT: MARTY GORDON

RADIO DAZE (2010)

Collage

The illustrator here readily
acknowledges the influence of American
graphic artist, Jim Steranko (b.1938),
who created a personal comic book
style that was heavily influenced by
surrealism and the psychedelic
movement of the sixties.

LEFT: PETER QUINNELL

BOOM (2002)

Collage/Adobe Photoshop

For an article in *The Face* magazine,
the artist exploited the vibrancy and
endless duplication of Pop Art in his
illustration that revisits typical sixties
imagery and colours for the fashion
savvy audience of the noughties.

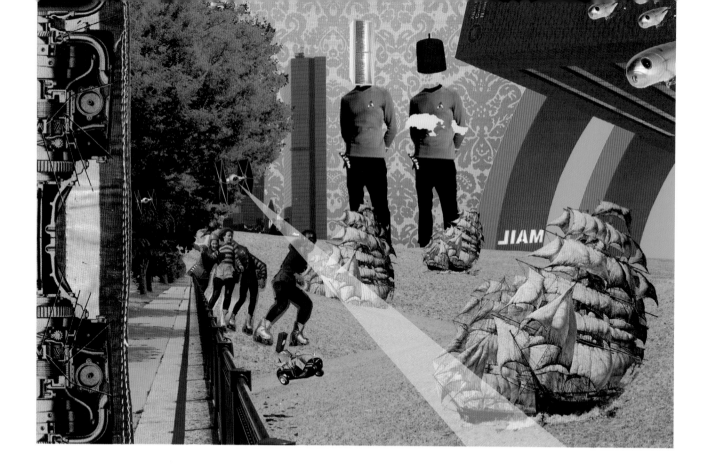

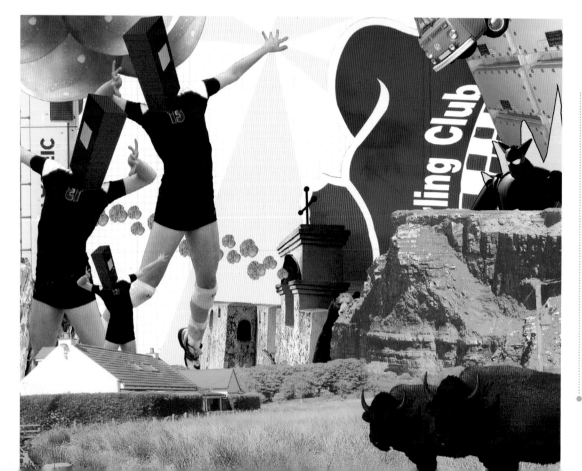

ABOVE & BELOW:

ADRIEAN KOLERIC
UNTITLED 56 & UNTITLED 15
(2010)

Adobe Photoshop

Pop Art took the accessible images of popular culture and often reinvented them as alternative observations on a society fixated by consumerism. Television, advertising, Hollywood movies, comics still saturate today's mass media. Here the artist has removed recognisable images away from their context and asks the viewer to contemplate their 'add-on' value when playfully juxtaposed as in these two digital mash-ups.

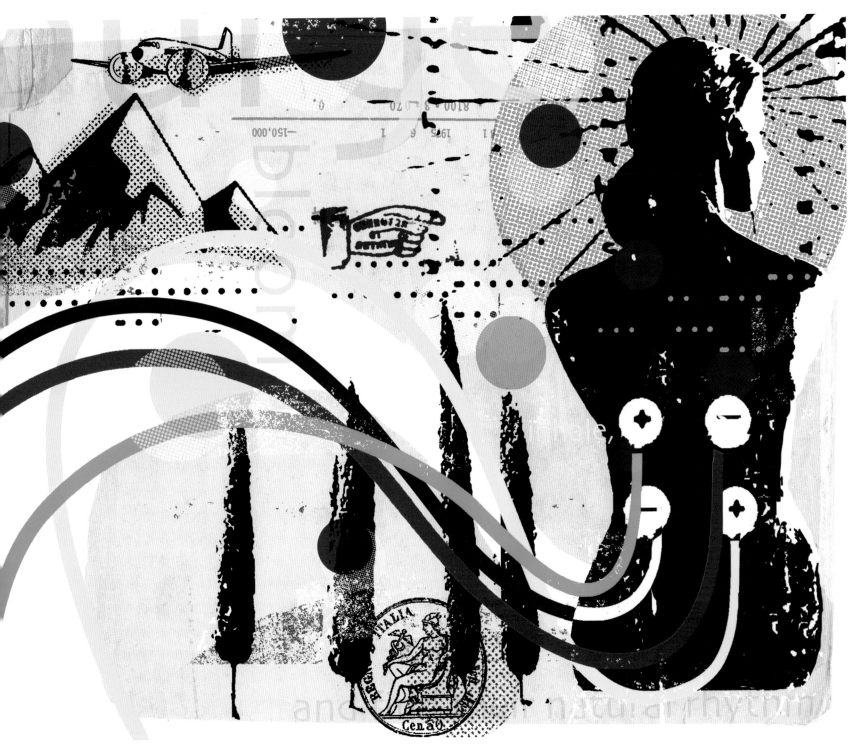

ABOVE: KELLY SCHYKULSKI

L' ELECTRO AVVENTURA (2010)

Adobe Photoshop

Responding to a retro sixties request by Conde Nast for their *Traveler* Magazine for an article on the Henri Chenot spa resort in Italy, the illustrator here has extracted imagery from vintage

picture postcards of the decade to recall its sense of style and place. The special electrostimulation treatment at the spa is symbolised by the Pop Art primary colouring.

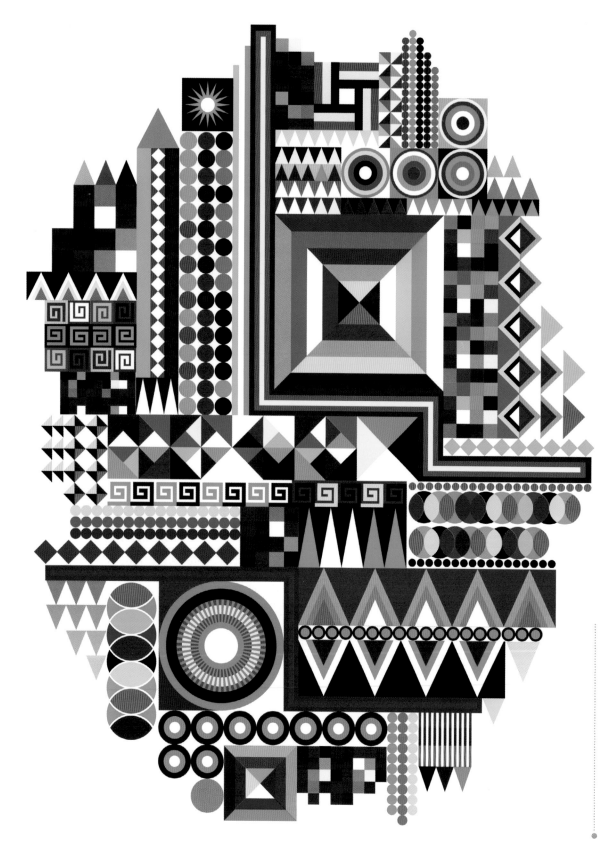

LEFT: MATT W MOORE
NEW BLACK (2005)
Acrylic/Spray paint
An example of the illustrator's
'vectorfunk' abstracts that makes merry
with the multitudinous building blocks
of 60s vibrant colour. Its hard-edged
patterns are reminiscent of the 1,000
square metres of mosaic patterning
that Eduardo Paolozzi created for
London's Tottenham Court Road
underground station.

ABOVE & BELOW:

MATHIS REKOWSKI
THE CIRCUS #01 & THE CIRCUS
#02 (2010)
Adobe Photoshop

These two digital illustrations are the
artist's own Pop Art interpretations of the
pace and energy of contemporary life's
pleasure seekers expressed using the
vibrant colour palette of the sixties. The
colourful imagery is here chaotically
trapped, like a tripping animated film
sequence set on pause, to reveal a much
darker message on closer inspection.

LEFT: MATT W MOORE
CYCLES & SEASONS: VORTEX (2010)
Adobe Illustrator

This digital illustration is part of a series commissioned by
Manpower Global for their annual calendar. Its brightly coloured
kaleidoscopic design is akin to the psychedelic swirling patterns
produced by a lava lamp. Invented by Edward Craven-Walker
(1918–2000) during the mid-sixties, the Lava Lite Lamp became
an instant fad with interior designers of the decade.

BELOW: ADRIEAN KOLERIC
UNTITLED 11 (2010)
Adobe Photoshop

After taking some time out, the artist wanted to explore
new colours and compositions in this 'over the top' Pop Art
treatment that operates like Richard Hamilton's 1956 collage *Just
what is it that makes today's homes so different, so appealing?*
by similarly questioning 21st century lifestyle and aspirations.

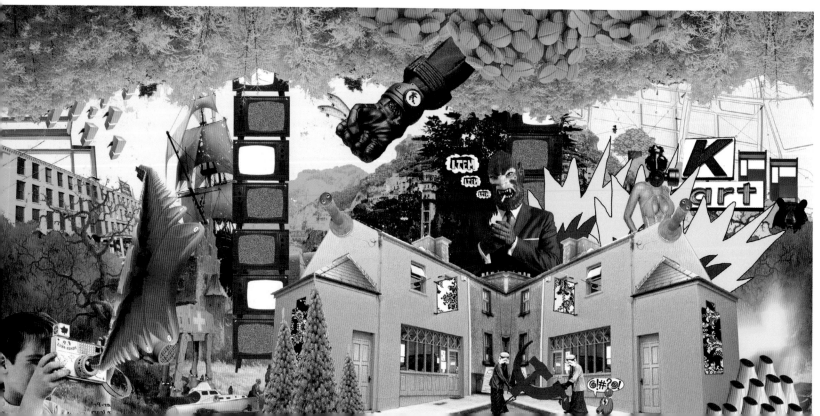

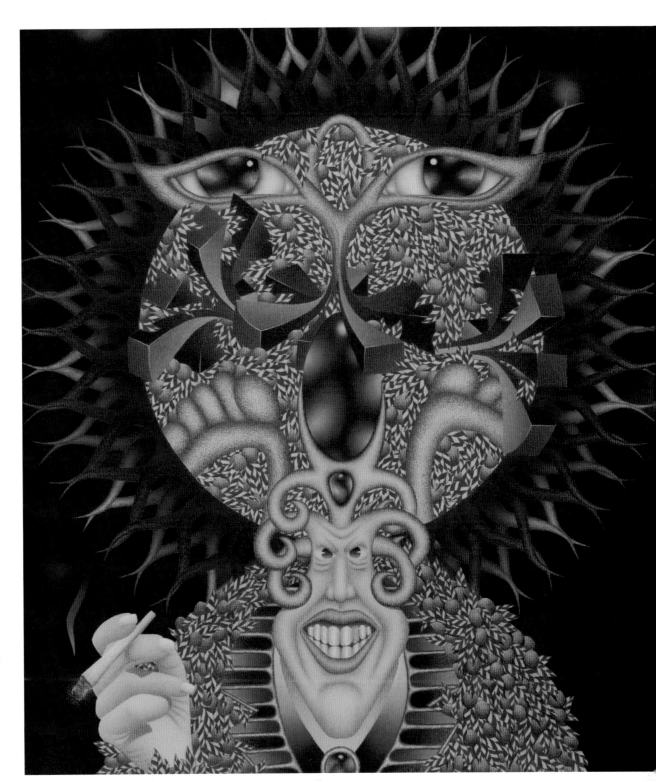

RIGHT: ADAM PINSON

ORANGE BARRON (2010)

Coloured Pencil

The artist has based this drawing
on a chance meeting with an actual
Baron in New York who had outstayed
his time in a sun-tanning booth. The
fanciful Pop Art treatment makes him
look like a cartoon inhabitant of
Pepperland from the 1968 animated
film *Yellow Submarine* based around
the music of The Beatles.

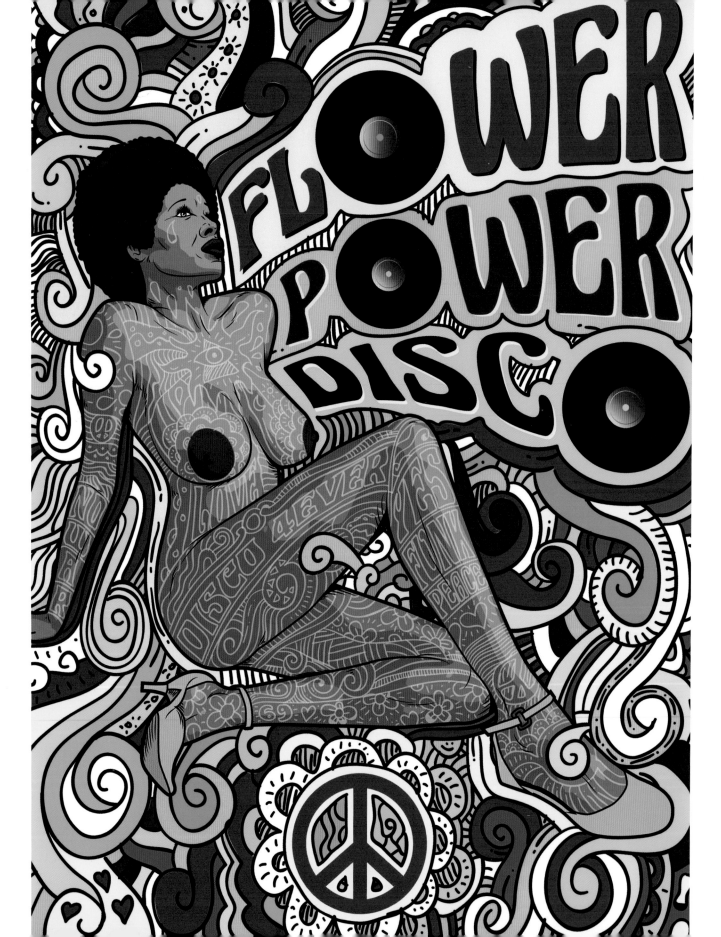

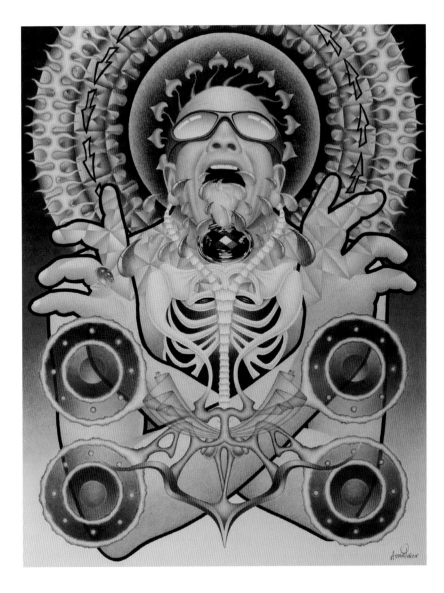

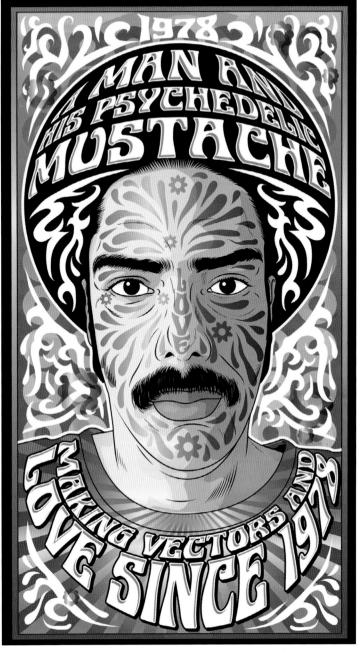

OPPOSITE PAGE: ROBERLAN BORGES PARESQUI

FLOWER POWER DISCO (2011)

Adobe Illustrator

The artist confesses to being a compulsive doodler and this, combined with his obsession with the psychedelic rhythms of The Summer of Love, has resulted in this psychedelic piece made using typically flat Pop Art colouring.

ABOVE: ADAM PINSON

BLAAA (2006)

Coloured pencil

The artist freely admits to creating this self-portrait depicting the effects of his overindulgence in candy. The mind-expanding quality of the image owes as much to the psychedelic sixties as to the symmetry and framing within an Alfons Mucha poster.

ABOVE: ROBERLAN BORGES PARESQUI

PSYCHEDELIC MUSTACHE (2008)

Adobe Illustrator

In this illustration the artist has connected references from Art Nouveau and Pop Art to conjure up a retro psychedelic self-portrait.

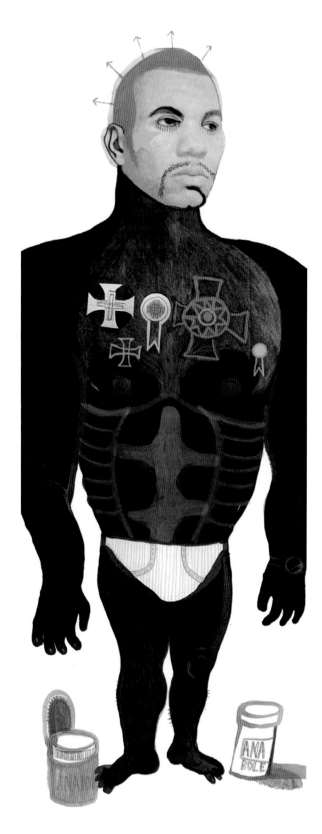

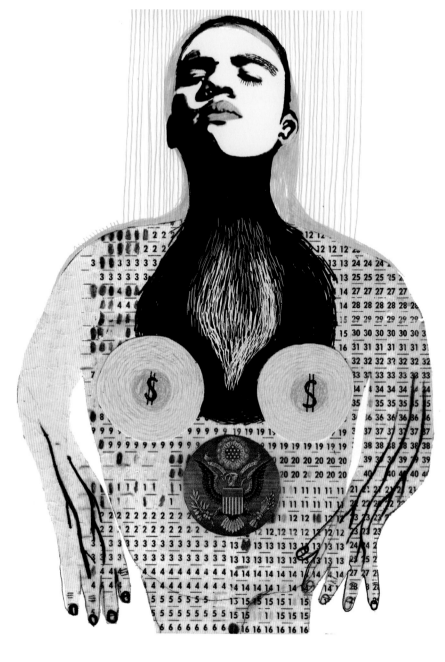

ABOVE, LEFT & RIGHT: AGATA DUDEK

GOLDEN BOY (2009)

Collage

Two portraits of the American rapper, Jayceon Terrell Taylor, better known as Game, conjured up with typical Pop Art exuberance. Unlike traditional portraits, clues to the sitter's identity are left like forensic art decoratively collaged onto his distorted body.

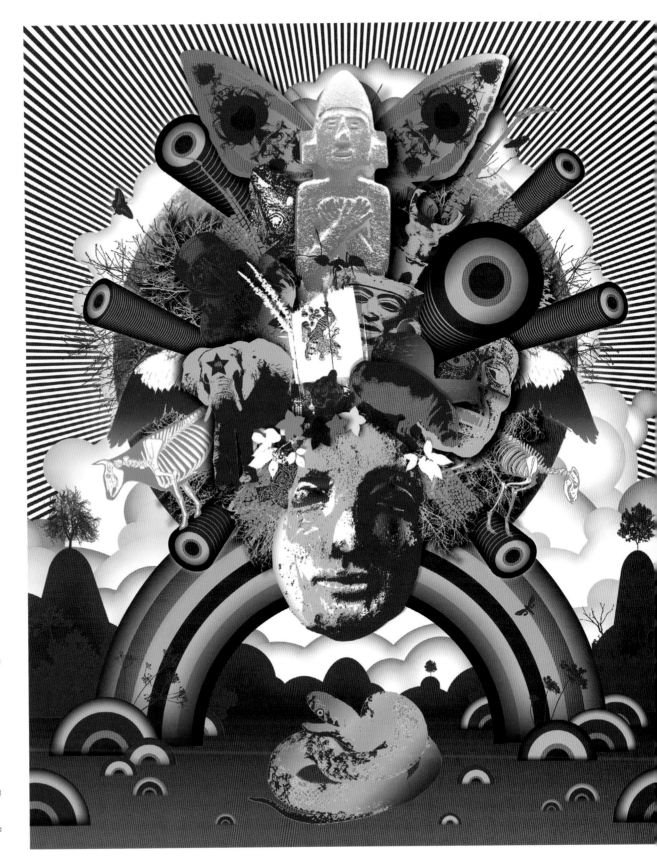

RIGHT: MILES TEBBUTT

WHAT DO SNAKES CARE (2010)

Adobe Illustrator

The photomontage technique of Peter Blake is an obvious influence here. The Pop Art movement brought photomontage back into circulation by their rejuvenation of the earlier techniques of Dadaism. By combining photographic images and vector illustration, the illustrator has created a striking contemporary abstract.

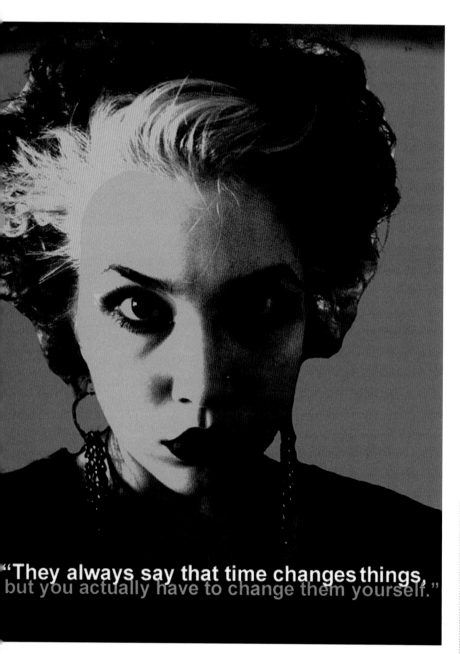

ABOVE: **NÁDIA DOMINGOS**

HOMAGE TO ANDY WARHOL I (2009)

Adobe Photoshop

An arresting digital portrait that duplicates the flat colouring found on Warhol's serigraphs. The quotation is from the taped conversations published in 1975 as *The Philosophy of Andy Warhol: From A to B and Back Again*.

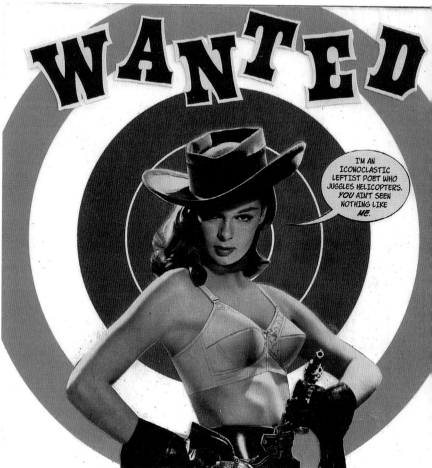

ABOVE: **MARTY GORDON**

WANTED (2009)

Collage

The clean target lines in solid colours frame the imported celebrity with a Pop Art style halo to accentuate her appeal. Andy Warhol's fascination with fame and celebrities started in 1962 with his portraits of Marilyn Monroe and became the principal ingredient of his output.

OPPOSITE PAGE: **FABRÍCIO RODRIGUES GARCIA**

MARILYN (2009)

Acrylic

The most celebrated of the Andy Warhol *Marilyns* is based upon her publicity headshot from the 20th Century Fox movie, *Niagra* (1953). Despite the distortion of her face, the screen legend still remains easily recognisable and the application of the flat silkscreen colours highlight this tribute.

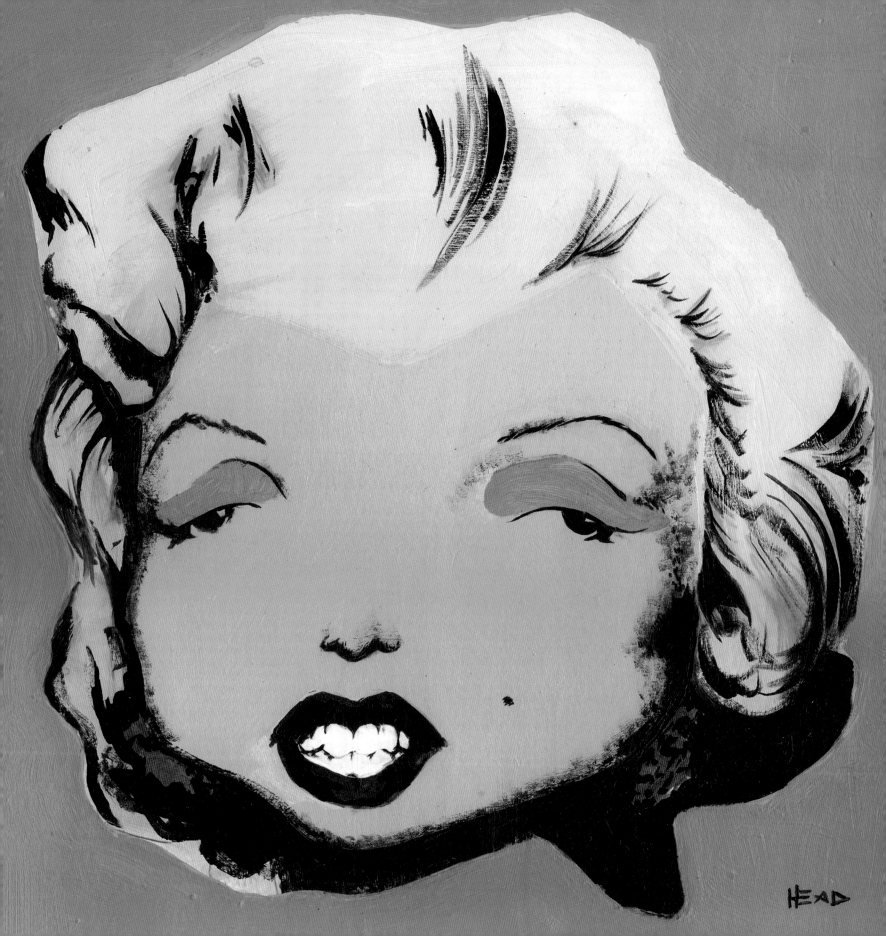

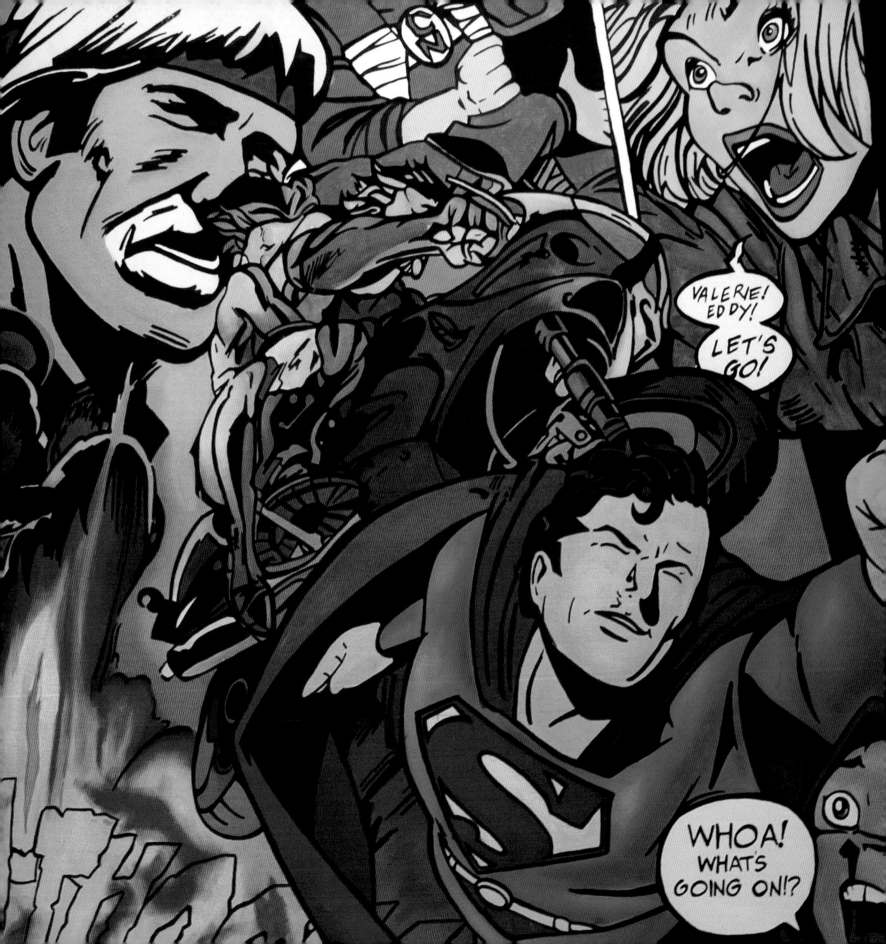

COMIC BOOK & SEQUENTIAL ART

Comic book and sequential art has its own unique visual language and attraction. It is easy to overlook the skilled mechanics and the sheer diversity of creativity and draftsmanship that is brought to bear when creating these sequential mini-canvases.

Black and white comic strips were a well-established tradition of early twentieth century newspapers. However, the impact at American newsstands in the late 1930s by a new type of action hero was unprecedented. Action Comics' Superman singlehandedly changed the future of the comic strip and initiated an army of superheroes that left a publishing phenomenon in their wake. Their expansion into separate comic books by DC became the precursors of today's graphic novels.

In the wake of Harvey Kurtzman's ground breaking, ad-free magazine, MAD, the 1950s saw underground comix and fanzines create their own waves and the popularity of the Japanese Manga comic grew to international proportions in the late 1980s with the arrival of anime.

The comic book tradition was given an alternative treatment in 1961 when Roy Lichtenstein (1923–1997) 'purloined' the traditional format of the comic-strip by magnifying six barely altered miniature frames up to art gallery proportions. Comic book art provided him with his signature trademarks of thick lines, stenciled Ben-Day dots, boxed captions and thought bubble balloons.

NEAL ADAMS • ROBERT CRUMB • STEVE DITKO • PHILLIPE DRULLIET • WILL EISNER • BOB KANE • HARVEY KURTZMAN • ROY LICHTENSTEIN • JACK KIRBY • FRANK MILLER • MOEBIUS • ALAN MOOR

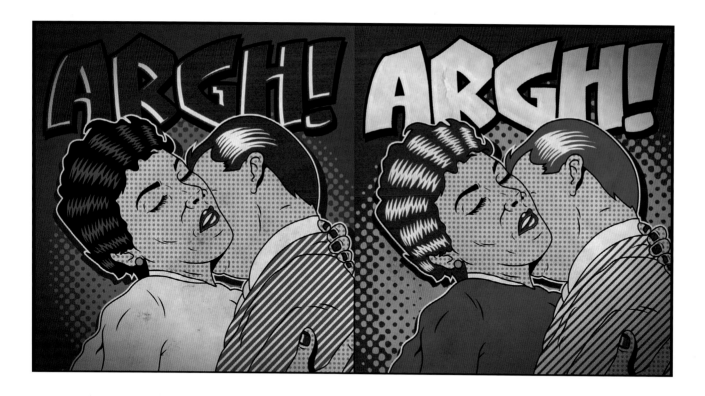

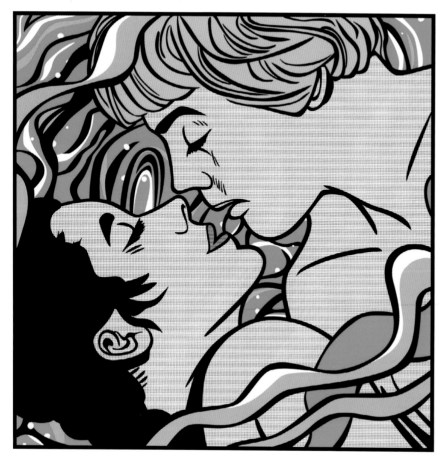

PREVIOUS PAGE: **HJALTI PARELIUS FINNSSON**

FATHER (2010)

Oils

The artist has factored in a crowd of DC comic book references to support his concept that parents are the true heroes. The father image here is American movie action hero, Chuck Norris (b.1940), who appears as the protector rushing in to chase away his son's nightmares.

ABOVE: **ROBERLAN BORGES PARESQUI**

ARGH! LOVE (2007)

Adobe Illustrator/Adobe Photoshop

A personal take on the comic strip formula that Roy Lichtenstein commandeered for his own paintings (halftones, repetition, vibrant colours, etc.). The alternate colourways play with the gender focus within the repeated image cells.

LEFT: **THOMAS BERGMANN**

R2D2 ABSTRACT (2010)

Adobe Illustrator

The artist here trades in on the schmaltzy comic strip scenario of the lovers' kiss for a full cinematic close-up in his own kitsch version that invents an embrace between Princess Leia and Luke Skywalker from George Lucas' *Star Wars* (1977).

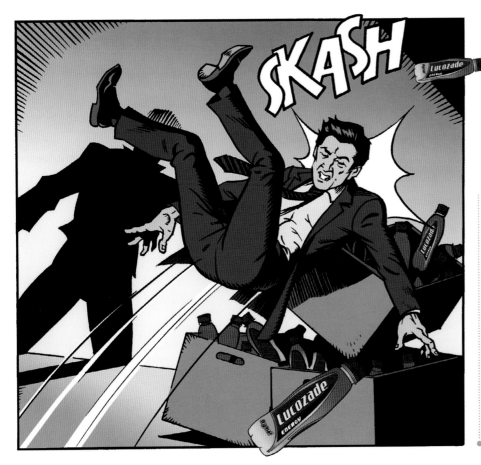

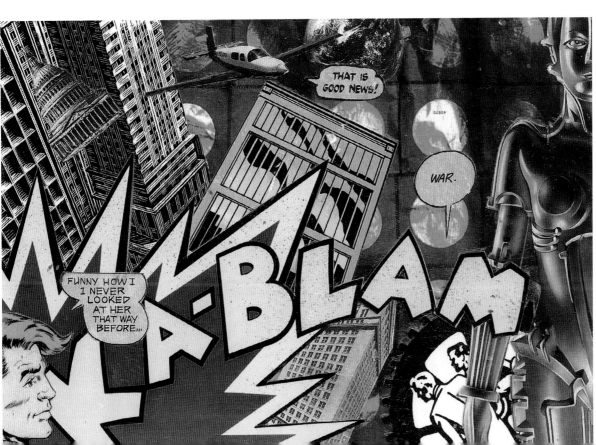

LEFT: EOIN COVENEY/NB ILLUSTRATION
LUCOZADE MAN (2007)
Pen & ink/Adobe Photoshop
For this commission the artist has responded to his client's wishes in typical comic strip style with a single cell layout inspired by the graphic style of American comic book artist, Ed McGuinness.

BELOW: MARTY GORDON
KA-BLAM (2006)
Collage
The explosive comic book text across this image automatically endows the handcrafted collage the same impact to be found in its original context. The comic strip effect is also reiterated by the inclusion of word balloons.

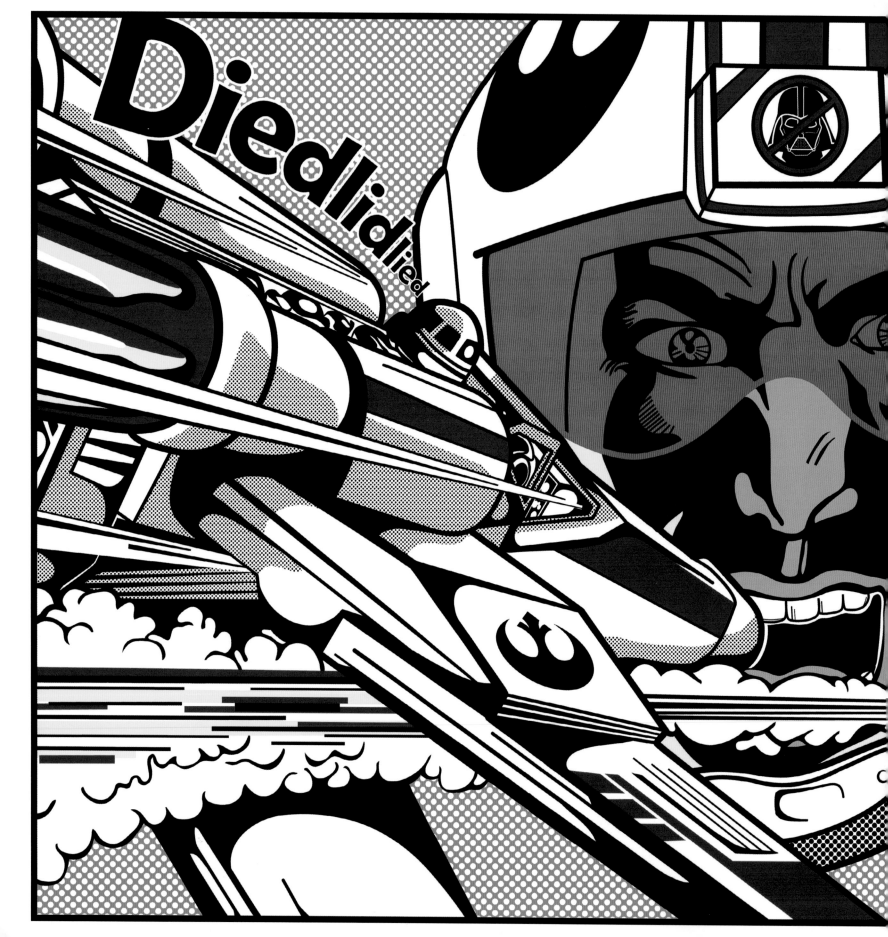

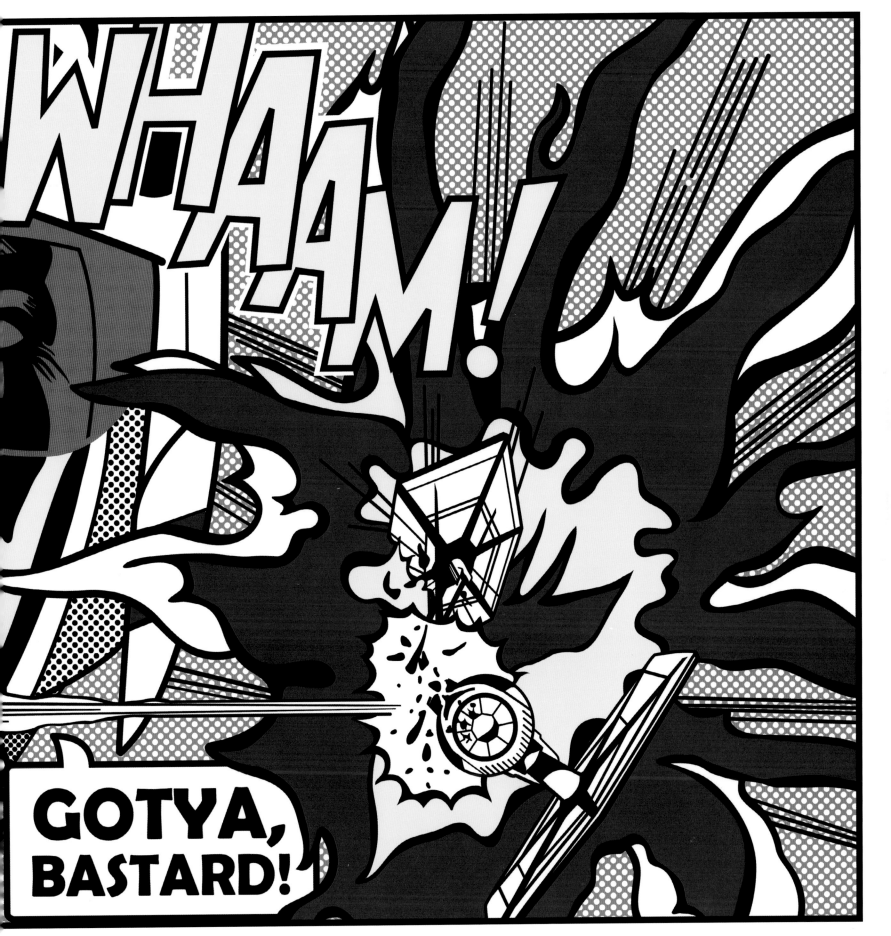

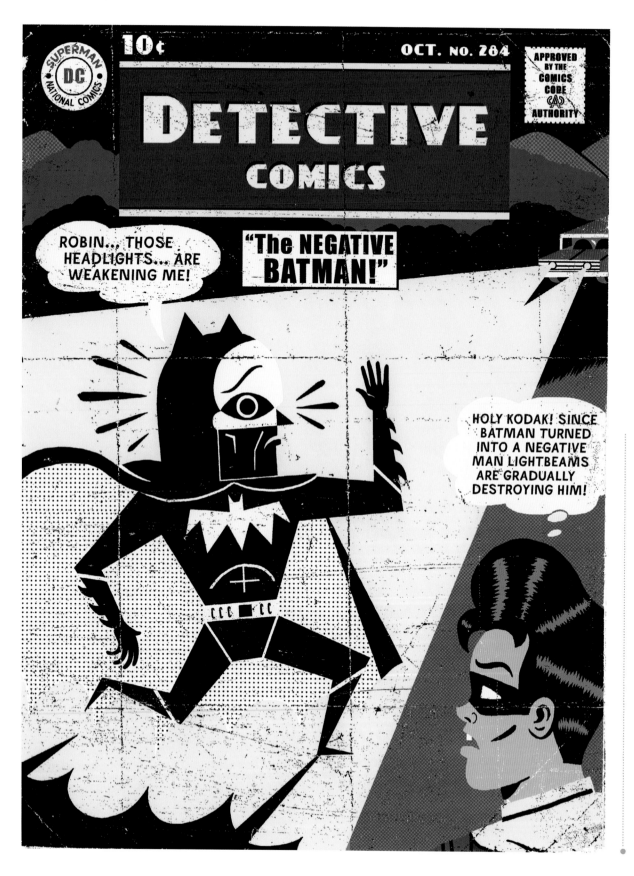

PREVIOUS PAGE:
THOMAS BERGMANN
BATTLE (2010)
Adobe Illustrator
Roy Lichtenstein's 1963 comic strip painting *Whaam!* is the obvious inspiration behind this eye-catching digital mural that makes full use of his tell-tale trademarks of Ben-Day dots, lettering and speech balloons.

LEFT: BEN NEWMAN
DETECTIVE COMICS 68 – THE
NEGATIVE BATMAN (2009)
Pencil/Paper/Adobe Photoshop
At Robin Goodin's *Covered* blog, illustrators and cartoonists are repeatedly asked to select their favourite comic book covers and redraw them in their own style. This artist selected vintage Batman comics from the fifties and sixties because of their unique colouring and storylines.

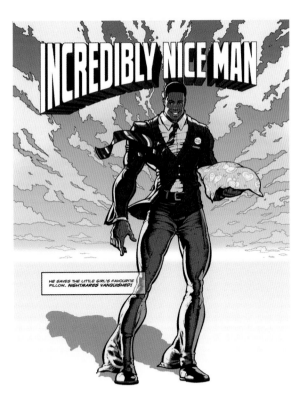

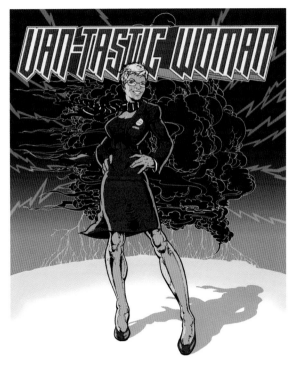

Corel Painter/Adobe
Photoshop/Adobe Illustrator

The intention here was to capture the
spirit and nostalgia of the Golden Age
of American comics for a commission
by Avis car rental in South Africa. The
concept was to illustrate actual customer
feedback in terms of Avis employees
becoming super heroes based on the
quality of each customer's report. The
typography is easily recognisable as
based upon the iconic extruded
Superman logo.

ABOVE: HJALTI PARELIUS FINNSSON
HOLD FRIGGIN' STILL (2010)
Oils

The use of a wide-angled comic book frame for this image has allowed the artist to create a vibrant scene that conveys a lot of physical energy. The diagonally framed, gun-toting heroine is suitably highly stylised with comic book flair and appears ultra-dynamic.

LEFT: THOMAS BERGMANN
R2D2 ABSTRACT (2010)
Adobe Illustrator

This illustration mixes the bold colours and the thick outlines of the comic strip format for a Piet Mondrian (1872–1944) decorated R2D2. The usually flat grid formula of Mondrian's paintings is intriguingly manipulated across on an untypical rounded surface.

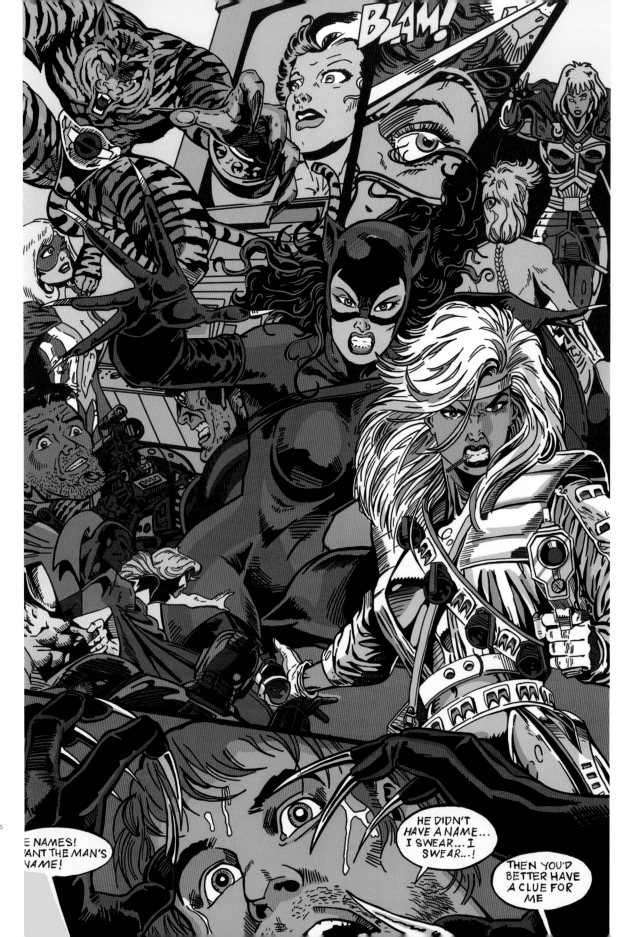

RIGHT: HJALTI PARELIUS FINNSSON

TIGERBLOOD (2011)

Oils

A fractured and wild re-invention of comic book super heroes that the artist sees as indicative of the current madness and hype surrounding the Hollywood actor, Charlie Sheen. The artist often regrets the lack of an 'undo' key when working with oils which gives him a different challenge from when working digitally.

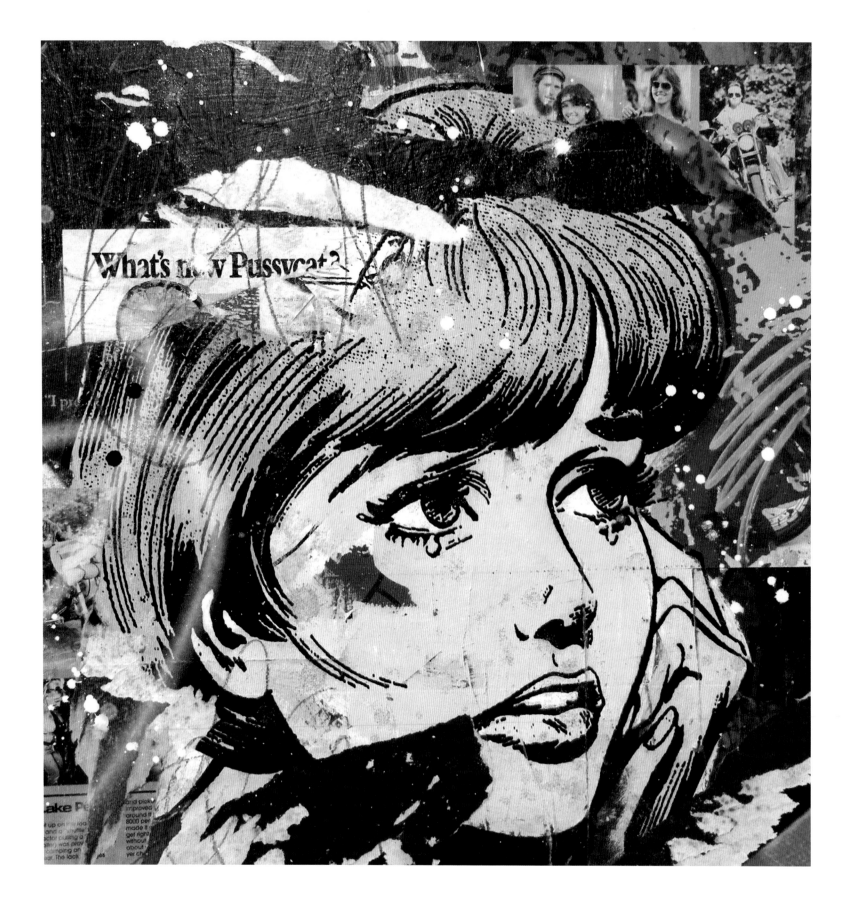

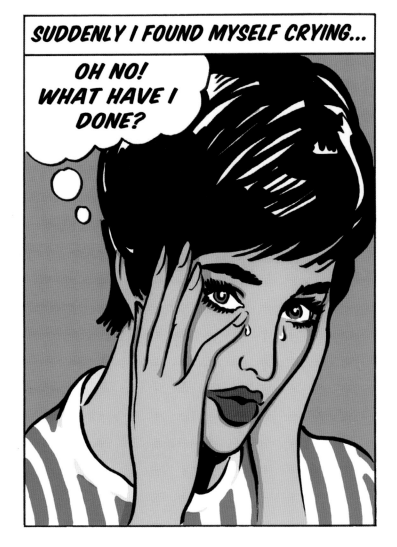

THAT SINKING FEELING (2010)

Pen & ink/Adobe Photoshop

The artist here resorts to just a single frame to condense a whole comic strip storyline. In this way the strapline and thought bubble leave it open for each viewer to put their own spin on the ensuing drama

ABOVE RIGHT: **JACQUIE BOYD**

COLD CALLER (2010)

Pen & ink/Adobe Photoshop

Admitting to being one of the 'last magic-marker toting dinosaurs', this artist has recently adopted the digital pen to work out her comic book ideas prior to committing them in bold acrylics on canvas.

OPPOSITE PAGE: **GREG GOSSEL**

GOLD 2 (2009)

Acrylic/Silkscreen/Collage/Graphite/Spray paint/Ink

This mixed media image takes elements from the comic book artist's kit bag and gives them a distressed appearance pointing towards the deconstruction to come in Punk art. A tearful eye was a common feature of Romance pulp magazines. Roy Lichtenstein famously contrasted a crying face with cheerful colours in *Crying Girl* (1963), *Hopeless* (1963) and *Drowning Girl* (1963).

ABOVE: JOSH DEITERS

GIRL TALK, SEATTLE SHOW POSTER (2011)

Screen print/Adobe Illustrator

The Roy Lichtenstein trademark of Ben-Day dots is well to the fore in this poster treatment. Comic books originally incorporated Ben-Day dots as a low-cost printing process that spaced small coloured dots to give the optical illusion of creating a further colour.

ABOVE: EOIN COVENEY/NB ILLUSTRATION

HSE SEXUAL AWARENESS CAMPAIGN (2006)

Adobe Photoshop

This image originated from a campaign concerning unprotected sex. The artist aped the Roy Lichtenstein/comic book mannerisms of flat colour and thick black outlines because the client judged the style would appeal to both sexes.

ABOVE: JACQUIE BOYD

TRAVELER MAGAZINE (2010)

Pen & ink/Adobe Photoshop

This was a commission that requested a retro visual feel to its all too familiar contemporary theme. As with most comic

book artwork, a single frame presents the viewer with all the necessary facts to articulate the situation instantaneously.

BEFORE EVELYN LEFT, SHE EMBARKED ON AN ODYSSEY OF AFFAIRS. HER CONTENTION WAS THAT SHE HAD **EVOLVED** BEYOND ME... THAT I WAS TOO **ANALYTICAL** AND **COLD**; THE WARMTH OF MY HEART CHOKED OUT BY THE **FRIGID SCIENCE** OF NUMBERS AND CHARTS. THE ONLY LESSON HER **CRUELTY** TAUGHT ME WAS TO THROW MYSELF EVEN **DEEPER** INTO MY WORK. I DECIDED THAT I SHOULD NEVER BE **HURT** AGAIN, THAT I WOULD REMAIN...

LOVELESS!

OR SO I HAD THOUGHT...

I RESOLVED TO MAKE MYSELF **INVISIBLE** TO HUMANITY – A HUMANITY, IT SEEMED, THAT WAS ONLY TOO HAPPY TO **OBLIGE.**

ABOVE: JIM RUGG

LOVELESS (2008)

Pen & ink/Adobe Photoshop

An excerpt from a 4-page comic strip for the Fall 2008 fashion issue of *NY Magazine* that takes its inspiration from Ogden Whitney's (1918–1970) 1950s romantic comics, *Romantic Adventures* and *Wedding Bells*.

ABOVE: **JIM RUGG**

ROMANTIC (2006)

Pen & ink/Adobe Photoshop

This is the cover art to a commission by Adhouse Books for a collection of contemporary romance comics. The artist acknowledges a deference to both the romantic comics of the 1950s and American graphic designer Chip Kidd's (b.1964) use of close-up photography akin to old comic books.

ABOVE: **BRIAN EWING**

THE WHITE TIE AFFAIR (2009)

Pen & ink/Adobe Photoshop

Enjoying the freedom from both the agent and band, the artist took his motivation from the typical Romance Comic covers of the sixties and furnished the final image with a suitably torn and scratched appearance. The portraits of the band members are framed in the style of a Fantastic Four or X-Men comic book cover.

ABOVE: **JOSHUA KEMBLE**

SILHOUETTE (2010)

Pen & ink/Adobe Photoshop

The artist created a comic book T-shirt image in response to a commission by the fashion label, Garçon Chic, who requested a storyline to support the Italian League for the fight against AIDS (LILA) as part of their 'Rievolution' Collection.

ABOVE: **JOSHUA KEMBLE**

SILHOUETTE (2010)

Pen & ink/Adobe Photoshop

The artist created a comic book T-shirt image in response to a commission by the fashion label, Garçon Chic, who requested a storyline to support the Italian League for the fight against AIDS (LILA) as part of their 'Rievolution' Collection.

OPPOSITE PAGE: **JOSHUA KEMBLE**

EVERYTHING IS HANDMADE (2011)

Pen & ink/Adobe Photoshop

Taking his motivation after a walk through the city, the illustrator decided to create this one-shot comic. For the graphic arrangement of his thoughts he looked at George Herriman's (1880–1944) layouts for the popular 'Krazy Kat' comic strip that numbered Pablo Picasso (1881–1973) among its readers.

EVERYTHING IS HAND-MADE

THIS *MIGHT* SEEM *STRANGE*...

TODAY I WAS WALKING ON THE STREET, WHEN IT *DAWNED* ON ME...

THAT THE SIDEWALK, WAS ACTUALLY *MADE* BY SOMEONE.

I KNOW IT DOESN'T SOUND ALL THAT PROFOUND... BUT *THINK* ABOUT IT.

IT WAS *PROBABLY* A *HOT* DAY...

WITH *LOTS* OF *TRAFFIC*...

AND *PROBABLY* QUITE A *CHALLENGE* TO WORK WITH BUILDING CODES, LABOR *NIGHT* AND *DAY*, AND LEVEL THE CEMENT... TILL *EVENTUALLY*...

SOMEONE MANAGED TO *FINISH* CREATING THE SIDEWALK. PERHAPS THIS *ISN'T* HOW SIDEWALKS ARE MADE, BUT IT'S WHAT I *IMAGINED* IT WAS LIKE.

SUDDENLY THE *CITY*, AND ALL THESE *SIMPLE* THINGS LIKE SIDEWALKS THAT I JUST TAKE FOR GRANTED HAD A NEW *WEIGHT* TO THEM.

BUILDINGS...

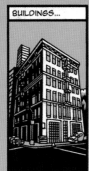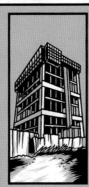

CARS...

SEEMINGLY EVERYTHING.

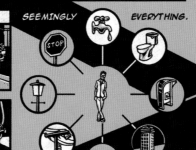

SO I STARTED TO WALK WITH A *BRIGHTER* STEP, HAVING REALIZED...

THAT *EVERY* BUILDER, *ANYONE* TRYING TO *CREATE* SOMETHING FUNCTIONAL TOILS AWAY... AND EVEN IF THEIR TOIL IS SIMPLY WALKED ON WITHOUT *NOTICE*...

ITS PURPOSE REMAINS.

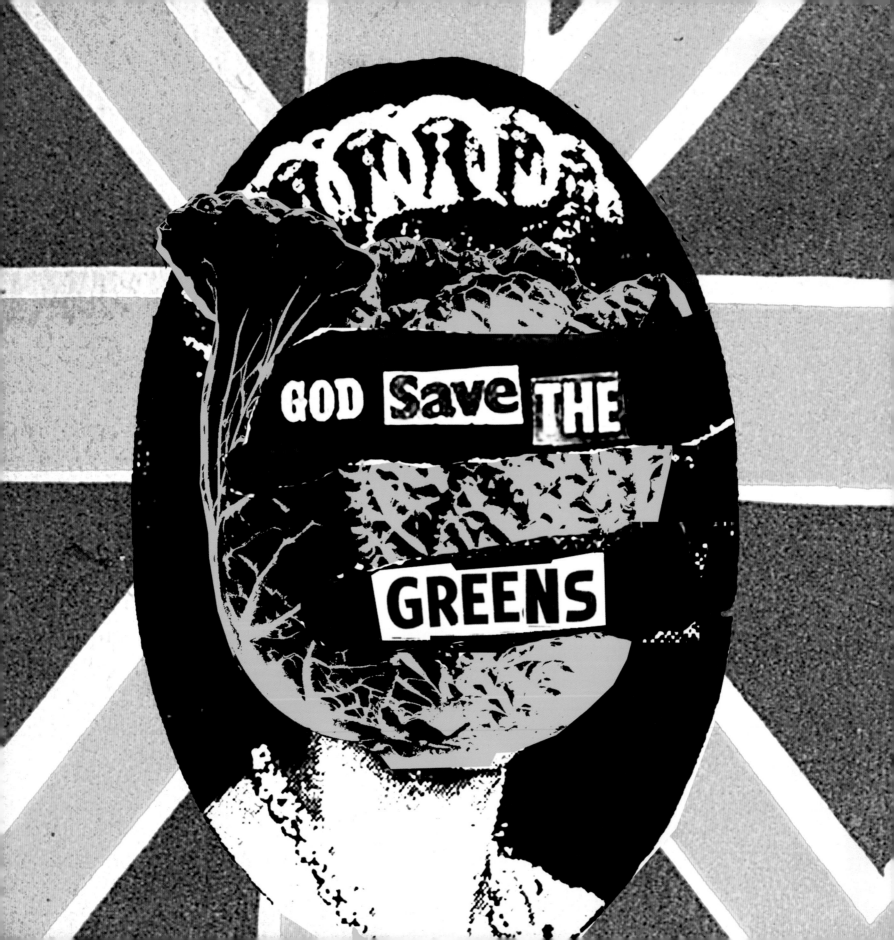

> In the end, it was our fault that we didn't articulate our ideas well enough.
>
> **Jamie Reid**

PUNK

Punk was first identified in the mid-1970s through the sub-culture of New York fanzine publishing as it championed the alternative music scene. More than any other art movement of the twentieth century, the visual identity of Punk is indelibly linked to its underground musical roots. Punk visual artists expressed their own anger and rage against the establishment using similar do-it-yourself methods and seeking shock value results. The whole appearance of punk was intended to disturb and distress.

Punk 'officially' arrived on the British art scene in 1976 with the exhibition 'Prostitution' at the ICA galleries. Described by the newspapers as 'sickening', 'depraved' and 'obscene', it incited a public outcry that provoked discussions in Parliament forcing its closure after only eight days. Anarchy and Punk would always be viewed as two sides of the same coin.

The controversial in-your-face graphics of punk, often arrived at with just a pair of scissors and glue, had originated in black and white. Later on colour was restricted to brash fluorescents. The two worlds of art and music scandalously collided in 1977 during the Silver Jubilee celebrations of Queen Elizabeth II with the release of the Sex Pistols' version of 'God Save the Queen' with cover art by Jamie Reid.

Punk became increasingly fashionable as it gained more media coverage but ultimately sold itself out as it became the mainstream that it had originally fought against.

(MID-1970S – MID-1980S)
JAMES CAUTY • BILLY CHILDISH • NAN GOLDIN • DEREK JARMAN • RAYMOND PETTIBON • JAMIE REID • KATE SIMON • PENNIE SMITH • LINDER STERLING

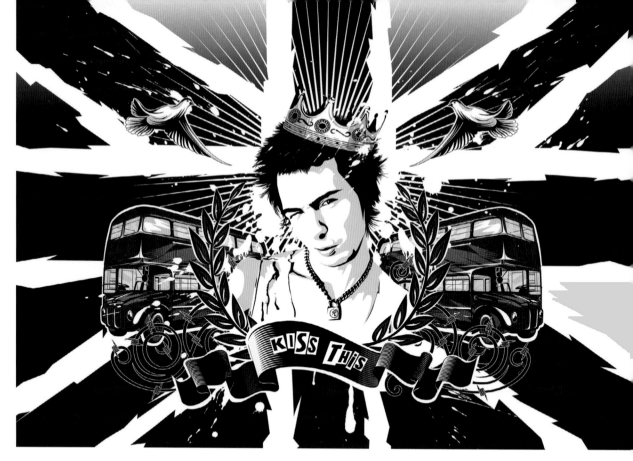

PREVIOUS PAGE:

PETER QUINNELL

GOD SAVE THE GREENS (2009)

Collage/Adobe Photoshop

For this commission from *Men's Health* magazine the artist has seized on Jamie Reid's anti-monarchist cover art for the Sex Pistol's first single record, *God Save The Queen* (1977). Reid created two treatments for the original release, as here, with cut and paste ransom text, and an alternative, with swastikas and a safety pin added to the Queen's face.

RIGHT, TOP & BOTTOM:

XENIA BYSTROVA

KISS THIS & NO FUTURE (2009)

Adobe Illustrator/Adobe Photoshop/Ink/Paint textures

These posters were created by their Russian artist as a tribute to a favourite band. These inflammatory images depicting crowned members of The Sex Pistols fronting Union Jacks bearing ransom-note graphics are a personal riff that mixes typically controversial Punk imagery.

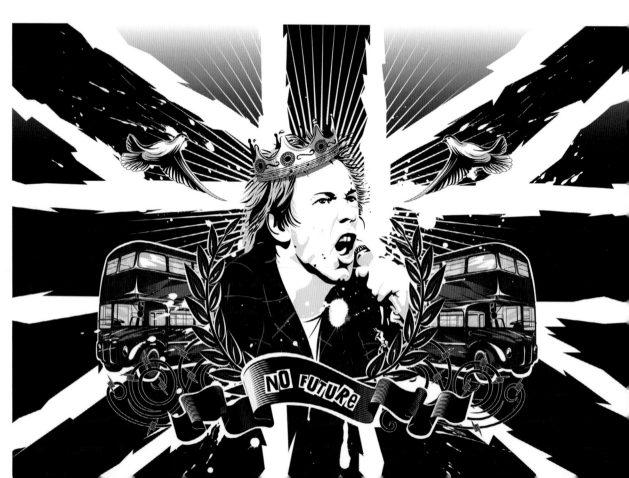

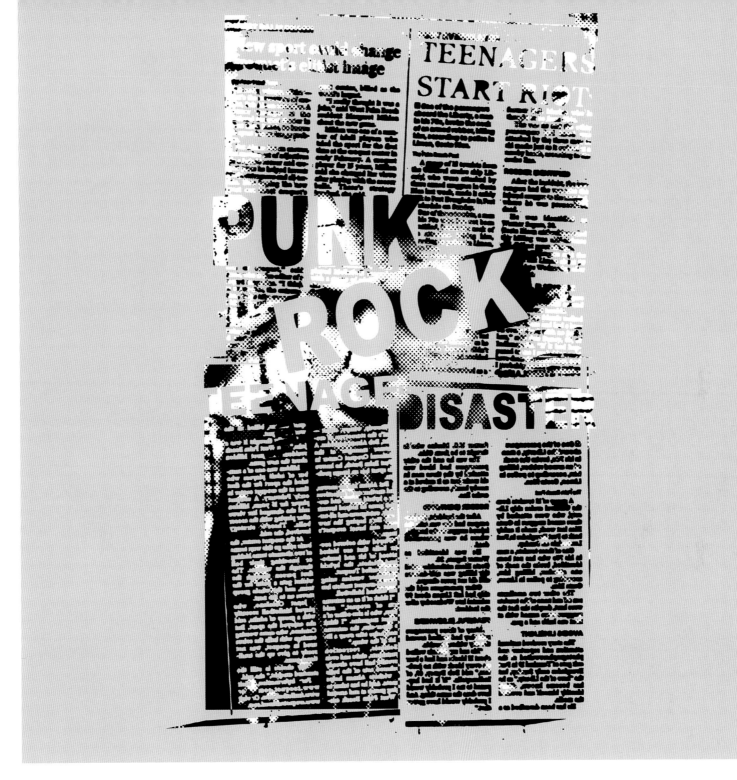

ABOVE: ROSS ROBINSON

PUNK'S NOT DEAD (2008)

Adobe Illustrator/Adobe Photoshop

This T-shirt image is the artist's own personal response to Punk's DIY philosophy that railed against the manufactured, the marketed, the overproduced and the fake. In a world of Britneys, Gagas and Rhiannas the artist is convinced that there is – more than ever – a need for a Sid Vicious.

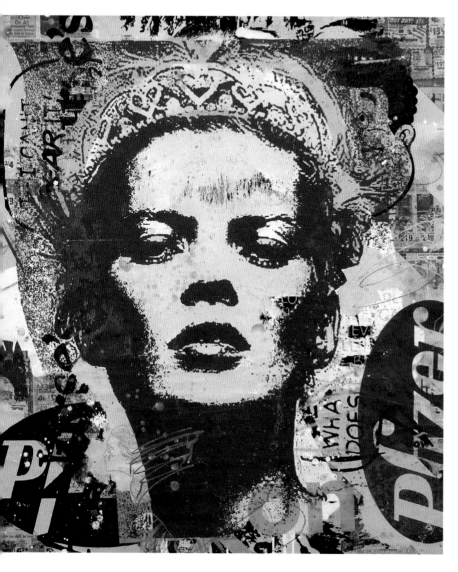

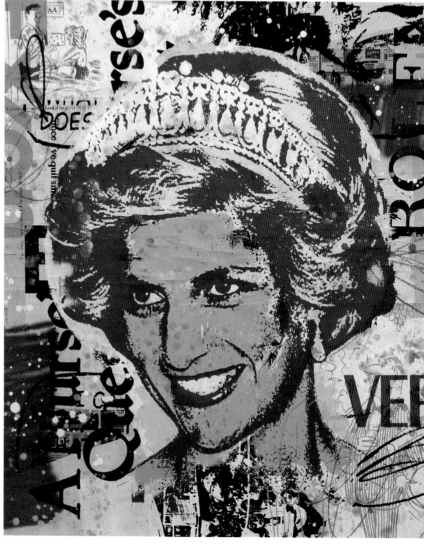

ABOVE, LEFT & RIGHT: GREG GOSSEL

KATE IN BROWN (2009) & DIANA IN RED (2009)

Acrylic/Silkscreen/Collage/Pencil/Spray paint/Ink

Both of these Punk style posters originate from the artist's exhibition at the White Walls Gallery in San Francisco in 2009. Using his own personal repertoire of pop culture imagery, the artist's spontaneous hands-on approach is true to the Punk DIY aesthetic. The fall from grace of both tiaraed subjects is suitably signaled in the complex layering within each canvas.

OPPOSITE PAGE: MATHIS REKOWSKI

VENUS POLICE (2008)

Adobe Photoshop

The artist's intention to create something 'raw, dirty and angry' seems fully realised with this digital Punk treatment. By using the distinctive mannerisms of Punk's trash culture the designer is well able to express his reaction in a typically deconstructivist manner.

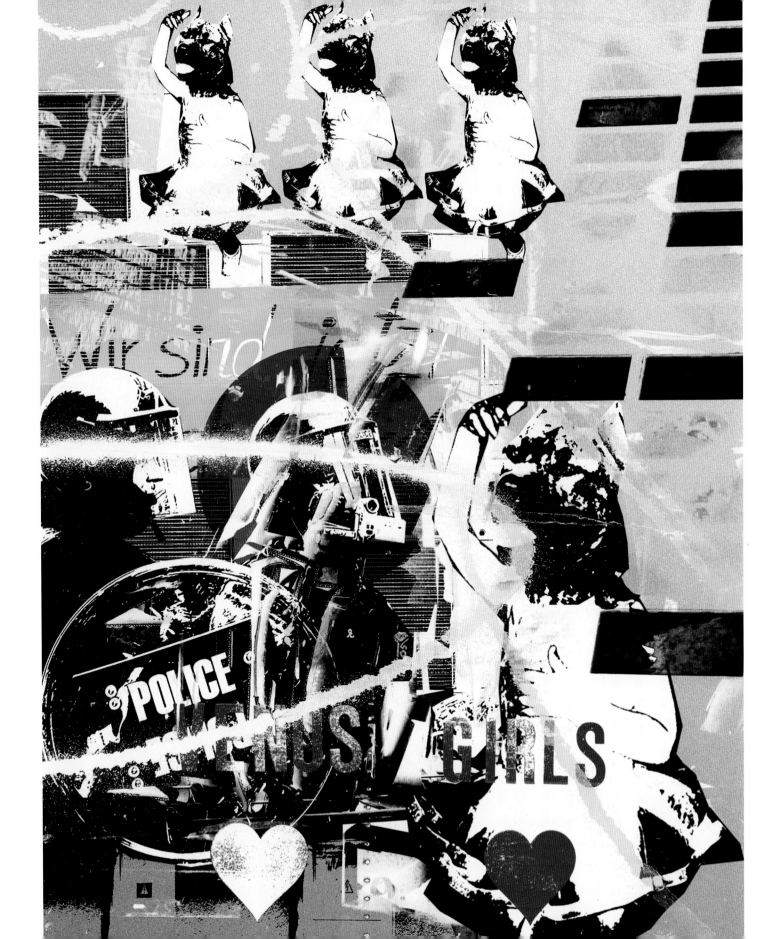

AMEN (2007)

Handmade silkscreen

In this irreverent depiction of the Pope as a Red Devil the illustrator is applying the distinctive shock tactics of the Punk artists who were out to undermine and poke fun at moral respectability and social conformity.

GASMASK TERROR – GIG POSTER (2006)

Adobe Photoshop

The artist has taken a literal response to the name of the caustic French hardcore Punk band, Gasmask Terror for this striking gig poster. The image was also inspired by the subversive American artist Winston Smith (b.1952), best know for his controversial Cross of Money collage on the Dead Kennedys' EP album *In God We Trust* (1981).

RIGHT: PAUL GILES

PATROL WITH INTENT (2010)

Pen/Spray paint/Ink/Adobe Photoshop/Adobe Illustrator

A concept design for a T-shirt image inspired by the public perception of the local police force. The subversion of authority figures was a staple of Punk's inflammatory visual language.

BELOW: PAUL GILES

GAG MAGGY – SHUT UP BITCH (2009)

Pen/Spray paint/Ink/Adobe Photoshop/Adobe Illustrator

Punk art was always produced with shock tactics in mind. Here the artist replicates that expression of anger and distrust with a visual reaction to the political opinions of the former British Prime Minister, Margaret Thatcher.

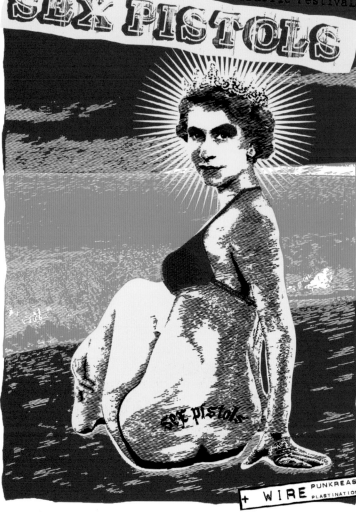

ABOVE: **BRIAN EWING**

PUNK ROCK SOCIAL - WELT (2006)

Pen/Adobe Illustrator

Given free reign by the promoters of the event, the designer of this poster exploited the styles of American tattoo artists Sailor Jerry (1911–1973) and Don Ed Hardy (b. 1945) to provide a suitably arresting image that would appeal to the featured punk rock bands and their audience.

ABOVE: **MALLEUS**

SEX PISTOLS (2008)

Handmade silkscreen

The artist has combined two of the Sex Pistols' songs – 'God Save the Queen' and 'Holidays in the Sun' – from their 1977 studio album, *Never Mind the Bollocks, Here's the Sex Pistols* – to assemble this voyeuristic Punk screen-print.

OPPOSITE PAGE: **PAUL GILES**

TELEVISION RULES THE NATION (2010)

Pen/Spray paint/Ink/Adobe Photoshop/Adobe Illustrator

Here the artist set himself a personal project to illustrate each track on the Daft Punk album: *Human After All*. The duo's third studio album set about satirising today's reliance upon technology that the designer has simultaneously glamourised and trivialised as with all Punk graphics.

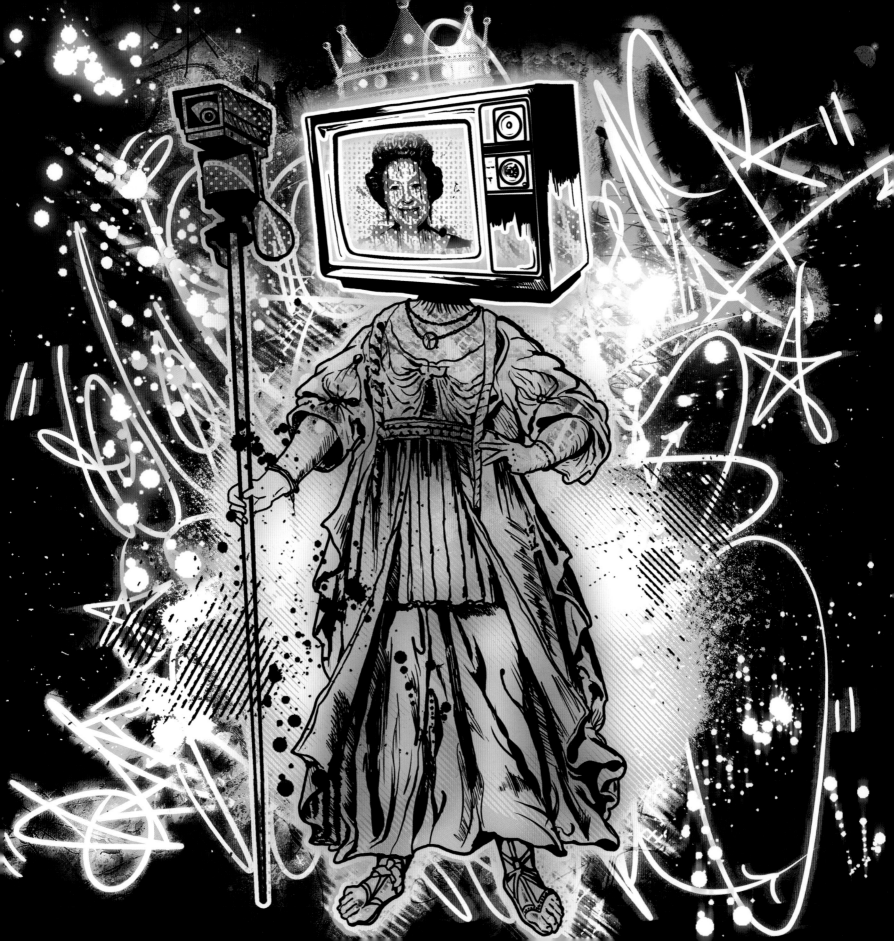

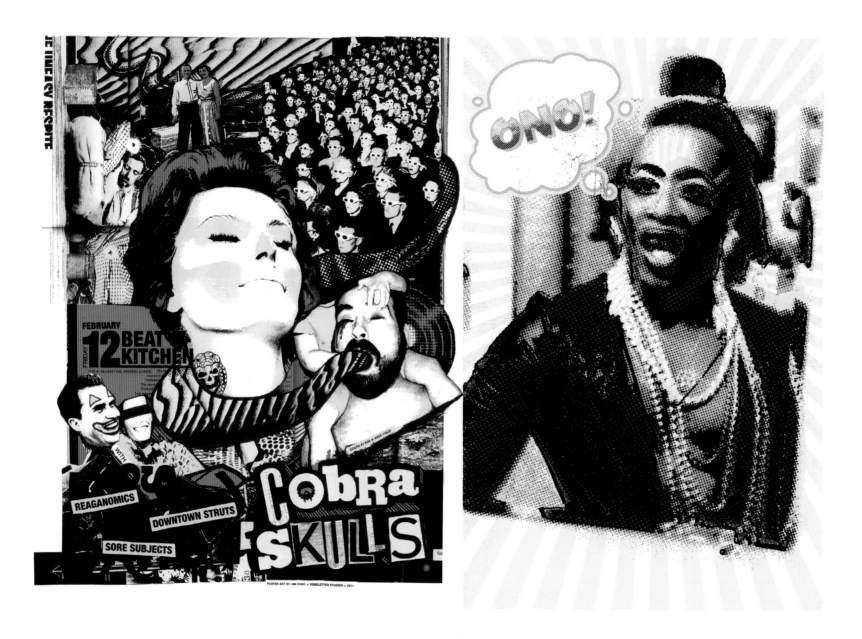

ABOVE: **JIM FORD**

COBRA SKULLS AT BEAT KITCHEN (2011)

Photocopy/Collage/Marker/Adobe Photoshop/Silkscreen

A screenprinted poster commissioned from punk rock band, Cobra Skulls, for their Beat

Kitchen show in Chicago. It combines an old school Punk approach with a more

contemporary use of imagery and colour.

ABOVE: **JIM FORD**

ONO BLANK SHOW POSTER (2010)

Photography/Adobe Photoshop/Silkscreen

The designer adapted a photograph of a drag queen hanging up in his bathroom by

enlarging and deconstructing the already manipulated image towards a Punk conclusion.

The resulting halftone patterns also give this image a comic book feel.

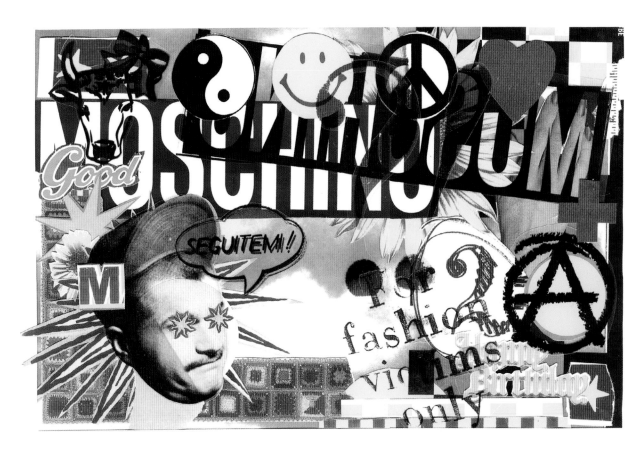

ABOVE RIGHT: PETER QUINNELL

MOSCHINO (2004)

Collage/Adobe Photoshop

A Punk re-shuffle for the Italian fashion house, Moschino, in a commission for *Jack* magazine. The deconstructivist treatment throughout, particularly of the logo, is typical of Punk's reaction to the pretensions of the mainstream public image.

RIGHT:

TOM CORNFOOT

A PUNK MANIFESTO (2007)

Collage/Adobe Photoshop

This digital collage was produced for a 'zine celebrating 30 years since the release of The Sex Pistols album, *Never Mind the Bollocks* in 1977. The artist has attempted to marry the Punk DIY aesthetic with contemporary digital techniques.

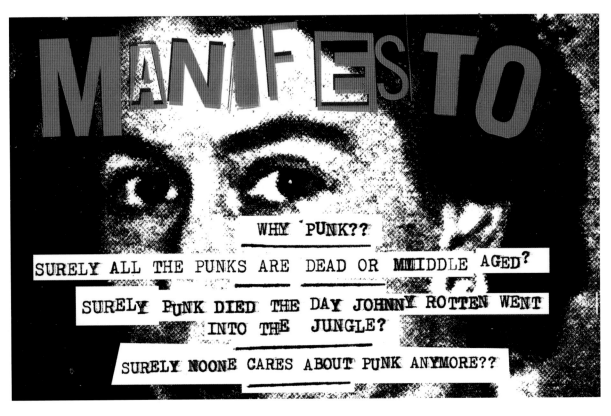

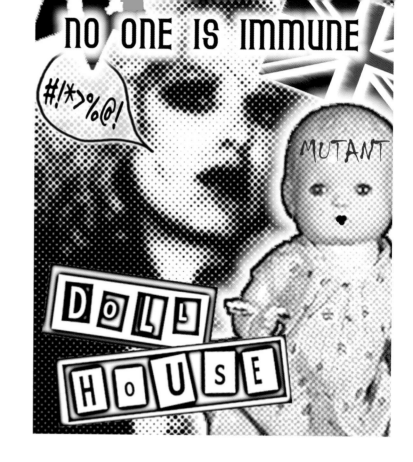

RIGHT: PAMELA THOMPSON

NO ONE IS IMMUNE (2000)

Adobe Photoshop/Adobe Illustrator

Inspired by punk posters that made use of collage and relied upon B&W photocopiers for a cheaper printed output, the mixture of taglines used here emphasizes the ambiguity of the doll and the girl.

BELOW: RITA GOMES (A.K.A. WASTED RITA)

KILLING TRENDS (2008)

Adobe Photoshop

This CD artwork for the Portuguese punk-rock band, Killing Trends, was created by mixing hand collage with stenciling techniques to create a striking DIY Punk reinvention.

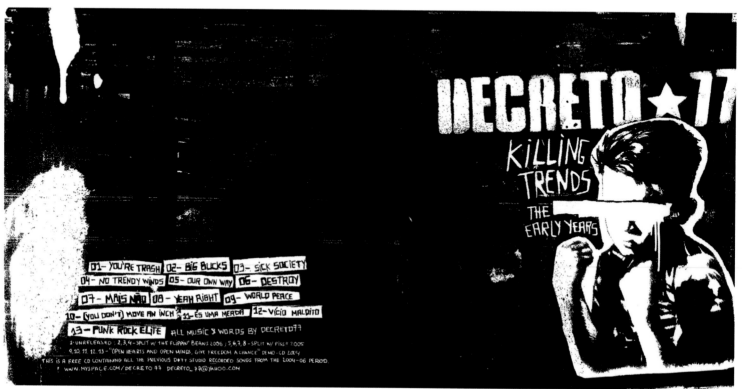

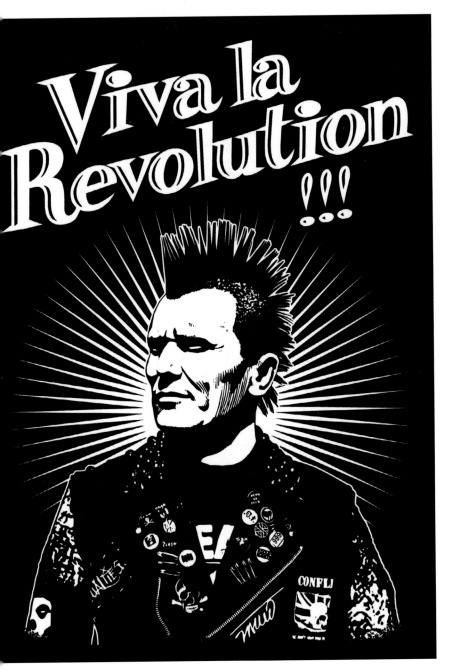

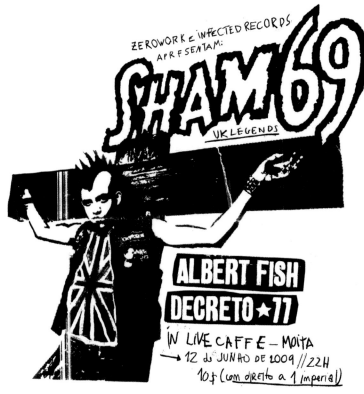

ABOVE: **LJUBOMIR BÁBIC**

VIVA LA REVOLUTION!!! (2010)

Adobe Photoshop

The illustrator has given a black and white Punk style reinvention for this celebratory T-shirt design created for the 30th anniversary of the death of Josip Broz Tito (1892–1980), leader of the Yugoslav anti-fascist resistance during WWII.

ABOVE: **RITA GOMES (A.K.A. WASTED RITA)**

PUNK IS DEAD (2009)

Adobe Photoshop

A brutal B&W, linoleum block-printed poster for the British punk-rock band, Sham-69, that draws upon the same style of provocative imagery that identified Punk's radical cultural iconography.

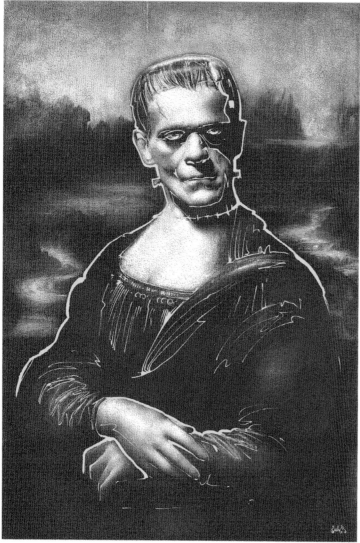

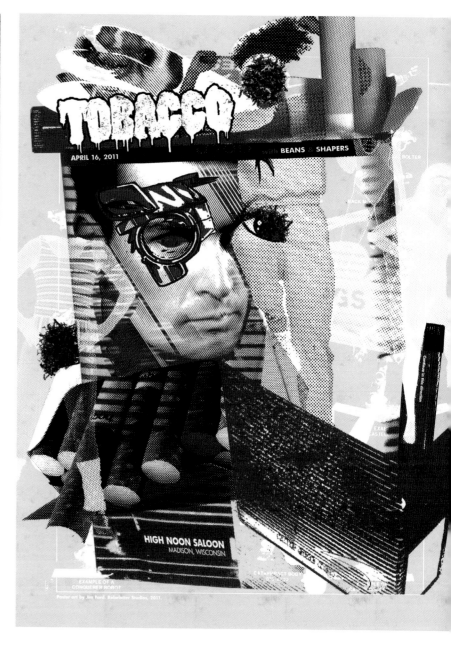

ABOVE LEFT: MALLEUS

ELECTRIC FRANKENSTEIN (2005)

Handmade silkscreen

For this commission the artist has used the band's name as a springboard into subverting the immortal Leonardo da Vinci (1452–1519) *Mona Lisa* portrait with the head of the classic Karloff Frankenstein monster. Punk was always fond of redressing iconic images with its own inflammatory brand of beauty. The reversed text is in imitation of da Vinci's celebrated 'mirror writing'.

ABOVE RIGHT: JIM FORD

TOBACCO AT HIGH NOON SALOON

Collage/Adobe Photoshop/Silkscreen

This poster was a response to a commission by True Endeavors Productions for the electronic group, Tobacco. The group's passion for the bizarre is well exploited in this fractured punk style treatment of associated imagery that reflects their gritty and disorientated music.

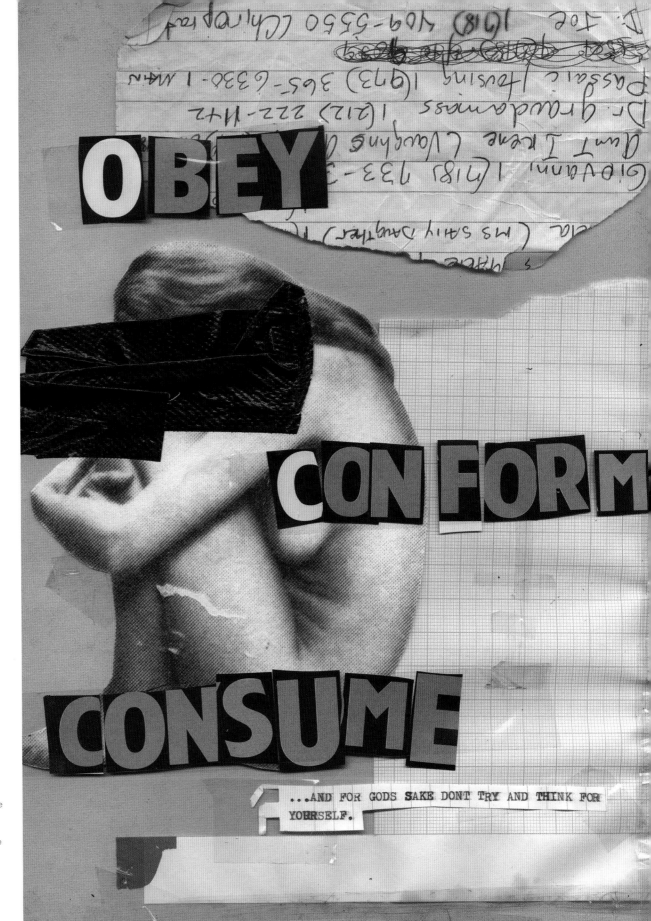

RIGHT: TOM CORNFOOT

OBEY, CONFORM, CONSUME

(2006)

Gaffer tape/Collage

Here the artist enjoys using found
ephemera to create his arresting
illustrations. This exercise in hand
crafted collage follows the cut-and-paste
aesthetic of Punk by bringing together
trashed items with imagery from vintage
porn magazines.

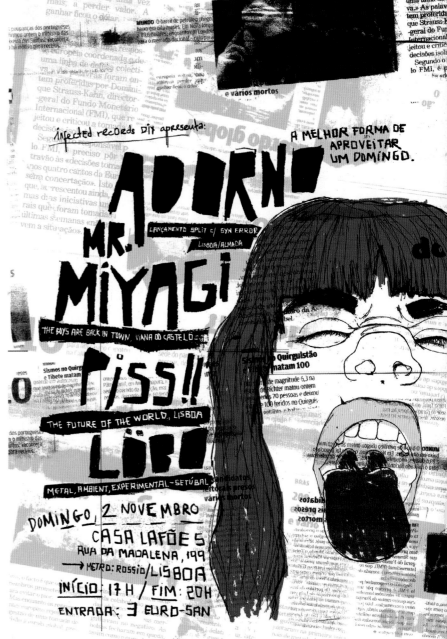

YAKUZA AT BEAT KITCHEN (2011)

Photocopy/Collage/Marker/Adobe Photoshop

For this poster the designer worked from a two-layer collage of photocopies to help visually replicate the music of the band, Yakuza, who intermix avant-garde metal with free jazz. The eastern influence in the poster is a reflection of the band's name taken from the Japanese mafia syndicate.

ABOVE: **PETER QUINNELL**

BUY ONE GET ONE FREE (2010)

Adobe Photoshop

In this T-shirt design for The Collect in London's Covent Garden, the artist has digitised the familiar fragmentary DIY Punk cut-ups with prominent fluorescent colouring suggestive of the PVC and vinyl textures that became a staple of any Punk wardrobe.

ABOVE: **RITA GOMES (A.K.A. WASTED RITA)**

ADORNO (2008)

Adobe Photoshop

A promotional flyer for a punk-rock matinee that bears all the hallmarks of Punk's DIY and do-it-now approach to image making. The immediacy of the imagery is the designer's individualistic visual representation of the music making.

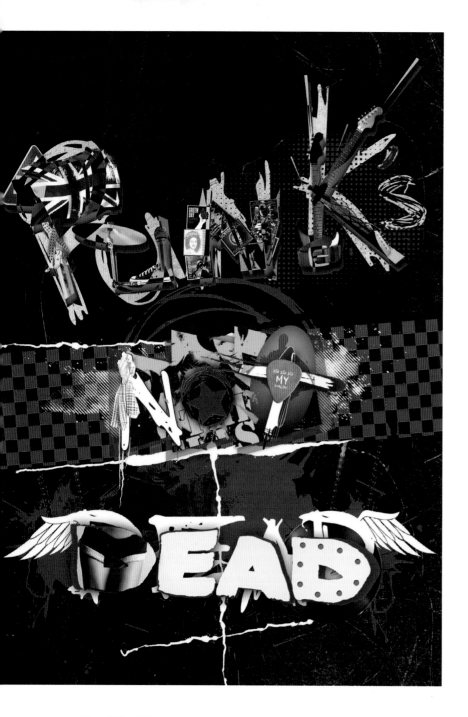

ABOVE: **YOUNES BADI**

PUNK'S NOT DEAD (2010)

Adobe Photoshop/Adobe Illustrator

The legend 'Punk's Not Dead' was also used by Susan Dynner as the title for her celebrated 2006 documentary about the legacy of the Punk era. This trashed poster art juxtaposes elements from present-day graphic design with the non-conformist, DIY spirit of the original Punk movement to dramatic effect.

ABOVE: **GLYN SMYTH**

BRUTAL TRUTH – TOUR POSTER (2007)

Pen & ink/Adobe Photoshop/Screenprint

American band, Brutal Truth, are notorious for their unique Punk sound fuelled on extreme grindcore and metal. For this tour poster the designer's intention was to capture the darker side of the band's lyrics with radical imagery that also represented the new religious wars that arose in the latter part of the twentieth century.

ABOVE: **GENARO DE SIA COPPOLA**

PUNK IT (2008)

Adobe Illustrator

The artist has mashed up a heady brew of inspiration from psychedelia and retro UV posters to
create hos own confrontational in-your-face poster that is also reminiscent of post-apocalyptic punks
from the video games of the 1980s.

CONTACT DETAILS

Nicky Ackland-Snow
Email: enquiries@nickysnow.co.uk
www.nickysnow.co.uk
Represented in the USA by Wanda
Nowak
Email: life_on_mars@virgilio.it
www.wandanow.com

Aire Retro
Email: violeta@soydeimago.com
www.flickr.com/photos/aireretro/

Marc Arundale
Email: marc.arundale@talk21.com
www.marcarundale.com

Mathilde Aubier
Email: a.mathilde@gmail.com
www.mathildeaubier.com
Represented by: Colagene, Illustration
Clinic
www.colagene.com

Ljubomir Babi
Email: babic.ljubomir@gmail.com
www.coroflot.com/ljuba

Younes Badi
Email: younes9879@hotmail.com
www.behance.net/younes/frame

Anne Bail-Decan
Email: a.decaen@orange.fr
www.abdportraits.deviantart.com/gallery

Liam Bardsley
Email: liamakathedoctor@hotmail.co.uk
www.liambardsley.co.uk

Johanna Basford
Represented by NB Illustration
Email: info@nbillustration.co.uk
www.nbillustration.co.uk

Rosaria Battiloro
Email: rosariabattiloro@gmail.com
www.rosenrot.carbonmade.com

Thomas Bergmann
Email: bergie81@gmail.com
www.bergie81.deviantart.com

Adrian Borda
Email: adrian.borda@gmail.com
www.adrianborda.com

Jacquie Boyd
Represented by Debut Art
Email: andrew@debutart.com
www.debutart.com

Teó Brito
Email: teobrito@gmail.com
www.cargocollective.com/teobrito

Xenia Bystrova
Email: koivoart@gmail.com
www.koivo.com

LEFT: JAVIER EDUARDO PIRAGAUTA MORA

GO!!! DOCTOR CORAZON (2008)

Adobe Photoshop

Taking inspiration from the collage techniques of the Dadaist movement, the artist
has regrouped his downloaded imagery to support in his personal reflections on
everyday life.

Angus Cameron
Represented by NB Illustration
Email: info@nbillustration.co.uk
www.nbillustration.co.uk

Genaro De Sia Coppola
Email: genarodesia@gmail.com
www.genarodesiacoppola.com

Tom Cornfoot
Email: hello@tomcornfoot.co.uk
www.tomcornfoot.co.uk

Eoin Coveney
Represented by NB Illustration
Email: info@nbillustration.co.uk
www.nbillustration.co.uk

Francesco D'Isa
Email: francesco.disa@gmail.com
www.gizart.com

Fred van Deelen
Email: studio@arty2.com
Represented in the UK by The
Organisation
www.organisart.co.uk
Represented in France by L'un et l'autre
www.lunetlautre.fr

Josh Deiters
Email: joshdeiters@gmail.com
www.joshdeitersart.bigcartel.com

Arnaud Dimberton (a.k.a. noxea)
Email: adimberton@gmail.com
www.noxea.deviantart.com/

Nádia Domingos
Email: nadia.domingos@gmail.com
www.nadiapuurrr.blogspot.com/

Chris Down
Email: chris@chrisdown.co.uk
www.chrisdown.co.uk

Agata Dudek
Email: fikmik@gmail.com
www.agatadudek.pl

Josh Emery
Email: josh.emery@yahoo.com
www.joshuaalanemery.com

Brian Ewing
Email: Brian@brianewing.com
www.brianewing.com

Rudy-Jan Faber
Email: contact@rudyfaber.com
www.rudyfaber.com

José Ignacio Fernández
Email: hola@forbetterdays.com.ar
www.forbetterdays.com.ar

Hjalti Parelius Finnsson
Email: bjorn@parelius.is
www.parelius.is

Jim Ford
Email: jimiford413@yahoo.com
rebeletter.bigcartel.com

Jeff Foster
Email: jeff_artstuff@me.com
www.jefffoster.com

Oli Frape
Email: oli@olifrape.co.uk
www.olifrape.co.uk

Nick Gaetano
Email: nic1@cox.net
www.nickgaetano.com

Fabrício Rodrigues Garcia
Email: pintordigital@gmail.com
www.manohead.com

Rudy Gardea
Email: rudygardeaart@gmail.com
www.rudygardea.net

Jürgen Geier
Email: juergenc.geier@web.de
www.juergengeier.de

Paul Giles
Email: pfg84@blueyonder.co.uk
www.pfg84.com/

Rita Gomes (a.k.a. Wasted Rita)
Email: wastedrita@gmail.com
www.wastedrita.com

Marty Gordon
Email: renzntzman@gmail.com
www.whatwouldjesusglue.com

Greg Gossel
Email: info@greggossel.com
www.greggossel.com

Nazario Graziano
Email: studio@nazariograziano.com
www.nazariograziano.com
Represented by: Colagene,
Illustration Clinic
www.colagene.com

Jack C. Gregory
Email: jackgregoryart@gmail.com
www.jackgregoryillustrator.blogspot.com

Sam Hadley
Represented by Artist Partners Ltd
Email: christine@artistpartners.com
www.artistpartners.com

Jonathan Haggard
Email: info@jonathanhaggard.com
www.jonathanhaggard.com
Represented by Artist Partners Ltd.
www.artistpartners.com

Stevan Jacks
Email: stevanjacks12@gmail.com
www.stevanjacks.com.au

Tonwen Jones
Email: info@tonwenjones.co.uk
www.tonwenjones.co.uk
Represented by: Colagene, Illustration
Clinic
www.colagene.com

Marsha Jorgensen
Email: marsha@tumblefishstudio.com
www.tumblefishstudio@blogspot.com

Joshua Kemble
Email: joshkemble@gmail.com
www.joshuakemble.com

Adam Kissel
Email: akissel@iprimus.com.au
www.fleetofgypsies.deviantart.com

Sara Ramírez Sáez (a.k.a. Kitakutikula)
Email: kitakutikula@hotmail.com
www.kitakutikula.com

Adriean Koleric
Email: adriean@thinkitem.com
www.thinkitem.com

Michael Leigh
Email: wastedpapiers@yahoo.co.uk
www.laughingshed.blogspot.com

Darek Liszewski
Email: liszewski.dar@gmail.com
www.dardef.blogspot.com

Rose Lloyd
Email: roselloydillustrator@yahoo.com
www.roselloyd.co.uk

Gyuri Lohmuller
Email: gyurka2@yahoo.com
www.sites.google.com/site/surrealpainti
ngs/

Olivier Lutaud
Email: olivier.lutaud@gmail.com
www.olivierlutaud.com

Malleus
Email: malleus@malleusdelic.com
www.malleusdelic.com

Tim Manthey
cloudnectarstudio@gmail.com
www.cloudnectar.blogspot.com

Oliver Ler Marinkoski
Email: om_ler@hotmail.com
www.olivermarinkoski.com

Brigid Marlin
Email: brigmarlin@aol.com
www.brigidmarlin.com

Elio Marruffo Perea
Email: aelivs@gmail.com
www.fineartamerica.com/profiles/elio-
marruffo.html
www.artbreak.com/aelivs
www.artbreak.com/TotalNudeArt

Margo McCafferty-Rudd
Email: mcruddart@gmail.com
www.mcruddart.com

Stuart McLachlan
Email: stuartrex@iinet.net.au
www.stuart-mclachlan.com

Lars Julien Meyer
Email: adonislein@googlemail.com
www.adoniswerther.deviantart.com

Maxim Mitenkov
Email: vik@vimark.biz
www.vimark.deviantart.com/

Matt W. Moore
Email: matt@mwmgraphics.com
www.mwmgraphics.com

Shannon van Muijden
Email: s.vanmuijden@hotmail.com
www.ysa.deviantart.com

Ben Newman
Email: ben@bennewman.co.uk
www.bennewman.co.uk
Represented by Pocko
Email: info@pocko.com
www.pocko.com

Christian Northeast
Email: christiannortheast@gmail.com
www.christiannortheast.com

Julien Pacaud
Email: julien.pacaud@gmail.com
www.julienpacaud.com
Represented by: Colagene, Illustration
Clinic
www.colagene.com

Javier Gonzalez Pacheco
Email: javiergpacheco@hotmail.com
www.javiergpacheco.deviantart.com
www.javiergpacheco.blogspot.com

Mariana Palova
Email: mariana.palova@hotmail.com
www.marianapalova.com

Roberlan Borges Paresqui
Email: Roberlan.borges@gmail.com
www.roberlan.deviantart.com

Alessandro Pautasso
Email: kaneda@nosurprises.it
www.nosurprises.it

Javier Eduardo Piragauta Mora
Email: javb1er@hotmail.com
www.flickr.com/javierpiragauta/

Daniel Pelavin
Email: daniel@pelavin.com
www.pelavin.com

Tara Phillips
Email: tara@taraphillips.ca
www.taraphillips.ca

Adam Pinson
Email: redeyeart@mail.com
www.redeye-art.com

Stephanie Power
Email: hello@stephaniepower.com
www.stephaniepower.com

Peter Quinnell
Email: peterquinnell@gmail.com
www.peterquinnell.com
Represented by: Debut Art
www.debutart.com

Mathis Rekowski
Email: hello@mathis.tv
www.mathis.tv
Represented by: Agency Rush
www.agencyrush.com

Russ Revock
Email: r.revock@csuohio.edu
www.russrevock.com

Rodolfo Reyes
Email: rodolforever@hotmail.com
www.rodolforever.deviantart.com/

Anna Rigby
anna@annarigby.com
www.annarigby.com

Ross Robinson
Email: contact@rossrobinson.com.au
www.rossrobinson.com.au

Dhella Rouat
Email: dhellarouat@gmail.com
www.zhaana.deviantart.com/

Sonia Roy
Email: info@soniaroy.com
www.soniaroy.com
Represented by: Colagene, Illustration
Clinic
www.colagene.com

Jim Rugg
Email: jimrugg@jimrugg.com
www.jimrugg.com

Ezequiel Eduardo Ruiz
Email: ezequielruiz_1@hotmail.com
www.flickr.com/photos/ezecuchy/
www.behance.net/Ezecuchy
www.flickr.com/photos/ezecuchy/
www.ezecuchy.blogspot.com/

Saks Fifth Avenue
Email: Kimberly_Grabel@s5a.com

El Reino de la Sandia
Email: elreinodelasandia@yahoo.com
www.flickr.com/photos/elreinodelasandi
a/

Kelly Schykulski
Email: kschykulski@yahoo.com
www.kellyschykulski.com
Represented by: Colagene, Illustration
Clinic
www.colagene.com

Bob Scott
Email: bob@bobscottart.com
www.bobscottart.com

Aleksandra Sendecka
Email: asendecka@hauru.eu
www.ethlinn.deviantart.com/

Katrina Shillaker
Email: trina@shillaker.net
www.shillaker.net

Danny Castillones Sillada
Email: dsillada@gmail.com
www.dannysillada.weebly.com
Represented by Robert De Tagle
Email: artempoNY@gmail.com

Lorna Siviter
Email: lorna.siviter@virgin.net
www.lornasiviter.co.uk
Represented by The Organisation
www.organisart.co.uk

Laura Smith
Email: Laura@LauraSmithArt.com
www.LauraSmithArt.com
Represented by Margarethe Hubaurer
(Europe)
Email: mhubauer@margarethe.de
www.margarethe-illustration.com

Glyn Smyth (a.k.a Scrawled Design)
Email: scrawled@hotmail.com
www.scrawled.co.uk

Whittney Streeter
Email: grandmazilla@gmail.com
www.whittneyastreeter.com

Josh Taylor
Email: info@joshtaylorart.net
www.joshtaylorart.net
www.birdandgirl.com

Miles Tebbut
Email: miles@milestebbutt.com
www.milestebbutt.com

Ruth Terrill
Email: rterrill@email.toast.net

Pamela Thompson
Email: pamela@pamelathompson.com
www.pamelathompson.com
www.tinyfrockshop.com

Felix Tjanhyadi
Email: info@felixtjahyadi.com
www.flixm.blogspot.com

John W Tomac
Email: john@johnwtomac.com
www.johnwtomac.com

Gillesse Ukardi
Email: gillesseu@hotmail.com
www.gillesse.ca/

Damien Vignaux
Email: hello@elroy.fr
www.elroy.fr
Represented by Colagene, Illustration
Clinic
www.colagene.com

Laurence Whiteley
Email: info@laurencewhiteley.com
www.laurencewhiteley.com

David Whitlam
Email: davewhitlam@yahoo.co.uk
www.davidwhitlam.com

Stina Wiik
Email: info@stinaw.se
www.stinaw.se

Dave Wittekind
Email: d.wittekind@comcast.net
www.davesink.com

Barry Zaid
Email: bzaid@bellsouth.net
www.barryzaid.com

Egon Zukuska
Email: egonzakuska@propagit.com
www.propagit.com (project site)
www.caovoador.com (studio site)